HPBooks®

Pro Techniques of
PHOTOGRAPHING
Children

Erika Stone

Published by HPBooks
A Division of HPBooks, Inc.
P.O. Box 5367, Tucson, AZ 85703 (602) 888-2150
ISBN: 0-89586-390-1 Library of Congress Catalog No. 86-80359
©1986 HPBooks, Inc. Printed in U.S.A.
2nd Printing

Publisher: Rick Bailey
Executive Editor: Randy Summerlin
Senior Editor: Vernon Gorter
Art Director: Don Burton
Book Design: Paul Fitzgerald
Production Coordinator: Cindy Coatsworth
Typography: Michelle Carter
Director of Manufacturing: Anthony B. Narducci

FOREWORD

One spring day, many years ago, Erika Stone brought her son to my office for treatment of poison ivy. Erika selected me because she had read an article I had written for *American Baby* magazine. We struck up a friendship.

After a while, we began working on projects together. Erika would take photographs of children in my office and I would write text to accompany the photos. Our work appeared in such publications as *American Baby, Parents, Baby Talk* and *Mothers*.

With her camera, Erika captures beautifully the special grace of children. She has a special talent for recording telltale facial expressions, gestures and postures and thereby bringing out the rich gamut of a child's emotions. Through her photos, Erika opens our eyes and senses to the joy, exuberance, anger, jealousy, fear or puzzlement of all children.

Erika loves children. Her photographs show that she does! Through this book, I believe that her love, enthusiasm and skill will rub off on many photo enthusiasts!

Christine Guigui, M.D.
Pediatrician
Ridgefield, Connecticut

THANKS

My special thanks to the following organizations and individuals for their help:
Nikon, Inc.
Spiratone, Inc.
Minolta Corporation
Rick Sammon
Barbara Kirk
Marcia Weinstein

DEDICATION

To my husband Bill, for his years of encouragement and help, and to my first child models, my sons Michael and David, with thanks.

Erika Stone
New York City

Contents

Introduction

I love kids and I love photography. That's why I make my living photographing all the wonderful stages of childhood and the exciting experiences and expressions of individual children.

I have written this book for those who share my two loves. When I started out working with a camera, I often wished for a good book that would help me along the way. I wanted to learn more about children and photography. I managed to read occasional articles about photographing children in magazines. But I never did find a comprehensive, in-depth book on the subject.

How would I control a three-month-old, and what would be the best way to direct a toddler? Should I shoot outdoors or in a controlled studio setting? What camera, lens and film would be most suitable? I learned these things by bringing up my own children and observing them, and by experimenting with my camera and accessories.

I've now been a professional photographer of children for many years. I decided I would write for others the book that I missed so badly in my early days. I had a lot of fun preparing this book. Writing about my work and my experiences with children of different ages, and gathering together a suitable portfolio of pictures, brought back a lot of fond memories. But my real satisfaction will come from knowing that the book has helped others.

Nothing can ever take the place of your own, personal experience. I encourage you to experiment and break the rules, to find out what's best for you. However, I want to make the road a little easier for you. That's what this volume is all about.

If you own a Nikon, Minolta, Canon or other fine, sophisticated SLR camera, that's fine. However, you can take wonderful photographs of children with the popular auto-focus, auto-exposure, auto-flash cameras available today.

As long as you work within the limitations of these point-and-shoot cameras, you can work wonders. For example, don't try and take a head-and-shoulders portrait with a camera that has a fixed, 38mm lens. You'll have to get too close, and this will result in unflattering distortion of the face. Also, at such close range the image is likely to be very unsharp.

Don't expect artistic illumination with an on-camera flash. If you want striking lighting effects, using such cameras, work outdoors. The most spectacular daylight effects usually occur early in the morning or late in the afternoon.

Whatever equipment you use, don't expect it to do things for you that are beyond its capabilities. With a simple, fixed-lens camera you can't take all the pictures I take with my Nikon. But the ones you are able to take can be just as good as mine. Ultimately, your success depends on your capabilities, and your judgment, as a photographer.

My interest in photographing children began with my own two sons. When one of them mischievously wrapped himself in an entire roll of toilet paper, or raided a box of candy and got chocolate all over his face, I would get angry. Suddenly, I realized the wonderful potential for fine photographs in these "disasters."

After shooting numerous photos and picture series of my children, I learned that there were magazines—such as *Baby Talk, Mothers' Manual* and *Parents Magazine*—that would buy such material if it was good enough. My professional career began.

This book is intended for photographers of children, no matter whether the photos are intended for a family album or a national magazine or advertising campaign. If you have a desire to become a professional, the last of the essays deals specifically with that subject.

The bulk of this book consists of a portfolio of photographs. I selected these with two ideas in mind. First, I wanted to present an exciting visual mix of images. Second, I wanted to present as wide a variety of technical challenges because in this way I could impart the greatest amount of useful information.

When you study the images in this book carefully, one thing will quickly become evident: With children, you have to work fast. That perfect expression is very fleeting and may never be repeated in quite the same way again. Therein lies the special challenge and excitement of child photography: If you take a truly fine picture, no one else is likely to ever duplicate it!

I wish you luck, and a quick eye!□

Psychology of Photographing Children

Psychology plays a particularly important part in child photography because the word "child" encompasses a wide range of characteristics and needs. Between birth and the time a human being ceases to be a child, innumerable and continuous changes occur.

The greatest changes in my young subjects seem to take place between birth and the age of three. This applies equally to appearance, communication and attitude.

In the first year in particular, you should expect a lot of changes as baby grows physically and emotionally. As his perception of his environment becomes more acute, your "directing" technique must change accordingly.

Following are some descriptions of children at different ages, and some tips on psychological techniques you can use when photographing them.

third month, baby starts to smile. If propped up, he will watch what is going on around him. He begins to show interest in moving objects. The face shows varied expressions, indicating how baby feels. At the age of four months, most babies respond to sounds and have quite a repertoire of expressions.

In baby's fifth month he starts grasping and otherwise using his hands with some dexterity. In his sixth and seventh month, the baby becomes aware of his feet. He also becomes interested in mirrors and what he sees in them. You can exploit this photographically to get photos with wonderful expressions. At about seven months, most babies start trying to sit up unsupported.

Newborn babies must be photographed in a passive state, just sleeping, lying with their eyes open, or feeding. As they get older, babies offer more and

you can take fascinating baby pictures.

PERSONALITY

Although the progressions in physical aptitude and intellectual interest are pretty standard, baby personalities are no more standard than those of adults. There are happy babies and solemn babies, friendly babies and aloof babies, carefree babies and timid babies.

I can often tell whether a baby is shy or outgoing when I first greet him or talk to his mother about the shooting session. Some babies seem at ease and smile at me from the first moment. Some hide, cry or appear upset because a stranger has intruded into his life.

If you learn to watch babies carefully, you'll get some useful messages. Eventually, you'll be able to evaluate a baby very rapidly and to communicate with him appropriately.

When a baby is shy, go along with it. Photograph this baby held tight in his mother's arms or interacting with her. Many babies have a period in which they don't want to be held by anyone but mommy and get upset if anyone else approaches.

A month or two later, the same baby may greet strangers with delight. Then is the time to get more adventurous in your photography.

There are happy babies and solemn babies, friendly babies and aloof babies, carefree babies and timid babies. Evaluate the baby you're photographing and treat him in a manner that's likely to be most effective.

BABIES

A child is regarded as a baby until the time he begins to take his first steps. Then, he's called a *toddler*. The transition takes place at about the age of one.

TINY BABIES

Up to the age of about one month, a baby sleeps most of the time. At one to two months, the eyes begin to focus, but the head must still be supported. In his

more opportunities for your photography.

OLDER BABIES

At seven, eight or nine months, an infant usually starts to crawl. This exposes him to a new and fascinating world. Learning to stand up and take his first steps engages much of his time from nine months to about one year.

In each of the phases just described,

ENDURANCE

Unless you want pictures of a baby asleep, the baby should be alert during the shooting session. As attention wanes, so will the quality of the pictures you get.

How long you can expect a baby to remain alert and interested varies from baby to baby. To some extent it depends

on age and strength. A newborn generally won't stay awake for very long. The longest I would expect to work with a baby of one year is about one hour. I would shoot a younger infant for no longer than 20 or 30 minutes.

However, I can't predict how long a specific baby will last for a photography session. With some babies I can shoot and shoot. After an hour, they still smile at me and react to my actions. Others tire and get cranky quickly.

Although I can rarely anticipate a baby's endurance, it's generally true that a frail-looking baby will not provide as many opportunities for good photos at one session as a more robust baby. Of course, a robust baby may shorten the

and other toys for this purpose.

While I shoot, I often enlist the help of baby's father or mother to keep him interested. Parents generally know best which sounds or gestures will get a good reaction.

TODDLERS

When a baby begins to move on his feet, he becomes a *toddler*. This happens at the age of about one year, although it can vary from about 10 to 14 months. Toddlers have more staying power than babies but still get disinterested or cranky eventually.

Toddlers are notoriously temperamental and, because they are more aware, more apt to be shy than babies. If

gets cranky. You may not get the images you had anticipated, but there are other excellent picture-taking opportunities.

PRESCHOOL CHILDREN

A big change takes place at the age of about three years. From this age, children can be talked to and reasoned with. You can ask them to pose for short times. Give them interesting toys and props and photograph them while their attention is at its peak.

Preschool children are interested in each other. Photograph them playing with one another, such as at the swimming pool, or involved in some other group activity.

This is an occasion for action photography. It enables you to hone your skills at shooting fast to get good candid shots.

YOUNG SCHOOL CHILDREN

In many ways older children are much easier to photograph than toddlers or preschoolers. They can follow directions, confine their activities to one place and repeat activities for you to photograph.

Children go through positive, cooperative stages and negative, rebellious ones. These stages tend to alternate through childhood. Be aware of the negative periods each child goes through. Parents generally recognize these periods with their own children. Through tactful discussion with parents, you can determine whether a particular child is at his best for photography.

I frequently make funny noises to get a subject's attention. I also make funny faces and use puppets and other toys for this purpose. However, I'm always careful to not startle or frighten a child.

session for other reasons. For example, he may get hungry.

When I photograph babies for commercial purposes, such as advertising, I anticipate possible problems relating to a baby's endurance. For a big assignment, I'll arrange to have two or three babies available. If one gets tired or doesn't react as desired, I can go to work immediately with another. On small editorial jobs, where I get paid considerably less, I can't afford the modeling fees for more babies than I'll actually need.

The best times to photograph babies are after feeding and after a nap. That's when they are likely to be most satisfied and alert. Even so, a baby frequently gets hungry in the middle of a session. When this happens you must stop for feeding—for the baby's sake as well as the quality of your pictures!

GETTING BABY'S ATTENTION

I frequently make funny noises to get my subject's attention. A loud "bow-wow," "quack-quack," "meow," or "ah-choo" can work wonders. Use anything that gets the child's attention and interest. However, you must be careful to not startle or frighten a child.

Visual attention-getters are also effective. I make funny faces and use puppets

my subject is shy, I photograph him first with his mother, and alone only after he is more comfortable with me, the camera and the location.

Toddlers are mature enough to appreciate rewards and are generally prepared to work for them. Promise a toddler cookies, ice cream, milk, juice or anything mother knows will make him cooperate. Always deliver on your promise!

To get appealing photos, enlist the toddler's curiosity. For example, suggest he listen to the ticking of mommy's watch, look in mommy's purse or have mommy tell him a secret. Each of these activities should give you time for several shots.

MISHAPS

Even when there are unexpected mishaps, or when a child falls and hurts himself and cries, there are opportunities for good pictures. Photographs of mommy kissing a scraped knee or of a toddler making a mess with kitchen pots and pans can be both attractive for the family album and useful for commercial sale. You'd be surprised how many requests I get from textbook publishers for just such pictures.

So don't stop working when a child

ADOLESCENTS

In my experience, adolescence is the problem period. When children reach their teens, they are very self-conscious and easily embarrassed. This sensitivity gets worse when you put a teenager in front of a camera.

One thing that works with adolescents is payment. It's not just that they want the money—being paid makes them feel they are doing an important job and so they are much more likely to cooperate. Payment need not always be cash. Many boys and girls are happy to receive copies of the photographs I take as payment.

Never talk down to teenagers. Always treat them as equals. Respect them and take them into your confidence. Explain

what you're trying to achieve and you're well on your way to winning their cooperation.

One thing you have to be prepared for from time to time with adolescents is the giggles. Fits of it can start at the most unexpected moments. I have no magic cure for it. All I can say is that the fewer teenagers you have together, the fewer giggles are likely to occur. Keep the group assembled in the studio or on location as small as possible.

When I'm working on an assignment, with an art director present, and teenage models are overcome with the giggles, I shoot a lot of extra film to be sure I get the pictures needed. I'll be lucky to get a couple of usable frames in which my subjects aren't convulsed.

Normally, you can't tag along with teenagers and expect to get good photographs of their personal activities, alone or with friends. You must respect their privacy and not intrude. However, you can *set up* activities or catch the youths engaged in public activities such as sports, games and music.

SUBTLE PERSUASION

My experience as a mother has been a big help to me as a photographer of children. I know about the "terrible twos" from personal experience. As I mentioned earlier, there are subsequent negative periods during all of childhood and adolescence.

You can't be sure of the exact ages at which a child will be rebellious. One two-year-old may be totally uncooperative, while another will be perfect until three and then become a problem.

You can't predict the behavior pattern of older children, either. A six-year-old may be very cooperative and easy to please. At six-and-a-half or seven he may be sulky and disagreeable.

One thing is certain. The cooperative and negative stages of a child repeat themselves. They are a normal part of growing up.

From my experience as a mother I learned to use subtle, "reverse" persua-

sion. If I really wanted my child to do something, I would pretend that I *didn't* want him to do it. It often worked and the same approach can work with your photographic subjects. If all else fails, discourage them from the very thing you want them to do.

WORKING WITH PARENTS

When I first meet a parent, I can quickly tell what kind of rapport we'll have and whether I can depend on his or her help as I photograph a child. Most parents are great to have around and are a lot of help.

How active a role a parent should take depends on the age of the child. Having the mother help with babies and toddlers is almost essential. With school-age children, a parent needn't be present.

I try to keep nervous parents away from the session, suggesting they have a cup of coffee and relax in another room. Some overprotective mothers, however, are not so easily put off. In such cases, I have to diplomatically try to keep them busy. I keep them occupied finding changes of clothes, looking for new toys in the toy box or participating in some other way. This tactic usually works.

PARENT AND CHILD INTERACTION

Most parents react naturally and easily with their babies and small children, and I just shoot what happens. Occasionally, however, a mother is camera-shy. Usually, this is easily overcome. I get her involved in an activity, suggest-

ing she blow at her baby, whisper in his ear or kiss his head. Mother is soon so involved that she forgets about the camera.

CLOTHING

Clothing has an important psychological effect on people. Children are no exception.

I like my subjects to wear everyday clothes rather than having them dress up. Shorts, blue jeans or whatever else is comfortable and familiar make the best wardrobe for child photography. Photographs with pleasing expressions depend more on comfort and self-confidence

I like my subjects to wear comfortable, everyday clothes rather than having them dressed up. Photographs with pleasing expressions are dependent on relaxed self-confidence. Formal clothing tends to make a child feel inhibited and, as a result, somewhat stiff.

than anything else. Formal clothing tends to be uncomfortable and also tends to make a child *feel* formal and, as a result, somewhat *stiff*.

When the mother is willing, I like to take at least a few photographs of toddlers when they are wearing no clothes at all. Most mothers love to have their babies photographed naked.

WATCH FOR POSSIBLE MODELS

I often need child models for magazine or advertising assignments. I always keep my eyes open in the search for suitable models—children and entire families. Model agencies that handle children are aware of the developmental stages of different ages, as well as the emotional ups and downs of childhood. A good agency can provide models when they are emotionally at their best and most cooperative for shooting.□

Shooting Location

You can use several shooting locations for child photography. They include your home, the child's home, a studio or an outside location. Each has its advantages.

MY HOME

There are obvious advantages to working in my own space. I don't have to transport heavy equipment and can be sure of having everything I may need close at hand. The lighting and background can be arranged before my subject arrives.

This leaves me free to concentrate on the subject's mood and expression and on camera technique. This is particularly important in child photography, which must proceed rapidly because the subjects tend to tire easily.

FAMILIARITY

My home offers many different shooting locations, and I'm intimately familiar with each of them. I know the kind of ambient lighting I can expect in each room and can predict with considerable accuracy correct exposure in different weather conditions and at different times of day.

When I use electronic flash, I know the effect that bouncing it from ceiling or walls will have, and I know how to combine flash with daylight to get a variety of effects. Total familiarity with my environment enables me to shoot much faster in my home than in the child's home.

USE ANY ROOM

Almost any room in my home can be used for photography. I regularly take pictures in the living room, posing an infant on a blanket on the floor. I shoot from near ground level as well as straight down. I also pose mothers with their babies in a chair near a window.

I photograph small children playing on the floor, older children looking at a book by a window and teenagers posed against a wall, possibly with a potted plant or some other suitable prop in the foreground or background.

Most homes—and I'm sure yours is no exception—have one or two areas that are particularly suitable for child photography. Those locations are not always the most obvious, such as the living area. I frequently use my bedroom for photography. It has wonderful natural window light in the early afternoon, and a big double bed on which to place a mother and baby. I've even posed an entire family on that bed!

I have a dining alcove with a lovely white-brick background. I also shoot in the bathroom and the kitchen.

Although I shoot throughout my home, I have a couple of areas set aside as studio spaces. In these areas I have backgrounds, lights and props that can be used with minimal preparation. I'll discuss this more fully later, when I talk about studios.

EXAMINE YOUR HOME

Take a careful look around your home and find the best shooting locations. Consider the ambient lighting, the props and backgrounds the location offers and the amount of space available for lights and camera. If you have a children's playroom, it's probably ideal for child photography.

In addition to the considerations mentioned, deciding which room to use also depends on the age of the children and the intended use of the pictures.

Generally, I plan to shoot in three or four locations during each shooting session. Sometimes, however, the sitting goes so well in one location that I shoot everything there. By the time I've exhausted the possibilities in that one location, the child is also exhausted, and it's time to call it a day.

THE CHILD'S HOME

I have mixed feelings about the advantages of shooting in my home or the child's. From a practical standpoint, it's advantageous to work in an environment that *I'm* totally familiar with—*my own*. However, a child will always feel more comfortable and confident in his own home. For this reason, I often prefer to work in the subject's home—especially if I know the child to be a bit shy or timid.

When I first arrive at a child's home, I look around for suitable, uncluttered working areas with good backgrounds such as a plain wall, a fireplace or a draped window. I look for locations with good ambient lighting.

PREVIEW THE LOCATION

For a major assignment, I'll examine the shooting location well before the actual shooting. If I'm shooting for a private client or for my own stock file, I also try to review the location just prior to shooting.

To determine in advance what equipment to bring, I get as much information as I can from the parents regarding the nature of various possible shooting areas, the ambient light conditions and the colors of walls.

PREPARATION

Before you start shooting, be sure everything you need—props, backgrounds, camera and lighting equipment—is at hand. Equally important, "clear the decks" before you start shooting. Remove anything in the working area that might disturb the session. Also remove any undesirable objects in the picture area. Once you get started, you should not have to interrupt the session for anything.

I often remove paintings and photographs from walls and move furniture about. I also check to be sure the color and pattern of the clothing worn by my subjects harmonizes with the background. If two or more people are to appear in one picture, I make sure their clothing is compatible in style and color.

STUDIO

Each photographer must decide for himself whether he needs a separate studio facility for his child photography. A photographer's career development goes through several stages. When he first sets out, he may not need a studio at all. Later, a studio area in his home may be adequate. When a separate studio is needed for specific assignments, such space can be rented by the hour or day in most large cities. Eventually, a child photographer may need his own studio.

Certainly, working in a studio has many advantages over taking pictures all over the house. Lighting and exposure can be standardized. Total control in an area that serves only as a studio is an attractive idea. However, in my view a studio is rarely a necessity for a child photographer—and can be a great expense.

STUDIO AT HOME

I compromise. I work in my home but, as indicated earlier, I have converted a couple of locations there into more or less permanent studio areas. Should I need more space, I have the reassurance—living in New York City—that I can rent studio space easily.

Advertising, promotional and editorial clients often want studio pictures instead of pictures that look as if they were taken in a home. However, such pictures can be made in your home—in a studio section. If you don't have a spare room in your house, arrange things

so one room can serve double duty—as living area and studio. That's precisely what I do.

I have a living room that has floor-to-ceiling windows across the north end—a real north-light studio. An adjoining, raised dining section overlooks it. I use three different locations in this area for shooting.

BACKGROUNDS

Rolls of seamless background paper are hung from the ceiling in two of the three areas. The rolls are on pulleys and can be easily lowered when I need them. I can easily change rolls, so it's no problem to change background color and tone.

The ceiling is high, so when the rolls are raised they are relatively unnoticeable.

If I have a big job that calls for a lot of space and camera-to-subject distance, I use my largest working area. My furniture is easy to move out of the way. I pull

Before you start shooting, be sure everything you need—props, background, camera and lighting equipment—is at hand. Remove anything in the working area that might obstruct your movement. Once you get started, you should not have to interrupt the session for any reason.

the paper out into the room and tape it down on the floor. This gives me, literally, a seamless, unbroken background. In this studio area I work entirely with electronic flash, never with ambient light.

The second shooting space is smaller but gives me the advantage of the diffused north light from the large window. To control the lighting, I often add electronic flash or use reflector cards.

My third studio space is the raised dining alcove, with the white brick wall for a background. In this area, ambient daylight is too dim, so I work with electronic flash.

AVOID CLUTTER

One of the main advantages of having a studio that's separate from your home is the avoidance of clutter. When you use a home studio, you must exercise special care to have in the picture area—

as well as in the working area—only those things you want and need. That's where a seamless-paper background proves particularly useful.

I frequently pose my subjects—from whole families to a single tiny infant—on the bare, seamless-paper backdrop. Then, I rely on gesture and expression alone to "make" the image.

Often, I'll use a single chair on the seamless paper. You can get a wide variety of attractive portraits with no more propping than this.

The pictures I take in the "studio" section of my home are generally relatively formal, both in posing and lighting. The photos I make in my "real" home, and in the homes of my subjects—complete with furniture, paintings, plants and bookshelves—are more candid and casual.

FORMAL AND INFORMAL

For a comprehensive picture-taking session, I often like to take both formal studio photographs and candid home pictures. Having my studio in my home makes this very easy, as it all happens in one location.

Although I allot less time to my studio sessions than to informal sittings, the most important factor in determining the length of a sitting is how long the subject stays interested and cooperative.

COMMERCIAL STUDIO

At a certain point in his or her career, a professional photographer may feel the need for a separate, commercial studio. If you should reach the stage where you must make such a choice, you should give careful thought to specific needs.

Select a location suitable for your kind of work. For child photography, it would probably be a residential area, where many families live. The proximity of schools is another advantage.

You must decide whether to locate in

a more or less affluent area. Structure your pricing accordingly.

Select studio space that's large enough, but not too large. Don't over-extend yourself where costs are concerned—rent is a major expense.

When you have found a location you like, make sure the electrical and plumbing facilities are adequate. Examine the space carefully to determine whether it enables you to do everything you want, such as add a reception area, a dressing room and a darkroom.

LOCATION PHOTOGRAPHY

Working on location is less convenient than shooting in a studio. At home, in my studio, I have all my equipment readily at hand and am familiar with all possible lighting variations. However, location photography is challenging and greatly extends my creative possibilities. I certainly wouldn't avoid it.

EQUIPMENT ON LOCATION

When I shoot away from home, I usually take three camera bodies, each with a different lens. This enables me to shoot fast because I need not change lenses during the shooting. The lenses I use most are 35mm, 50mm and 85mm.

Generally, I take more equipment than I'll need. It's frustrating—and unprofessional—to get stuck in the middle of an assignment because you've forgotten a vital piece of equipment.

LOCATION SCOUTING

There is always a commercial need for pictures of children taken in locations other than the home or a studio. Such pictures are used in large quantities in books and magazines, and for advertising and publicity.

I try to spend some of my spare time scouting for new locations. When I find a likely place, I make a note of its features and characteristics. I indicate in my notes from which direction the sun strikes the scene at different times of the day. It's a good idea to keep a file of Polaroid photographs of such locations.

When I decide to actually shoot in such a location, I return there before the shoot to make sure it hasn't changed significantly since my previous visit. At that time, I also check for possible problems I may encounter, such as cluttered areas.

SCHOOL

Classrooms and other school locations, such as playing fields and gyms, make logical locations for shooting older children. In addition to providing a be-

SPECIAL NEEDS

For some activities, and in certain locations, you may need to use shooting techniques or equipment you would otherwise rarely use.

For available-light photography in dimly lit areas, you may need high-speed film. For some action photography, you may have to use on-camera flash. It's easy but may not give you the esthetic effect you usually want in your home or studio.

For high-speed sports action and other fast-moving events, you may need a motor drive or auto winder. Some sports activities will demand long lenses—200mm to 500mm—or a telephoto zoom.

KEEP YOUR VISION FRESH

Try to see each location and each picture-taking situation as a new challenge. Use different angles, lenses, vantage points. I find that certain shooting techniques suit some locations and activities better than others.

For example, I often use a low camera angle when working with children at playgrounds. When a child is on a slide, I'll aim the camera upward to include the top of the slide. This view makes the slide look as high—and exciting—as possible. Similarly, if a child is climbing on a jungle gym, I'll often lie flat on the ground and shoot almost straight up. Often, such pictures are most effective when exposed as a silhouette against the sky.

For a comprehensive picture-taking session, I like to take formal studio photographs and candid home pictures. Having my studio in my home makes this easy because I can do it all in one location.

When I shoot in very limited space, such as a bathroom, or want to include much of the surroundings, I occasionally use a 28mm or a 24mm lens.

I always carry two exposure meters—a spot meter and a flash meter. I take two or three Dyna-Lite flash heads plus the power pack, a portable flash, such as the Vivitar 285, bounce-flash brackets, light stands and sometimes a blue tungsten flood bulb. I also take a tripod.

If I know that all my shooting will be outdoors, I don't take all the lighting equipment. I'll pack a couple of reflectors and a portable flash for fill light.

lievable setting for teenagers, schools also conduct many activities that provide good photographic opportunities. They include dramatic presentations, band practices, singing groups, science clubs, debating teams, dance performances and rehearsals. In addition, there's a wide variety of sports for girls and boys: track, baseball, soccer, football and basketball.

When I shoot while a class is in session, I try to work with available light. If I do need additional illumination, I'll set up my lights before class begins, so I cause the least possible disturbance.

SAFETY FIRST

No matter where you shoot, always take safety precautions. Clear the floor of toys and other objects you or your subjects might trip over. If there are stairs—especially going down—close them off with a gate or a suitable piece of furniture.

Put lights on sturdy stands with the legs spread all the way out. Lead the cords along walls as much as possible. They are easy to trip over if they run across the floor. If you use tungsten lights, be sure a child does not get close to one. Serious burns could result.

Especially with small children, a parent or assistant should be present at all times to watch for and anticipate potentially dangerous situations.□

Equipment and Film

I use 35mm cameras for most of my child photography. Occasionally, I also use medium-format cameras that make 2-1/4-inch square images on 120-size roll film.

As you'll see a little later, I use only single-lens reflex (SLR) cameras. They offer precision in viewing and focusing and versatility because of lens interchangeability. They are the ideal tool for the professional.

Even if you own a compact auto-focus, auto-exposure and auto-flash 35mm camera with a fixed lens, you can take excellent photos of children. I'll say a little more about these later.

WHY I USE 35MM CAMERAS

For many years, professional photographers were expected to shoot color assignments on 4x5-inch sheet film. This applied even with active subjects such as children.

Clients and customers believed that only with the large format would they

and medium-format cameras are more than adequate for most assignments.

Buyers of photographs have gradually learned how to evaluate 35mm slides—either with a magnifier, by projection or by having enlarged proof sheets printed.

SHOOTING FAST

Much of the work I do would be virtually impossible without a 35mm camera. I have to be mobile and capable of shooting fast. I must also be as unobtrusive as possible.

Photojournalists and their editors knew the value of "candid-photography" 35mm equipment decades ago. It took the world of commercial and portrait photography a little while to follow.

ECONOMY

Children are unpredictable and move fast. To be sure you get good pictures, you need to shoot a lot of film. In this aspect, too, the 35mm format is ideal. Because the image is small, you can expose a lot of frames at reasonably low cost.

So remember, to get good, spontaneous child photos, use 35mm and shoot a lot of film.

ACCESSORIES

My preference for 35mm cameras is due not only to their easy use, the high-quality images possible and the relatively low film cost. 35mm SLRs offer a wider range of interchangeable lenses and accessories than any other camera type. In addition, the cost of such items is generally lower than for medium-format accessories.

MEDIUM FORMAT IS SOMETIMES BEST

On some occasions, such as when the final image is to be cropped square, the 2-1/4-inch square format is a definite advantage. A typical *commercial* example would be photos taken for record covers. In *child* photography—whether commercial or personal—I would also advise against the 35mm format when the final crop is to be square or nearly square. Cropping the 35mm image square would waste a lot of film space and require a high degree of enlargement.

Often, art directors specifically request that I work in the 2-1/4-inch-square format. It gives them a larger image to evaluate.

Some medium-format cameras offer another advantage over the 35mm SLR. This is in flash synchronization.

35mm SLRs have a focal-plane shutter that cannot be used at all speeds with flash. With most cameras of this type, shutter speeds faster than 1/60 or 1/125 second will give you an incomplete flash

Even if you own a compact auto-focus, auto-exposure and auto-flash 35mm camera with a fixed lens, you can take excellent pictures of children.

get the image quality needed. Furthermore, the large format was easier to evaluate and select from.

With the incredible developments in lens and film quality and image sharpness in recent years, the first reason is hardly valid any longer. Today, 35mm

I expose several rolls on each assignment. Suppose I shoot five rolls of 36-exposure film. I get 180 exposures at remarkably low cost. Were I to translate this into 180 sheets of 4x5 Ektachrome, it would suddenly sound like much more—and represent a very large cost.

picture. That's because the entire picture area is not exposed at the time the flash fires.

Some medium-format cameras, on the other hand, have a leaf shutter in each lens. Electronic flash will synchronize with them at up to 1/500 second. This additional choice of shutter speeds is a great advantage when you're using fill flash. It gives you much more scope for balancing daylight and flash in the exact proportions you want.

I discuss fill flash in the next essay.

VIEWING SYSTEM

For rapid and precise viewing and focusing, it's essential to have a viewfinder system that's easy and accurate to use.

SLR ADVANTAGE

All my cameras—35mm and medium-format—are SLR models. What I see in the viewfinder is what the film will record. An SLR is the only compact camera that offers this feature.

Precise image framing is desirable for all photography. It's essential when I must work to an art director's precise layout, allowing space for type and logos. I don't want any unpleasant surprises after a shoot, and neither does the art director.

DEPTH-OF-FIELD PREVIEW

With most modern SLRs, you view and focus the image at maximum lens aperture. This gives you the brightest possible image. It also lets you view at minimum depth of field, and this makes accurate focusing easier. The lens automatically stops down to the preselected aperture just before the shutter exposes the film.

I use only SLRs that have a depth-of-field preview button. By pressing it, I can stop the lens down to the shooting aperture and inspect the viewfinder image for approximate depth of field.

LENSES

As indicated earlier, no camera system offers as wide a selection of interchangeable lenses as a 35mm SLR. Lens focal lengths from less than 20mm to more than 500mm are available. That gives you a selection from super-wide-angle to long telephoto. Which are the most useful lenses for child photogra-

phy? Let's look at what's available.

STANDARD LENS

The lens that's most useful in a wide range of photographic applications is the one that usually comes with the 35mm SLR—the standard 50mm lens. With the 2-1/4-inch-square medium-format camera, the standard lens has a focal length of 80mm.

The standard lens is ideal for most two-person shots, such as mother and baby posed on a bed or in a rocking chair by a window. Shooting from a greater distance, you can photograph an entire family gathered on and around a couch, standing by a piano, or posed on a porch or lawn.

Picture-taking possibilities with a standard lens are almost endless. I advise you not to buy additional lenses until you really need them. As you continue photographing, you'll suddenly realize that there are frequent situations when you could use a longer or shorter lens. That's the time to buy.

Standard lenses usually have a larger maximum aperture than wide-angles, telephotos and zooms. With them, you can work more effectively by ambient light indoors and in low light levels outdoors.

TELEPHOTO LENS

The most useful lens for head-and-shoulders portraiture is a short tele-

portraits is an 85mm. Focal lengths up to 135mm are also satisfactory. With the 85mm lens, I get a full-frame head-and-shoulders shot at a distance of about five feet. If I need to, I can get as close as four feet with it.

I'll use a 200mm lens at events where I can't get as close to the subjects as I would like. This includes graduations and theatrical, sporting and musical events. Occasionally, I'll use it for close-up portraits.

WIDE-ANGLE LENS

The wide-angle lens I use most is the 35mm. It's perfect both indoors and out for groups ranging from a few children playing to an entire family gathering.

Wide-angle lenses are wonderful for showing a group and its environment. Because these lenses offer relatively great depth of field, backgrounds and surroundings are easy to record with detail.

A wide-angle lens will give you more image in the foreground as well as at the sides. Avoid a foreground of empty floor. Fill the foreground with items that form a good composition. You can use chairs, plants, books and a wide variety of other items found around any house.

ZOOM LENS

In general, I like to use single-focal-length lenses rather than zooms because I'm sure I get better image quality that

Precise image framing is desirable for all photography. When I must work to an art director's layout —specifying the exact location of type and logos —precise framing is essential.

photo. With it, you can shoot from a sufficient distance to avoid distortion of facial features. Depth of field is inherently more limited than with a standard lens. However, this is generally an advantage. It enables you to record the background out of focus and concentrate viewer attention on the subject.

The additional shooting distance of a longer lens also helps the subject feel more relaxed. No one likes to be scrutinized from a couple of feet away—least of all by a camera.

The lens I use most for my 35mm

way. However, there are times when a zoom is invaluable. A typical example is when I'm shooting candids, especially outdoors, where distances can vary considerably and rapidly. I can change image size in an instant to catch pictures that would be lost if I had to stop to change lenses on the camera.

The zoom lens I use on my 35mm SLR is a 35—85mm. It incorporates the focal lengths I use most often.

DISTORTION AND DISTANCE

If you photograph a subject from too

short a distance, the photos may show unflattering distortion of facial features. This is most likely to happen with a wide-angle lens because you must place it close to the subject to get a frame-filling image. It can also happen with a standard lens, so be careful not to get too close to your subjects.

When photographing adults, it's best to get no closer than about seven feet from a subject, even to get a frame-filling head shot. You should use a lens of the appropriate focal length to fill the frame. Because children have smaller faces and features, you can generally come closer and cause no noticeable distortion. I would recommend a minimum shooting distance of about five feet.

When using a wide-angle lens, it's important to avoid placing people near the image edge. This causes a special kind of distortion. It doesn't merely exaggerate features but tends to twist the whole face out of shape. It is very unflattering. Even when you're shooting a group, avoid placing people near the picture edge.

CHOOSING LENSES

I have a selection of lenses because I work in many situations. You can take many excellent child photos with a standard lens or with a camera having a fixed lens. Many of the photos reproduced in the portfolio section of this book were made with a standard lens.

I suggest you start out with a standard lens. As you photograph more, you may find you have a special interest in head-and-shoulders portraiture. If so, get an 85mm lens. Should you find your interest is in environmental portraiture, where the surroundings play an important part, you may want to get a wide-angle lens. For candid photography of fast-moving activities, a zoom may prove invaluable.

If you're just starting to equip yourself with a new camera system and feel you don't particularly need a standard lens, you can buy a camera body with a lens of a different focal length.

ACCESSORIES

In the course of my work, I use a wide variety of accessories. Some are used only rarely. Here, I discuss those I use most frequently.

TRIPOD

Child photography demands spontaneity and mobility. These are hardly compatible with the use of a tripod. However, there are occasions when a tripod is indispensable. I always use one when I have to follow a precise layout. I also use a tripod when working in dim, available light. My sturdy tripod is a trusted piece of equipment even though, in my child photography, I like to avoid using it as much as possible.

The most interesting and captivating child expressions and actions are fleeting and must be captured in a fraction of

a second. Using a tripod would often slow me down too much. Because most of my indoor work is done with electronic flash, I rarely need a tripod.

MOTOR DRIVE

My motor drive is invaluable, even though I rarely use it for rapid-sequence shooting. I use it basically as an auto winder. It lets me keep the camera up to my eye while I'm shooting. I don't have to wind the film manually.

Rapid sequences rarely play a part in my work, but it's nice to have the capability when needed.

FILTERS

Although I don't use filters often, there are a few that I always have with me.

My most frequent filtration need is to warm up skin tones in lighting that's too blue. This occurs on overcast days or in the shade under a blue sky. I carry two light-balancing filters for warming an image—an 81A and an 81B.

Sometimes the light is a little too warm, such as at sunset. However—unlike a bluish image—a slightly warm image can be very flattering and I rarely find a need for corrective filtration. If

such filtration were needed, I would use light-balancing filters in the 82 series.

I use a polarizing filter to remove unwanted reflections from water, glass and other shiny surfaces and, occasionally, to darken a blue sky.

I also carry a diffusing filter, for softening images, and several special-effect filters.

COMPACT 35MM AUTO-FOCUS CAMERAS

Today's most popular 35mm camera for the amateur photographer is the com-

Start out with a standard lens. As you photograph more, you may find that you have a special interest in head-and-shoulders portraiture. If so, get an 85mm lens. If your interest is in environmental portraiture where the surroundings are important, get a wide-angle lens. For candid photography of fast-moving activities, a zoom may prove invaluable.

pact, fully automatic, fixed-lens type. Many excellent models are available. If you have one of these, and not an SLR, you can still take excellent photographs of children. Although these cameras don't have interchangeable lenses or a wide range of accessories, they have many other attractive features.

Typically, these cameras offer automatic focusing and automatic exposure control. There's usually a built-in, auto-exposure flash. The cameras also feature automatic film wind. In different models, the fixed lens varies in focal length from 35mm to 38mm. Closest focusing distance is about three or four feet. The maximum lens aperture generally is f-2.8 or f-3.5.

If your camera has overrides to the automatic focusing and exposure controls, you can operate the camera manually.

The maximum lens aperture is large enough to permit you to use creative lighting in a wide variety of situations. You can use the flash to brighten shadows or, in dim light, as the only light source.

Because these cameras feature relatively wide-angle lenses, you can't shoot frame-filling head-and-shoulder

portraits. However, you can have enlargements made to fill the frame of the final print in the desired manner.

I discuss these cameras again in the next essay.

FILM

Although a huge assortment of 35mm films is available, there are only three basic types: color slide film, color negative film and b&w negative film. Each type is available from several manufacturers and in a variety of speeds.

With such a wide selection available, it's tempting to try them all. However, I advise against using too many different films. Try a few to find out which you like best. Once you've decided, continue working with the tried and trusted

made, the pictures go into my stock file and are available for publication by commercial buyers. For that purpose, they must be in slide form.

Most of my pictures are taken on Kodachrome 64 film. It gives images of excellent color and sharpness and has a speed high enough for most purposes and conditions.

If I have to work in dim lighting, I'll select a faster film, such as Ektachrome 200 or Ektachrome 400. Sometimes, to get the utmost in sharpness and fine grain for big enlargements, I'll use the slower-speed Kodachrome 25 film. However, the 25-speed film is suitable only for fairly static subjects. It doesn't lend itself to action-photography exposures.

slide film in these cameras, I recommend shooting negative film only. As I explain in the next essay, this will give you better exposure accuracy.

B&W

I am asked to do a considerable amount of b&w work by both commercial and private clients, even in today's color-oriented world.

Modern, fast b&w films give good image quality and have remarkably fine grain. I do almost all my b&w shooting—indoors and out—on Tri-X film having a speed of ISO 400/27°. From these negatives, I can make 16x20-inch enlargements of excellent quality, even from a 35mm negative.

For best results, be prepared to do your b&w darkroom work yourself or use a custom lab. The work handled by local drugstores won't be consistently good enough.

My most frequent filtration need is to warm up skin tones in lighting that's too blue. This occurs on overcast days or in the shade under a blue sky. I carry two light-balancing filters for warming an image—an 81A and an 81B.

KEEP EQUIPMENT FROM CHILDREN

Children are full of curiosity, and cameras look shiny and tempting. Keep cameras, and all equipment, out of the reach of children at all times. Equipment I need while shooting is always either in my hand or in a bag over my shoulder. I never leave meters, lenses, cameras or filters lying about—not even for a moment.

Keep film—especially exposed film—away from the reach of children. I've had the experience of my day's shooting being extracted from the film cartridges while I was concentrating on photographing the offender's brother! Never again!

Be particularly careful with lights. Make sure children don't get close enough to burn themselves on tungsten lamps. Also keep children away from other electrical devices.□

few. This way, you can standardize your working technique.

COLOR

Most of my commercial and private clients want color pictures. For advertising and editorial purposes, clients want slides, also called *transparencies*. Private portraiture clients usually want color prints. Although color negative films are available, I use slide film for almost all my color photography. This helps standardize my shooting technique.

There's an additional advantage to shooting slides exclusively. I usually retain the reproduction rights to pictures shot on private jobs. After a client has selected pictures and prints have been

Working with slide film is substantially less expensive for me than using color negative film. Clients can select the images they want enlarged by looking at projected transparencies. If I shot color negatives, proof prints would become a costly necessity.

However, if you aren't interested in having slides but want to make prints only, I recommend color negative film. Such film can accommodate a greater subject brightness range than slide films. This film type will give better detail with contrasty subjects and is easier to use because exposure accuracy is not as critical.

Color negative film is ideal for the compact 35mm auto-focus cameras discussed earlier. Although you can use

Lighting and Exposure

Fine photography requires good lighting and correct exposure. If the lighting isn't right or the exposure isn't correct, photographs of even the most attractive children will be uninteresting and dull. You need to understand how different lighting affects a subject.

Outdoors, where you can't move the main-light source, choose locations and camera angles that give the best lighting. Learn how to augment daylight with reflectors and fill flash.

Indoors, build up your lights one by one, carefully observing the effect of each.

OUTDOOR LIGHTING

Watch the angle, quality and brightness of the illumination. The angle at which the light strikes the subject determines where the shadows will fall. It creates the modeling effect on the subject. To get the best subject lighting *and* the right background, you must sometimes wait for the sun to be in the right position.

The quality of the light may be *hard* or *soft*. Hard light comes from direct sunlight. It creates deep shadows with sharp outlines. To lighten the shadows, you can use fill flash or reflectors.

Soft light comes from an overcast sky. You'll also find it in shaded areas. It gives soft shadows and a lower subject-brightness range.

Outdoors, the lighting can change in an instant. Keep an eye on the in-camera meter or your separate exposure meter as the sun goes in and out behind clouds.

If the lighting is not favorable at the planned shooting location, change locations or come back when the lighting is better. Compromising with the light means you're compromising with picture quality.

I use daylight in several ways. I'll adapt the existing illumination to suit a specific need. For example, if I must shoot in direct sunlight but want a soft effect, I'll position the subject so the sun is behind him. The main light from the front will be sunlight reflected by a mat reflector. The direct sunlight from the rear provides attractive rim lighting and hair light.

DIRECT SUNSHINE

I like to shoot early in the morning or late in the afternoon on bright, sunny days. At those times, the sun is low enough to provide a flattering light on faces. Near midday, when the sun is high in the sky, the sun causes deep, unattractive shadows in eye sockets and under the chin.

The midday sun also causes excessive subject contrast that most color slide films can't cope with. If highlight areas are exposed correctly, shadows will be black and lack detail. If detail is recorded in shadows, highlight areas will be "burned out" and lack color.

Early-morning and late-afternoon sunlight is softer than midday sunlight. When the sun is near the horizon, the light is also warmer—a characteristic that often improves the appearance of skin tones. If the warmth of the light is excessive, it can easily be corrected with bluish light-balancing filters in the 82 series.

If you're interested in taking flattering pictures, avoid shooting in sunlight in the middle of the day.

BACK LIGHTING

Even though the sun is low enough early and late in the day to fully illuminate a face, I prefer to position my subjects with their backs to the sun. I like to use *reflected* sunlight as the main-light source and *direct* sunlight as rim and hair light.

It's rarely possible to take good portraits by back light alone, without the aid of a reflector. If you exposed correctly for the face, the background would be burned out and the subject outline would have a fuzzy halo of light. If you exposed for the background, the result would be a silhouette of the subject.

The size of reflector needed depends on the subject size. For a head-and-shoulders portrait, a 2x3-foot card is large enough. For several people, or full-length shots, you'll need something like a large sheet.

OVERCAST SKY

My favorite lighting for outdoor pictures is from a bright, overcast sky. This lighting is soft. It flatters the subject and, because subject contrast is kept low, gives a wider exposure range. I even prefer the soft light of an overcast sky for my b&w photography.

Sky as Giant Reflector—On an overcast day, the entire sky acts like a giant reflector, giving even overhead illumination. With this diffused light I can photograph from all angles and directions without considering lighting angle, as I would have to in direct sunshine.

Keep the Light Frontal—If you find that the light from an overcast sky gives you unwanted shadows in eye sockets,

place your subjects under a tree, awning or some other cover that blocks overhead light. When only the skylight from a relatively low angle strikes the subject, you'll get a more flattering result.

Overcast Sky is Bluish—The light from an overcast sky is bluer than the "average" daylight we experience when the sun is shining. If the cloud cover is very light and some direct sunlight penetrates it, the color of the light may still be acceptable. However, if the overcast is heavy, I'll generally use a warming 81-series filter to give more attractive skin tones.

OPEN SHADE

I often use locations in open shade for shooting on bright, sunny days. Open shade is found in areas shaded from direct sun and illuminated by skylight alone. A building or large tree can provide open shade on a sunny day.

Blue skylight is even bluer than an overcast sky. To record skin tones well, you'll have to use a warming filter—

folded up and carried in a small pouch. They are very handy for location work. One side has a silver surface, the other a golden one. The gold surface is excellent for warming shadow areas that might otherwise record too bluish.

Placing Reflectors—When you consider where to place a reflector, it's best to regard it as an *additional* light source. Place it where it gives the lighting effect you want. The placement of a mat reflector that gives soft reflected light is not as critical as the positioning of a shiny reflector that gives specular reflections.

Placing a large reflector on the ground in front of people will lighten shadows considerably. If you can slightly raise the end of the reflector farthest from the subjects, all the better.

If you don't have a ready-made reflector with you, you can improvise with a white towel or sheet.

By taking a couple of light stands and some clamps or adhesive tape with you, you have more control of your reflectors. An even better solution is to have

the main-light shadows.

Here's the way I calculate fill-flash exposures: I begin by calculating the daylight exposure, using a flash-sync shutter speed. To get the right amount of flash, I simply adjust the flash-to-subject distance accordingly. About 1-1/2 steps less exposure from the flash than from the daylight is usually right for my purposes.

For example, suppose the daylight exposure for the scene is 1/60 second at f-8. Use the flash guide number to find the correct flash-to-subject distance for a normal flash exposure:

Guide Number/f-stop = Subject Distance

If the flash guide number is 80 (feet), the flash distance for a *full* flash exposure would be 80/8 feet or 10 feet. To *halve* the effect of the flash on the subject, I can simply move the flash to a distance 1.4 times greater—in this example, 14 feet from the subject.

There are other ways of achieving the same effect. For example, I can change the exposure setting from 1/60 second at f-8 to 1/30 second at f-11. This will give the same available-light exposure. By closing the lens aperture by one f-stop, the effect of the flash will be halved.

An additional approximate half-step light reduction is caused by the flash being used outdoors, without reflecting surfaces nearby. Guide numbers for flash units are based on *indoor* use, where reflecting walls and ceilings contribute to the illumination.

A third technique is to put layers of lens-cleaning tissue over the flash. I know from experience that two layers of this material give me a one-step decrease in light. Four layers give me a two-step decrease.

You can use a white handkerchief or some other translucent, white material. Test it to determine how much one layer reduces the light from the flash. One layer of most white handkerchiefs holds back about half the light given out by the flash.

This technique is useful if you use camera-mounted flash and can't adjust flash-to-subject distance independently.

Some flash units can be set to 1/8, 1/4 or 1/2 power in the manual mode. This provides another convenient way to control the amount of your fill flash.

Electronic flash generates little heat and has a duration short enough to "stop" most child movement. It has the added advantage of giving light of a color temperature resembling average daylight. This means you can use the same color slide film indoors and out, and you can use the flash in combination with daylight.

probably a color-conversion filter in the 85 series.

REFLECTORS

Reflectors are an important part of my outdoor lighting arsenal. Each reflector represents, in effect, an additional light source.

My largest reflector is a 4x6-foot piece of white mat board. I also carry 3x4-foot reflectors.

In addition to white, mat reflectors, I have reflecting surfaces of both crumpled aluminum foil and smooth aluminum foil. The mat reflectors give me soft reflected light. A smooth aluminum-foil surface provides specular reflections of the sun, yielding the most directional and contrasty reflected light.

I also have commercially made, 48x56-inch cloth reflectors that can be

an assistant hold a reflector at the precise position and angle you want. If you want a slight change, you simply tell the assistant what you want.

For best color rendition, even in the shadow areas, be sure that all reflecting surfaces are white or neutral. Any color in the reflecting surface would be reflected onto the subject, causing a color cast.

FILL FLASH

The beauty of using reflector cards to fill shadows is that they can never overpower the main light. With flash, you have to be more careful. If the flash is too powerful, it can "kill" all shadows and destroy the modeling provided by the interplay of light and shade. A flash that's too powerful can also cause its own shadows, which will conflict with

SHADOW CONTROL WITH AUTO-FOCUS, AUTO-FLASH CAMERAS

The compact 35mm cameras with auto-focus and auto-flash, discussed earlier, cannot be used for *controlled* fill-flash. You can use flash to *remove* unwanted shadows or because the ambient light isn't bright enough. However, you can't brighten existing shadows by a *predetermined* amount.

I recommend you use flash whenever the daylight on your subjects appears hard, yielding deep shadows. Alternatively, you can use reflector cards, as I do with my SLRs. This will retain existing shadows but lighten them.

INDOOR LIGHTING

The two basic light sources available for indoor photography are tungsten lights and electronic flash.

TUNGSTEN LIGHTS

Tungsten has this main advantage: It is a continuous source, so you can see the effect you're creating with your lights. However, tungsten lights get hot and demand relatively long exposure times—two characteristics that make them less than ideal for photographing children.

ELECTRONIC FLASH

Electronic flash is cool and has a duration short enough to "stop" most child movement. It has the added advantage of giving light of a color temperature resembling average daylight. This means you can use the same color slide film indoors and out, and you can use the flash in combination with daylight, as discussed earlier.

Modeling Lights—The short duration of the flash can also be a disadvantage. You can't see the effect of the illumination until you look at the finished pictures. However, this problem is overcome in most professional flash units by *modeling lights*. These low-power tungsten lights are mounted very close to the flash tubes. They are bright enough to let you evaluate the effect of the lights.

Typically, modeling lights are not bright enough, nor is the flash duration long enough, to cause subjects to squint. Tungsten lights often make children with sensitive eyes uncomfortable, and this is not conducive to the making of attractive portraits.

I use electronic flash for almost all my indoor child photography. I'll use tungsten illumination only to get special lighting effects that can't be achieved with flash.

Versatility—To satisfy the varied needs of my advertising and editorial needs, as well as much of my private child portraiture, I use versatile, professional flash equipment.

I own a Dyna-Lite 400 and a Dyna-Lite 800. Each has two flash heads incorporating tungsten modeling lights. The 800 is twice as powerful as the 400. The heads are interchangeable, so I can use all four with one power pack if I want to.

With each Dyna-Lite power pack, I can vary the power going to the different flash heads. With the 400, for example, I could use two heads with 200 watt-seconds of power each. Or, I could use two heads, one with 300 watt-seconds and one with 100 watt-seconds.

Other alternatives would be to use one head at 350 watt-seconds and the other at 50 watt-seconds or all four heads at 100 watt-seconds each. I can also set one head for 200 watt-seconds of power and the other three at 50 watt-seconds each. As you can see, there are many possible combinations.

Portability—Because I work at many locations, portability was a major consideration in my choice of flash equipment. The Dyna-Lite 400 weighs 18 pounds, complete with power pack, two flash heads and carrying case. The Dyna-Lite 800 weighs a few pounds more. I rarely use the 800 outside my studio. When I do have to transport it, I always take an assistant.

The built-in auto-flash in the auto-focus 35mm cameras discussed earlier is also ideal for shooting candid photos of active children.

Umbrellas—I don't like the harsh effect of direct electronic flash. When I'm shooting indoors away from my studio, I generally bounce my flash off ceiling or walls, if they are white or nearly white. When shooting in my studio, or at locations where there are no white walls and the ceiling is too high, I use umbrella reflectors on the flash. Light bounced from an umbrella is softened and yet has sufficient direction to yield some shadows and subtle modeling.

Umbrellas are portable, lightweight and easy to fold. I carry my umbrellas and light stands, together with my tripod, in a golf bag.

Umbrellas are available in different sizes and with different surfaces. I use the white, mat variety, not those with metallic surfaces, because I prefer the softer reflected light.

Softbox—As an alternative to bounce flash as a large, diffused light source, I often use a softbox. This is simply a large enclosure with white interior surfaces and a translucent, diffusing front. It contains a light source—usually electronic flash. Light bounces around inside the box and is transmitted by the diffusing front. The result is a large, soft source of illumination similar to diffused window light.

The translucent front surfaces on my three softboxes measure 16x22 inches, 24x32 inches and 36x48 inches. With a well-designed softbox, you can take meter readings of any part of the translucent front panel and scarcely detect any

There are two basic steps in determining exposure. The first involves measuring the light reflected from or reaching the subject. This requires use of an exposure meter. The second step involves translating the light reading into a suitable camera exposure.

For candid portraiture in a child's home or for location work, I have two Vivitar 285 and two Sunpack 422D flash units. Although these are essentially designed for amateur use, I find them very useful and convenient for professional shooting outside my studio.

difference in light output from center to extreme edge.

EXPOSURE

Correct exposure is as important to a fine photograph as good lighting. There are two basic steps in determining expo-

sure. The first involves measuring the light reflected from the subject. This generally involves using an exposure meter. The second step involves translating the *light reading* into an *exposure*.

Exposure assessment, and the exposure meters used, differ for continuous light sources and for electronic flash.

CONTINUOUS LIGHT SOURCES

There are three basic types of exposure meters for continuous light sources such as daylight or tungsten illumination.

In-Camera Reflected-Light Meter—Most SLRs contain a through-the-lens (TTL) meter. There are different metering patterns among the many camera models. Most are center-weighted, meaning that the exposure reading is determined predominantly from the central part of the subject and progressively less from the outer areas. In many models, the meter's sensitivity in the upper part, when the camera is aimed horizontally, is minimal. This is because that part of

measure the lightest and darkest parts of the picture, to get the brightness range. You can also measure middle tones and other subject values. On the basis of these readings, you can decide on the exposure you need for the interpretation you want.

Reflected-light meters are usually used from or near the camera's viewpoint and pointed toward the subject.

Incident-Light Meter—These meters are designed to read the amount of light falling on the subject. They are used from subject position and pointed at the camera or at the light source. The meters used with electronic flash are incident-light meters.

ELECTRONIC FLASH

There are two basic methods for calculating exposure with electronic flash:

Guide Number—You divide the guide number provided by the flash manufacturer by the flash-to-subject distance to get the required lens aperture. Guide numbers are intended mainly for single

shooting 1/2 step more and 1/2 step less than my meter reading.

Like many professionals, I also use Polaroid instant films for making test shots with my Hasselblad camera. Such shots give me more than an exposure indication. They show whether the lighting and composition are as I—and my client—want them.

Auto-Flash—As the name implies, auto-flash automatically measures the light and provides correct exposure for an average subject. Auto-flash is not only part of the compact 35mm cameras discussed earlier, but also an optional feature in more complex SLRs.

EXPOSURE TECHNIQUES FOR SLIDES AND NEGATIVES

I expose differently with transparency and negative films. For transparencies, I want to be sure the highlights are exposed correctly and not burned out. Sometimes I work in situations where I have no control of the light. It may be too contrasty for the film to record the entire tonal range.

In such cases, it's more important to record the highlight areas satisfactorily, even if the shadows go black and lose detail. Consequently, my tendency with color slide film is toward slight underexposure. This gives the best color saturation.

Expose differently for transparency and negative films. In transparencies, you want the highlight areas to be exposed correctly and not burned out. Consequently, your tendency should be toward slight underexposure. This gives the best color saturation. For negative films—color and b&w—expose for shadow areas. To get good prints from negatives, you must have shadow detail.

the image is assumed to often contain sky, and a reading from bright sky can lead to an incorrect exposure setting.

Handheld Reflected-Light Meter—Handheld meters are also meant for general overall readings. They average the amount of light reflected by different parts of the subject.

Spot Meter—This is a reflected-light meter, too, but it measures the light reflected from *very small parts* of the subject. With this meter, you can easily

flash heads, used directly, not for bounce flash. Although they can be used for multiple-flash setups, too, the necessary calculations are quite complicated.

Flash Meter—Like most professionals, I use a flash meter. The meter is held at subject position and pointed at the camera. After I fire the flash unit, the meter gives me a suggested aperture setting. I use a flash meter for all my flash work and find it invaluable.

Even so, I also bracket exposures,

For negative films—color and b&w—I expose for shadow areas. You must have shadow detail to get good prints from negatives.

I mentioned earlier that compact autofocus, auto-flash cameras are ideal for color negative film. That's because they are programmed to expose for shadows rather than highlight areas. For best exposure with slide film, you would have to adjust the film speed setting on the camera. For example, when using an ISO 64/19° slide film, set the camera for ISO 100/21°. This would reduce the exposure given by about the right amount.

If you intend to use slide film in such a camera regularly, shoot a test roll to determine the film-speed setting that gives you the best exposure. □

Composition and Posing

Good composition is the arrangement of subject components in the most effective visual way. This arrangement includes tones, lines and colors, as well as objects and people. It also involves the best use of empty space.

BALANCE AND SIMPLICITY

An image should have balance. It should not appear top-heavy or lopsided. Image components should be so placed that viewer attention is directed toward the main subject. Avoid lines that lead the eye outside the picture area.

The best compositions are often the simplest. Leave out those things that don't play a part in telling your visual story.

RULE OF THIRDS

Generally, the best compositions are those that follow the *rule of thirds*. This rule states that the most effective position for key elements of an image is approximately one-third of the way into the image, from top or bottom, and from the sides. In pictures of people, the eyes are usually the dominant feature. Therefore, proper placement of the eyes in the frame is important.

Sometimes other features are more important than the eyes. You may want to emphasize the hands of a sleeping infant or a grasping toddler. If so, compose the image so the hands satisfy the rule of thirds.

Break the Rule, When Necessary— Rules should be regarded as *guidelines* rather than inflexible *laws*. In some instances central placement of the eyes is most effective. With a large empty area around the subject, this can provide a feeling of isolation. It can also indicate tranquility.

Use this rule, as any other, to guide you—and break it when you're after a specific effect.

POSING

When you're photographing people, whether adults or children, the main compositional factor involves proper posing of your subjects. In this essay, I explain how I pose children of different ages. Accompanying photos show you some possible posing ideas.

My cardinal rule for posing two or more subjects is to keep heads close together. This applies to a mother and baby just as it does for other pairs and groups. To make a composition more interesting, it's best to have the eyes of each subject at a slightly different height.

Here's a brief guide on how I apply different posing techniques to children of different ages:

BABY ALONE

It's not easy to make appealing photos of a newborn baby alone. I like to shoot down at a baby from a high angle. A very useful prop is a mobile, hanging over the baby, as shown in photo A. It attracts the baby's attention and keeps her happy and also enhances the composition of the image.

Eye-level photos of babies can also be very attractive, as shown in photo B. You can get this viewpoint with baby in a crib, if the crib's side is removable. Or, you can place baby on a blanket on the floor or on a table.

Having the baby on a high surface, such as a table, is easier for you—but can be dangerous for the baby. In such a situation, always have mother close by to prevent the baby from falling.

When I shoot from floor level, I use a

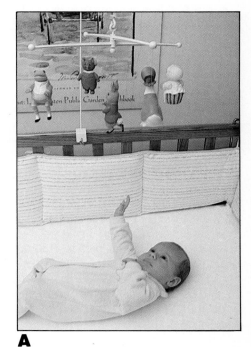

A

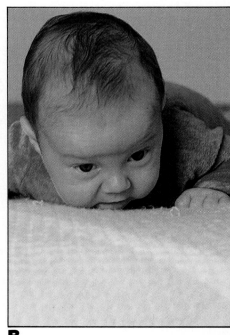

B

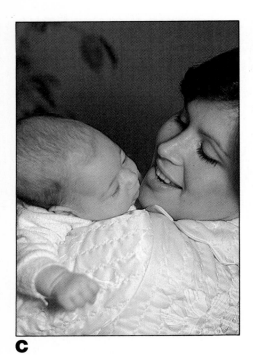

C

right-angle viewing attachment on the camera.

BABY WITH MOTHER

Little babies are best held in mother's arms, on her shoulder—as in photo C—or cheek-to-cheek with mother. I often ask a mother to cross her legs and then put the baby, facing her, on her knee. I ask the mother to bend forward and look in baby's eyes. The heads should be close enough together for a pleasing composition. Because of the immediate interaction between mother and baby, the expressions are usually animated, as shown in photo D.

Photos E and F show other effective poses with baby on mother's knee.

Having mother lean over baby from the far side of a table offers several pictorial possibilities. One is shown in photo G.

If a baby is old enough to raise his head, another alternative is to have mother and baby on a bed, side-by-side, both facing down. Get both to raise their heads, also making sure the heads stay close together. Move in close to fill the frame with the subjects.

BABY AT DIFFERENT AGES

How you photograph a baby depends very much on his age and development. Your subject may be a newborn baby who can't yet lift his head or a one-year-old who is just beginning to walk. Whenever you photograph baby, show him doing what he does naturally at that particular time.

Three Months—By the time most babies are about three months old, they are strong enough to be raised high in the air by their fathers. As photo H shows, this usually gives equal enjoyment to baby and father. Notice that, even in this kind of "action" shot, I keep heads close together.

At this age most babies are ready to be photographed with other familiar family members, such as grandparents and uncles or aunts.

Four Months—By the age of about four months, baby is capable of posing alone for attractive pictures full of action. Mother need not be in the picture any longer, although her encouragement from the "sidelines" is still needed. It's easy to elicit smiles and varied, amusing expressions by having her wave an in-

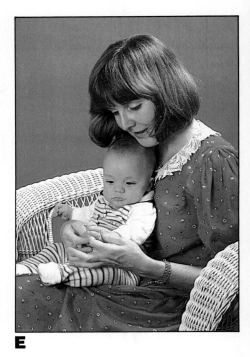

E

teresting toy near camera position.

Five Months—At about five months, baby begins to use his hands. He loves to grab fingers, glasses, hair, toys and rattles. Make the most of this in your pictures. For some shots, photograph his hands alone, shaking a rattle or holding the mother's finger.

Six Months—At six months, most babies are fascinated by what they see in a mirror—photo I. Use this opportunity. It is almost bound to give you a series of amusing and touching pictures. Compose some pictures so both the baby and his reflection are visible.

Seven to Nine Months—Sometime between seven and nine months, most babies start to crawl. Get down on the

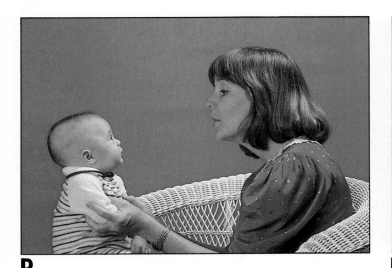

D

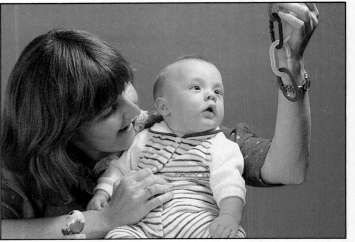

F

20

child's level and explore the newfound world with him.

About One Year—Usually between nine months and one year, a baby starts to stand and take his first faltering steps—photo J. A low camera viewpoint dramatizes this achievement best. Have someone hold a toy or noise maker high to induce baby to stand. Be prepared to shoot the falls as well as the successful steps.

TODDLERS

Posing and toddlers are basically incompatible concepts. Toddlers can't really be posed. The best you can hope to do is stay with them in their whirlwind activity, getting them to "pose" by involving them in stimulating activities and with exciting props.

Use Toys—I keep a full toy chest in my studio. I add to it constantly. I also ask mothers to bring their child's favorite toys to the studio for the sitting. I place toddlers on a tricycle, a bouncing horse or some other large toy and shoot quickly, while the child's fascination lasts.

Educational toys suitable to the child's age will often keep him in one place. Blocks, the toddler's classic, haven't lost their appeal through the years. You can usually shoot many frames as a toddler constructs something with them—photo K. Be sure the "construction" forms an attractive part of the total composition.

Go Outdoors—I like to photograph

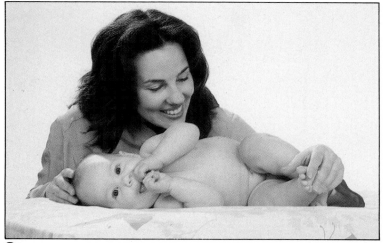

G

toddlers outdoors as well as in the studio. Outdoor activities that produce good pictures of toddlers are playing with pull toys, going up or down stairs, playing in a sandbox, or blowing and catching bubbles—photo L.

Verbal Direction—By the time a child is two, you can direct him verbally and thus anticipate his movements. Simple instructions, like "Look at the picture in the book"—photo M—or "Fill the bucket with sand"—photo N—will yield results suitable for interesting photographs.

HOW TO MAKE A CHILD LOOK SMALL

When you photograph a small child with an adult, comparison shows how small the child is. However, when you

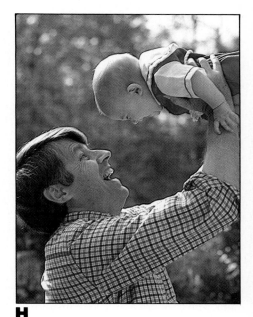

H

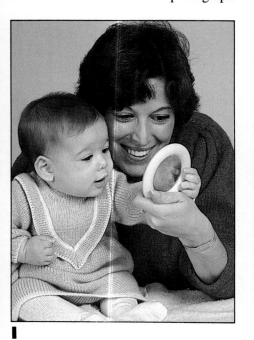

I

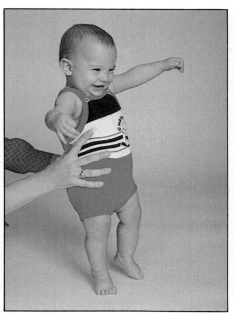

J

K

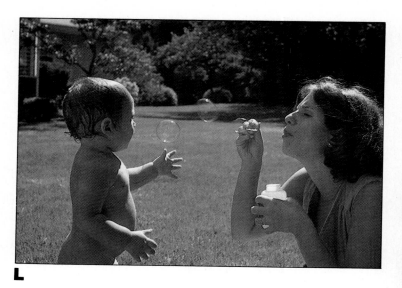

L

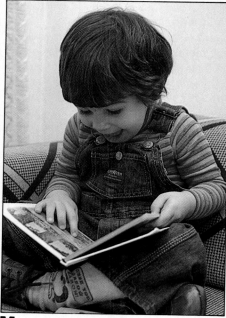

M

photograph a small child alone, only your knowledge of a child's growth pattern tells you how small the child is. You know what a child of 18 months or four years looks like, so you can imagine his size.

There's a compositional trick that can help to make a small child *look* small. It involves the proper placement of the child within the image frame. It applies equally to head-and-shoulders and full-length shots.

You would normally place the top of the head of an adult near the top of the image. To emphasize the small size of a child, leave more space above his head. You can enhance this technique by also leaving more space all around the child.

This is particularly important when you're shooting against a plain background such as seamless paper. When there are recognizable objects around a child, they serve as useful reference points for the viewer to establish the child's size.

This technique is most necessary when a child assumes what is basically an adult position—sitting or standing. When a small baby is lying down, the message of its size is self-evident and doesn't need graphic reinforcement.

CHILDREN OF SCHOOL AGE

By the time a child is four or five years old, he will follow directions easily. I try to get my subjects engaged in activities that capture their interest and take their minds off the camera. Their natural, un-selfconscious actions provide fine picture-taking opportunities. If they don't, I prompt my subjects.

Some activities that always provide an opportunity for attractive poses and compositions include having a child read a book, look at a flower or draw a picture.

I shoot as fast as I can, changing the camera angle, the shooting distance and lens, and always watching for special expressions.

SHOOTING FOR PUBLICATION

When you photograph for publication in magazines or for advertising, the editor or art director often needs empty space above, below or to the side of the image for headlines, logos and text. When working on assignment, follow the layout provided for you.

When you shoot pictures you hope might later sell for publication, it's worthwhile shooting the subject several ways. Or, leave plenty of space all around the subject so the picture can be cropped vertically or horizontally and provide the necessary space for typography. Then, your images may be suitable for use on magazine covers, packaging, greeting cards and a variety of other commercial applications.

When I was a beginner, I shot many verticals, hoping for magazine-cover sales. After being told several times, "We love the picture, but there isn't room for our logo," I got the message!

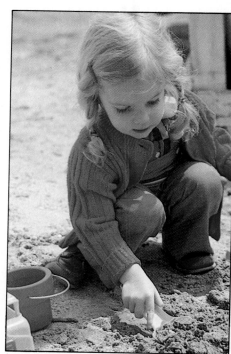

N

Since that time, whenever I shoot for an intended cover, I place the child far down in the frame—almost limiting him to the bottom half. It isn't easy to do because it runs counter to all of my compositional instincts—but it's needed for many covers.

Horizontal pictures are useful for two-page spreads in magazines. They are also essential in picture stories. Having all pictures vertical would make for a dull layout.☐

Formal and Candid Photography

I take formal, posed portraits and candid photos of children. There are differences in the purposes for which they are made, and in the techniques used. In this essay, I give my definitions of formal and candid photography and tell you something about how I set about shooting each.

FORMAL PORTRAITS

When sitting for posed, formal portraits, a subject is aware of the camera's presence and is expected to cooperate with the photographer. Typically, the subject makes eye contact with the camera—and, therefore, the viewer of the picture.

What's the difference between a can-

A good formal portrait depicts something of the subject's *character*. It says something about the individual, not only at one particular moment, under a specific circumstance. It makes a general statement about the person.

Making successful formal portraits of children is a real challenge. Small children haven't developed a "character" in the usual sense of the word. The best you can do is photograph their *reaction* to specific events. This makes children much more suitable for candid photography, which I discuss a little later.

Another reason why formal portraiture of small children is difficult is that you can't expect them to follow directions.

as beautiful as natural daylight. To control shadows and contrast, I use reflector cards. Occasionally, I'll use flash for the same purpose.

I especially like an outdoor setting when I'm photographing several people together. I can get much more attractive family groups around a bench or on a blanket on the ground, outdoors, than on and around a couch, indoors.

INDOORS

Indoors, the location I most frequently use is my living room/studio. There, I'm fully familiar with the surroundings and the lighting and have everything I may need readily at hand.

When I use other indoor locations for formal portraiture, I review the area carefully beforehand. My main concerns are having a suitable background and sufficient space for placement of my lights. This includes space *behind* the subject, for background and hair lights.

As mentioned earlier, I don't like to use direct flash for portraits of children. I bounce the light from umbrellas or off white walls and ceilings. This gives a soft, diffused light.

I use a standard lighting setup. The main light is generally aimed at the subject at an angle about 30° to the left or right of the lens axis. It is aimed down at the subject at an angle of about 45°. The fill light is near the camera. I adjust it—either by distance or by power setting—so its brightness on the subject is generally about half that of the main light.

A third light illuminates the background. Finally, I often highlight the subject's hair from high and to the rear.

Formal portraiture of small children is difficult because you can't expect very young kids to follow directions. This means that you must rely on capturing the right moment on film rather than creating that moment. And yet, the end result must represent what was asked for—a formal portrait, not a candid snapshot.

did shot and a formal portrait? For me, a formal portrait must survive extended scrutiny. You must be able to "live with it." You should be able to frame it and hang it in your home and enjoy it for years to come. Of course, this is sometimes also true of a candid photograph. However, I think that candid shots are generally most suited for one-time or occasional viewing but don't withstand the test of constant display.

This means that, even when making "formal" portraits, you must rely on *capturing* the right moment on film rather than *creating* it. And yet, the result must represent what was asked for—a formal portrait, not a candid snapshot.

OUTDOORS

I prefer to take pictures outdoors—even when formal and posed. No light is

This hair light is usually a direct, undiffused flash.

CLOTHING

Even for formal portraiture, I prefer children to wear comfortable, everyday clothes instead of having them "dressed up." This way, they feel more natural and are better able to relax for the camera. I frequently ask mothers to bring along several changes of casual clothes for their children and for themselves, too, if they are to be in the pictures. I don't necessarily photograph them in each outfit they bring. But it gives me a chance to select the most suitable clothes and the most compatible combinations.

I try to avoid very dark and very light colors and tones. To retain good detail and tonality throughout an image, it's best to avoid white, navy blue, dark brown, dark green and black. Bright colors—red, blue, green—are sometimes fine. However, I prefer pastels, such as light blue and pink. Not only are they more satisfactory photographically, but they are also the most suitable colors for children.

It's also a good idea to avoid boldly patterned or striped clothes. They can dominate the image and take attention away from your main subject—the child.

A good place to photograph a baby is on a table. I place an attractive soft blanket on the table for the baby to lie on. When including the mother, I place a bench behind the table. This puts the mother's head at about the right height to lean comfortably over the baby.

Toddlers tend to feel more comfortable on a carpet or on seamless paper on the floor than perched high on a chair, bench or table. This makes my job a little more difficult because the child can move about more freely and because I have to use a very low camera position. However, it's often worth it because a happy child makes a better picture.

PROPS

The main props I use in my photography of children are toys. My studio is well equipped with rattles for babies, stuffed animals for toddlers and trucks and airplanes for older children.

A very young child is more likely to be intrigued by a new toy than an old, familiar one. A baby's attention is certainly attracted more readily by something unfamiliar than by a toy to which he has become accustomed. I can elicit an expression of excitement by confronting a child with the surprise of a jack-in-the-box or the tune from one of my music boxes.

Older children usually feel happiest

When a child loses interest in one toy or prop, be prepared to confront him with another one.

A toy that is photographed with a child becomes an important part of the photograph's composition. Be sure the toy's colors don't clash with other key colors in the picture. If possible, position the toy in such a way that it becomes part of a pleasing graphic composition.

I usually have a child play with one toy at a time. Unless you're photographing a Christmas-morning scene, a lot of toys tend to clutter a composition.

When a child is photographed with his mother, props are less important. Usually, the interaction between mother and child is enough to create an attractive photo. However, sometimes I'll use a rattle or some other small toy as a focal point that mother and baby can examine together. With a toddler, a book can serve a similar purpose.

BACKGROUND

Simple backgrounds are best for posed portraits. In the studio, I use seamless paper. On location in other people's homes, I look for plain, painted walls. I usually avoid patterned wall paper. I am also careful to examine locations for objects on the walls that may detract from my subject. If necessary, I'll remove pictures, plaques and bric-a-brac stands from walls before I begin photographing.

Outdoors, I look for plain and simple backgrounds, too. I avoid trees, bushes and patterned walls. If I can't avoid a distracting background, I'll throw it out of focus by using a long lens and a wide aperture. Long lenses have an added advantage: They narrow the angle of view and thus eliminate unwanted background.

A toy that is photographed with a child becomes an important part of the photo's composition. Be sure the toy's colors don't clash with other key colors in the picture. Also, if possible, position the toy in such a way that it becomes part of a pleasing graphic composition.

SEATING

I prefer to pose my subjects on a bench or stool instead of a chair. Chair backs can cause an unattractive intrusion into an image. Sometimes I'll pose a mother and child on a chair, but I take care to either conceal the chair back or use it in a compositionally attractive way.

I love rocking chairs—and so do children! I have several in my home and frequently pose a mother and baby in one. Stop the rocking when you take a picture or be sure you have enough depth of field to retain a sharp image.

with their own, familiar toys. For example, a girl is generally much more contented with her own doll, even if it's old and the worse for wear, than with a brand-new but strange doll.

Toys are not the only things that will hold a child's attention. I advise you to have on hand a collection of pots, pans and other safe utensils that a child can explore and bang on. Pets are always effective in producing lively expressions in children, and "fun" foods, such as ice-cream cones, can also work wonders.

SUBJECT MOVEMENT

Unlike adults, young children will not sit still for long—even for a formal portrait. If you *make* them sit still, they'll look stiff and unnatural. Stopping subject movement is a major concern.

That's one reason why electronic flash is so valuable to me. Its short duration stops virtually any movement a child may engage in. It also avoids image blur that might otherwise occur because of movement of my handheld camera.

Outdoors, I use shutter speeds that I know will stop on film the motion that I'm confronted with. With a really lively subject, I'll shoot at 1/250 second or 1/500 second. Fast shutter speeds give me two advantages. First, they eliminate image blur caused by subject movement or camera shake. Second, because faster shutter speeds call for larger lens apertures, I'm able to render distracting backgrounds unsharp.

CANDID PHOTOGRAPHY

I've described a posed portrait as a "character study." A candid photo, often snatched while the subject is unaware of being photographed, shows a response to one specific stimulus or activity. Children, who are constantly learning and fascinated by new things, are ideal subjects for candid photography.

I generally try to keep my subjects unaware of the camera's presence. If I can't do that, I use toys or any other distraction I can find to make them forget my presence as quickly as possible.

In formal portraiture, I'm very much in command. I direct the proceedings. In candid photography, I try to "fade into the background" and simply observe—and record—what happens.

LENS CHOICE

Posed portraits are usually taken at a predetermined distance, with a lens of appropriate focal length. When I take candid pictures, I work at different, often rapidly changing camera-to-subject distances. This requires several lenses—or a zoom. To avoid wasting valuable shooting time, I use more than one camera, each with a different lens.

I can't give specific recommendations on which lens to use under different circumstances. There are just too many variables. However, I can give you a useful tip: Use a lens that lets you stay sufficiently far from your subjects to let you remain unintrusive.

As the children I'm shooting become more and more engrossed in what they're doing, I may be able to come closer and use a shorter lens.

Some spontaneous activities occur at known distances. For example, when kids are playing baseball, or watching it, I can pretty well know in advance what lens to use. I may change lenses simply to get variety in framing and composition.

FOCUS ON ACTION

When I photograph one child, I usually focus on the child continually as he moves about. When I photograph several children, all at different distances and often moving in different directions, I use *zone focusing*. This involves setting distance and lens aperture in such a way that I achieve a predetermined zone of sharpness, or *depth of field*. I must then be sure that all subjects are within this zone as I shoot.

When I know beforehand that action will take place at a specified place, such as at first base in a baseball game or 40 feet in front of me at a track meet, I prefocus the lens at that point. I'll then shoot when the action takes place at that preselected point.

If I pan the camera to follow a moving subject, I'll expose when the subject reaches the prefocused point.

STOPPING MOTION

As indicated earlier, the best way to

> *Children, who are constantly learning and fascinated by new things, are ideal subjects for candid photography. I try to "fade into the background" and simply observe—and record—what happens.*

stop action indoors is to use electronic flash. For candid shots indoors, I set up my flash before the children come into the room. I try to work in rooms having white walls and ceilings, so I can bounce the lights off them instead of using umbrellas. It gives uniform illumination over a wide area, ensuring satisfactory lighting regardless of the location of the subjects.

My flash meter serves two purposes. First, it indicates the lens aperture I should use. Second, by taking readings from various parts of the room, I can ascertain that the illumination is even over the shooting area.

Outdoors, the way to stop action is to use a fast shutter speed. If I don't need much depth of field, I can use 1/250-second exposure with ISO 64/19° film, even with a relatively long lens and under an overcast sky.

Sometimes it's essential to use a fast shutter speed, such as 1/250 second, to stop action, and a small aperture, such as *f*-11, for adequate depth of field. In such cases I use a faster film than the Kodachrome 64 I use for most of my pictures.□

Telling a Story with Pictures

Frequently, *one* picture tells a story, but sometimes it takes a *sequence* of pictures to do that. Consider the many picture-story possibilities in the daily life of a child. They include such activities as baby's bath, a toddler greeting daddy as he returns from work, a five-year-old setting off for his first day of kindergarten and a youngster training his new puppy.

PLANNING

My first step in making a picture series usually involves the preparation of a *shooting script*. It doesn't have to be elaborate—just brief notes on what pictures I plan to take to compose my story.

For a sequence of bathing a baby, for example, I may plan an opening shot of the mother pouring water into the bath. Next, I would probably plan pictures of baby being undressed. This would be followed by pictures of baby in the bath.

My shots of the bathing would include pictures of baby playing with appropriate toys in the water. The sequence could be effectively concluded with a picture of baby wrapped in a towel with only his little face peeking out.

The bath sequence can easily be shot in one session. More complex stories may need to be shot over several days. However the sequence is shot, I always plan and script ahead as much as practical.

Of course, you can't do much planning for totally spontaneous, unexpected events—which usually make for the best picture stories. Just stay alert, recognize an opportunity when you see it and be ready to photograph. If the lighting and other conditions are not ideal,

shoot anyway. Use plenty of film!

Even when you've planned a sequence in advance, try to get the pictures you need as the actual event unfolds. Your subjects will be more spontaneous and believable than when you have to direct them for a second run-through.

For a sequence on the arrival of a new puppy in the family, for example, accompany the family as it shops for the pet. Photograph the child as he looks at the puppies in the pet shop. Capture the actual moment when he decides, "This is the one for me!" You can never regain those moments of happiness in photos that are posed later.

If the child appears tired by the time you get back to his home, stop shooting. Return the next day and get some shots of the child playing with his new pet, feeding it and introducing it to its new environment. An effective final shot for the sequence would be of the child walking the tiny puppy on a leash.

Basically, all children make good subjects for picture stories. I'll hire professional models for major assignments involving large budgets and a lot of shooting time. However, I'll frequently use children from families of my personal acquaintance, even for professional assignments. When I meet attractive kids, I ask their parents about their willingness to allow them to pose for me. I keep a record of families with children of different ages.

In my portfolio, which I show to prospective commercial customers, I always carry a couple of picture stories. Many private portrait customers also like to have sequences as well as single portraits.

SCHEDULING

Shooting a picture story is more time-consuming than taking single pictures, so pick the time when your subject's energy level is highest. This varies from child to child, so discuss it with the parents beforehand.

Sometimes a picture in a sequence calls for a sad expression. Shoot this when the child is hungry or tired. This doesn't mean you should deliberately starve the child or keep him working until exhausted. It means shooting just a couple more before stopping.

If a story calls for a child who's unhappy or upset at the *beginning* of a sequence, it's often a good idea to make that shot at the *end* of the session, when the child is tired. Of course, you should not *make* a child unhappy—simply wait for the time when his patience and energy level are lowest.

CONSISTENT LIGHTING

To maintain smooth visual continuity in a picture sequence, keep the lighting consistent throughout. Avoid shooting outdoors just before sunset, when the light changes rapidly. Also avoid days when the sun shines one moment and is hidden behind clouds the next.

Indoors, the best illumination is soft flash light, bounced from walls and ceiling. It enables subjects to move about and remain in consistent lighting.

Be especially concerned about consistent lighting when you shoot a sequence over several days. If you start in sunshine, continue in sunshine. If your first pictures were taken under a heavy overcast, don't suddenly switch to direct sunlight.

An exception to the above is when the subject moves from one environment to another as part of the story.

TYPICAL ACTIVITIES

There's no limit to the possibilities for shooting picture stories. Practically every activity, from a young child helping mother with the cooking to one assisting father with fixing the car, is a suitable subject. Following are some tips on shooting just a few common activities.

CHILDREN AT PLAY

Watch before you *shoot*. The best sequences I've made of children at play have come about after I've studied their play patterns for a while. From my observations, I make a rough shooting script. I allow the action to unfold spontaneously, giving direction only where it's needed to get those shots that didn't offer themselves spontaneously.

SPORT

Know the rules of the game or event you're going to feature in your sequence. Watch the sport before you photograph it. Determine which locations usually offer the best opportunities for action shots.

Get to know the individual styles of participants. There may be one baseball player who is particularly photogenic at bat or one girl on the soccer team who kicks the ball more vigorously than the others.

Before a game or event starts, look over the area and try to pick several different vantage points from which to shoot. A sequence should have variety. This includes changes in location, shooting angle and subject size in the image.

Obviously, you can't be at the start and end of one specific race unless they are at the same location. However, you can shoot several races from different vantage points, or you can shoot from one position with a zoom lens—an invaluable aid in shooting sporting events.

High and Low Angles—Eye level is not the only vantage point, or necessarily the best, for sports pictures. For a picture sequence, you need variety.

Shooting from ground level is effective for many sports. It makes the participants appear towering and strong. A low angle can also provide good backgrounds, such as a clear, blue sky or a crowd in the stands of a stadium.

A high angle, from up in the stands, can give good general views of the action. It can also provide interesting designs, such as of a baseball diamond or a rippling swimming pool with marked lanes.

If you plan to shoot sequences of sports activities, watch sports coverage on television. Study the camera vantage points, shooting angles and visual effects. You'll also get useful tips and ideas by studying such magazines as Sports Illustrated.

If you plan to shoot a lot of sequences of sports activities, watch sports coverage on television. Study the angles, vantage points and visual effects. You'll also get useful tips and ideas by studying such magazines as *Sports Illustrated*.

BIRTHDAYS

There are key events at birthday parties that you should shoot to produce a meaningful sequence. They include the birthday child entering, blowing out candles on the cake, cutting the cake and opening presents. There should be general views of guests eating and drinking. An effective final picture would be of an empty room, with just the birthday child and mother remaining.

During the party, move among the children and adults as unobtrusively as possible. Be alert for good picture opportunities as people mingle and interact.

COSTUME PARTIES

Costume parties provide endless opportunities for good pictures. Dressed up, most kids are natural hams. Perhaps the best day of the year for this kind of photography is Halloween. Become familiar with school, youth club and church activities in your neighborhood, and I'm sure you'll find many other opportunities for this kind of photography.

FAMILY REUNIONS

Family reunions, when children are greeted by rarely-seen grandparents and cousins, can provide wonderful material for photography. Get photos of initial greetings, family members playing together and everyone at the dinner table. A rare get-together of people who are dear to each other is a warm experience that can yield equally warm, touching photographs.

CHRISTMAS

I have never been asked to take pictures in a home professionally at Christmas, Chanukah or other similar family celebrations. The only sequences you're likely to shoot on such occasions are in your own home or the homes of friends or relatives.

As with birthdays, you should shoot the key events. Record the children with their Christmas stockings, gathered around the tree, opening presents and playing with their new toys.

In advertising studios, Christmas scenes are often set up in midsummer, to shoot photographs for the following Christmas. I, too, have shot some of my best Christmas pictures at other times of the year. However, if you want to shoot an authentic series of the excitement of Christmas experienced by children, I recommend you shoot the *real* thing, at the *real* time!□

How to Become a Pro

When you've been photographing your own children and their friends for a considerable time and have developed advanced skills, you may consider becoming a professional photographer of children.

I had earned my living in photography for several years before my first child was born. I wanted to stay active in photography and also spend as much time as possible with my child. A natural solution was child photography.

MY FIRST CUSTOMERS

I started photographing my own child and the children of friends. I showed my photos to neighbors. Many wanted professional-quality photos of their children. They liked my work and became my first customers. The children I photographed at that time also became my first models for editorial pictures and advertising assignments.

SPACE

I've had my studio in my home for years and have never felt the need for separate business premises. This helps to keep costs down. I recommend that you avoid renting separate studio space unless your business absolutely can't continue to thrive without it.

Earlier, I discussed the best use of home space. There's also the human factor to consider. For the home/studio combination to work, members of your household must cooperate. They must realize that, when you're at work—either shooting or simply talking with prospective customers—they must respect your business space.

If much of your work is on location, a small studio area for shots of kids should be adequate, at least to begin with.

Darkroom—Today, many photographers work almost entirely in color and have all their processing done by commercial labs. If you want to do your own color or b&w processing and printing, you'll need darkroom space. The best location is a room that can be totally blacked out and has near access to plumbing.

I don't recommend having a bathroom double as a darkroom. The constant conversion, back and forth, is time consuming, messy and inconvenient to the entire household.

Efficient ventilation is important where photographic chemicals are used. Ideally, a darkroom needs a light-tight air intake and air outlet and a fan to keep the air circulating.

PORTFOLIO

Prepare a portfolio of a selection of your best work, both published and unpublished.

Show prospective clients material similar to the kind of work you seek. If you're looking for assignments taking posed portraits of children for private clients, show only posed children's portraits. If you're looking for clients who need editorial or advertising illustrations showing mother-baby interactions, include only such pictures in the portfolio when you make those calls.

If you want to get editorial assignments for photos of children interacting with their families, or at play, make up your portfolio with pictures of such themes.

If you're looking for assignments covering varied themes, make up different portfolios for each. Including all your best pictures in one presentation may confuse a prospective client and dilute a potentially strong impression.

Another good rule is not to show too much. If your portfolio consists of prints, 10 to 25 images is enough. If you carry slides for projection or viewing, limit the number to a maximum of 50 slides.

How you present your work depends to some extent on the market you are trying to reach. An 8x10-inch or 11x14-inch binder with plastic print sleeves is adequate for private portrait customers and magazine editors.

The first—right hand—page should hold your business card or promotional piece. The pictures should start on the first full two-page spread. Get the best possible color and b&w prints. Don't mix color and b&w—present them in separate sections.

For advertising clients, a classier and more expensive presentation is appropriate. Custom-made cases and laminated prints are in order.

Many editorial and advertising clients are accustomed to seeing 35mm slides projected. Prepare a well-organized tray of original transparencies. When you call to make an appointment to show your work, indicate that you want to project slides.

FINDING MARKETS

A library is a fine resource for finding potential clients. When you find book publishers or magazines that seem to represent possible markets for your pictures, call and make an appointment or submit appropriate photographs by mail.

When you mail your photos, include a self-addressed, stamped envelope the same size as the envelope in which you make the submission. Enclose the photos between two sheets of stiff cardboard. Accompany the shipment with a well-written letter.

Before suggesting a feature to a maga-

zine, go through several years' back issues to be sure the magazine hasn't run a similar story recently. Then, send a brief outline for the story you have in mind.

A great aid for finding buyers for your work is *Photographers' Market*, published by Writer's Digest Books, 9933 Alliance Road, Cincinnati, OH 45242. This annual guide lists publishing companies, advertising and public-relations agencies, greeting-card companies and other buyers of photography. It includes descriptions of the types of work each market buys, the prices typically paid and submission guidelines.

I also use *Literary Marketplace*, published by R.R. Bowker Co., P.O. Box 1807, Ann Arbor, MI 48106. As the title suggests, this is primarily a directory of book-publishing companies. However, it is valuable as a source of addresses and editors' names. It also includes similar, although not as extensive, information about magazine publishers.

A complete reference guide for magazines is *Magazine Industry Marketplace*, also published by R.R. Bowker Co.

MAKING AN APPOINTMENT

To make an appointment, call the prospective client. Say you photograph children and would like to show your work. Ask to see the picture editor, art director or art buyer.

Expect to be asked to leave your work for a few days. Editors get a lot of submissions and set aside specific times to look at them. Otherwise, they would never get their regular work done.

Don't be discouraged if you don't sell any pictures or story ideas at the first attempt. Call again in three to six months and make an appointment to show a portfolio of new work.

ADVERTISING

Placing ads in local papers or in magazines read by potential clients can be an effective way of getting customers for private portraiture. Such ads don't need to be large, but you should make the message as direct and appealing as possible.

Direct Mail—I do quite a bit of direct-mail promotion. I regularly send post cards and other promotional pieces to the clients on my mailing list. A mailing can

be as simple or elaborate as you wish. You can set your own schedule of mailings and compile mailing lists of any number of names from any number of sources.

Direct mail enables you to keep in touch with your regular clients, to help build repeat business. You can determine the effectiveness of each mailing by measuring the response in the days and weeks that follow.

Creative Directories—If you want to sell your photography for editorial or advertising use by major publishers or companies, consider taking out an ad in one of the creative directories, such as the *Creative Black Book, American Showcase, The ASMP Book, The Art Directors' Index* or one of the numerous regional directories published in the major cities. These annual books are distributed to ad-agency art directors and other corporate photography buyers.

These directories are very effective in promoting the kinds of business I've just

If you want to sell your photography for editorial or advertising use by major publishers or companies, consider taking out an ad in one of the major creative directories. These annuals are seen by ad-agency art directors and other corporate purchasers of photography.

described. Buying space in the books is expensive, ranging from about $2,000 to $5,000 or more per page, but most top-class photographers seem to get their investment back severalfold.

For the fee paid, most of the directories provide the buyer of space with a few thousand color reprints of his ad. These color sheets come in handy for mailings. In addition, I receive calls regularly from stock-photo buyers who have seen my ad.

I don't recommend that you invest in an entry in a creative directory if you are just beginning your career. However, when you're ready to work for nationally known clients, an ad in one or several directories can promote you very effectively.

PRICING

ASMP Professional Business Practices in Photography is a publication that

includes up-to-date pricing guidelines for editorial and advertising picture use and for assignment work.

I try to get ASMP *(American Society of Magazine Photographers)* minimum rates, but am not always successful. I'll compromise with clients who give me regular assignments or buy my stock pictures frequently.

Giving guidelines on pricing for private portrait customers is more difficult. It varies widely by location, affluence of the community and the photographer's reputation.

You must determine exactly what your fee will cover. Some photographers charge separately for the shooting and for the prints. Others include a specified number of prints in the shooting fee.

Many portrait photographers make a major percentage of their profits from print sales, charging little or nothing for shooting.

The best guide to pricing your work for private clients is to survey the prices of other photographers in your region who do similar work. Start with similar fees.

Sales Tax—Sales-tax laws vary from state to state, so check with your accountant. Generally, you must collect and pay sales tax if a product is turned over to the client, as are the prints to private portraiture clients.

When photographs are "rented" or "leased" for publication, as to a magazine or book publisher, and then returned to you, you usually do not have to collect sales tax.

RIGHTS

The purchaser of private portraits has the right to hang prints on a wall, send them to friends or use them for other personal purposes. He does not have the right to reproduce the photographs. Unless stated otherwise, the original images belong to the photographer, not the

client. However, to publish privately commissioned photos, a photographer must have written permission from the customer in the form of a model release.

Many clients wrongly think that the photographs and all the rights to their use belong to them. In your bill to your customer, state clearly your ownership of negatives, original slides and copyright. Additional prints or transparencies must be ordered from you and cannot be made by the customer by copying what you had initially delivered to him.

Editorial clients buy rights just as specific and limited, but frequently considerably more complex. Magazines usually buy one-time rights, permitting them to use a photograph once in one issue. If there are several editions, such as a British, German and Spanish edition as well as the U.S. edition, additional payment is required.

You sell limited rights to book publishers also, specified as to number of copies printed, countries involved and number of editions planned.

Always specify on your bill the exact rights you are selling. After a picture is reproduced, the magazine or book publisher should return the print or transparency to you. Request the return of the original on your bill. You can sell the right to use it again, as long as this doesn't conflict with agreements made with earlier buyers.

time a photograph is created. However, it is advisable to protect the copyright by accompanying a photo, and its reproduction in a publication, with the copyright notice just described. If the notice is mistakenly omitted, you don't necessarily lose the copyright.

You can register photos with the Copyright Office at the Library of Congress in Washington, D.C. although very few photographers actually do so. However, if you plan to take legal action against an infringer, it's best to formally register the copyright with the Copyright Office.

MODEL RELEASE

A model release is a written consent by the subject for photographs to be used for specified purposes. Model releases are very important if your pictures are to be published. Many book and magazine publishers will not print photographs that are not accompanied by a release.

Get releases from professional models and private portraiture customers alike. If a subject is a minor, the release must be signed by a parent or legal guardian.

Model releases are essential for photos taken for advertising or commercial purposes. Book and magazine covers are generally regarded as belonging to that category. However, I like to protect myself by getting releases for *all* my photos, even when they are intended

otherwise damaging to their son. In fact, they refused to allow the picture to be used in that way and the project was stopped before it was too late.

Please follow my advice and get a release whenever possible. Equally important, try to be aware of how your photographs are to be used.

It's customary to pay a subject something on signing a release. If you're not paying a model fee, a subject will often be happy to take payment in the form of prints. Another alternative is to agree to pay the subject a small percentage of the fee when a picture is sold.

Even if you don't know a child or his parents at the time you take his picture, you can often still get a release signed. For example, if you take pictures of children you don't know at your local playground, match up mothers and children after you've shot and ask if you can get releases in return for prints. If older children are playing unaccompanied, send a business card and a note home with them saying you've photographed the child and would like to exchange some prints for a model release.

PICTURE AGENCIES

Picture agencies, also called *stock agencies* or *picture libraries,* maintain collections of photographs available for commercial, editorial, advertising and other uses. An agency handles the selling and related paper work and shares the reproduction fee with the photographer. Agencies range in size from small cooperatives, representing the work of just two or three photographers, to large companies with branches around the world, representing the work of hundreds of photographers.

There are several types of picture agencies, and they serve a variety of purposes. Some actively seek assignments and stock sales. They employ salespeople who call on book publishers, magazines and advertising agencies with examples of your work and that of other photographers they represent. These agencies, or agents, also usually handle stock pictures and are able to fill requests for images from their files. Other picture agencies handle stock sales only and don't have an outside sales force.

The two stock picture agencies with whom I work provide me with sub-

A model release is a written consent by the subject for photographs to be used for specified purposes. Model releases are essential for photos taken for advertising or commercial purposes. However, I like to protect myself by getting releases for all my photos, even those intended for editorial use only.

A complete coverage of trade standards on rights, and prices, is in the *ASMP Professional Business Practices in Photography.* See also the *ASMP Stock Photography Handbook* for useful information.

Copyright—To indicate that you own the copyright of your photographs, mark each transparency and print—including private portraits—with *Copyright* or ©, followed by the year and your name. Under the Copyright Act of 1976, a copyright exists automatically at the

for editorial use only.

Even with a model release, you don't necessarily have total protection. A publisher once asked my permission to use a photo for a project other than the one for which it was taken, and I consented. Fortunately, I was sent a sample of the layout before publication. The photo—of a little boy—was to be used to illustrate a story about a retarded child.

Even though the parents had signed a release, they might well have sued on the grounds that this use was defamatory or

stantial additional income. Agencies get a lot more calls than individual photographers and are in touch with many markets I could never hope to reach. Their usual fee is 50% of the picture's selling price.

Most of the picture agencies in the U.S. are listed in the *ASMP Stock Photography Handbook*. If an agency is located near you, make an appointment to show your work. Alternatively, send a sampling of your best pictures for review. Good duplicate slides are fine for this purpose. Send a self-addressed, stamped envelope for the return of the photos.

All pictures submitted to agencies should carry your name and address and should be accompanied by a comprehensive caption.

FILING PICTURES

To retrieve and sell pictures from my own files, I need an effective numbering and filing system. This way, I can be sure of finding a photo on any topic quickly and dependably.

The first assignment or project I take each year is given the number 1, followed by month and year numbers. Thus, the first project of 1986, taken in January, is numbered 1-1-86. The 28th project may be shot in May. Its number is 28-5-86, and so on.

I log each job, with its number, in a notebook. I add relevant names, addresses and phone numbers. I also enter the magazine or agency, if the job was done for a client. The activities, locations and ages of the subjects are also recorded.

Model releases are referenced by the job numbers and filed separately.

Within each job, I number the films in the order they were shot. The same numbers go on contact sheets, transparency boxes and prints. Before I remove a slide from its box, I add its full reference number to the mount.

I generally need to find pictures by subject matter rather than date or other details. I get requests for such subjects as mother breast-feeding baby, baby sucking thumb, baby and two-year-old sibling, toddler playing with sandpail, baby with rattle, and preschooler finger painting.

I put pictures of the same subject matter together, regardless of the job for

which they were shot. I file them this way in plastic sheets holding 20 slides each.

Picture buyers are using more stock photos than ever before. I earn more from my stock photos, marketed by myself and two picture agencies, than I do from assignments. Repeated stock sales also often lead to assignments, which are rarely given to unpublished photographers. Only after you have many pictures in print do editors and art directors feel confident enough of your ability to entrust you with an assignment.

Your stock photos are a financial investment. If you're to benefit from it, you must know where each picture is. I

advise you to *start* with an effective filing system and to *keep* it effective.

TRADE ORGANIZATIONS

Several trade organizations can be helpful to beginning professionals. The *American Society of Magazine Photographers (ASMP)* performs several functions. It keeps an eye on business practices and has been a most effective organization in publishing price guidelines for published work, both stock and assignments. The ASMP can be useful defending a photographer's rights. The Society also offers a variety of group insurance programs to members.

The ASMP has regional chapters throughout the country. These regularly offer educational programs for members. You should get the ASMP's two publications, *ASMP Professional Business Practices in Photography* and *ASMP Stock Photography Handbook,* whether or not you decide to join the organization.

The *American Society of Picture Professionals (ASPP)* is an organization open to all people involved with photography, not only photographers. Its members include picture researchers, picture editors, picture agents and art directors, in addition to photographers.

Like the ASMP, the ASPP is a nationwide organization with regular meetings of its various chapters.

LEGAL HELP

Your nearest ASMP office can refer you to local lawyers who have worked with photographers.

My procedure for collecting late bills is to keep billing monthly for three or four months, sending the bills by certified mail with a return receipt requested.

If I am still not paid, I turn the job over to a collection agency. At that time I also terminate my working relationship with the delinquent client. Collection agencies take half of what is collected—but

half is better than nothing!

DEDUCTIBLE EXPENSES

When you declare your income as photographer, you're entitled to certain deductions. I can give you only rough guidelines, so it's important that you check with your tax lawyer or accountant for details.

In addition to obvious savings from not having to rent or build separate premises, working from your home can offer significant financial advantages. When rooms in your home are used exclusively for business, proportional rent or mortgage payment, property taxes and utility bills may be tax-deductible.

Other business expenses are deductible from your income for tax purposes. They include the cost of film processing, printing, studio props, depreciation of equipment, postage, subscriptions to magazines with whom you do business, professional books, memberships in professional organizations, business mileage on your car, other transportation for business purposes, and hotel and meals costs on business trips.

To derive tax benefits, you must keep extensive and accurate records. Your accountant can advise you on what to keep and how to maintain records.□

The photos in your own stock files are a financial investment. If you're to benefit from them, you must know where each picture can be located quickly and easily. I advise you to start with an effective filing system and to keep it effective.

Portfolio

Purpose: Test shot
Location: My studio, New York City
Camera: Nikon FM
Lens: 35mm *f*-2 Auto-Nikkor
Lighting: Two 200-watt-second
electronic flash units—one in softbox
and another aimed through a
translucent umbrella
Film: Kodachrome 64
Exposure: *f*-8 (shutter at 1/125
second)

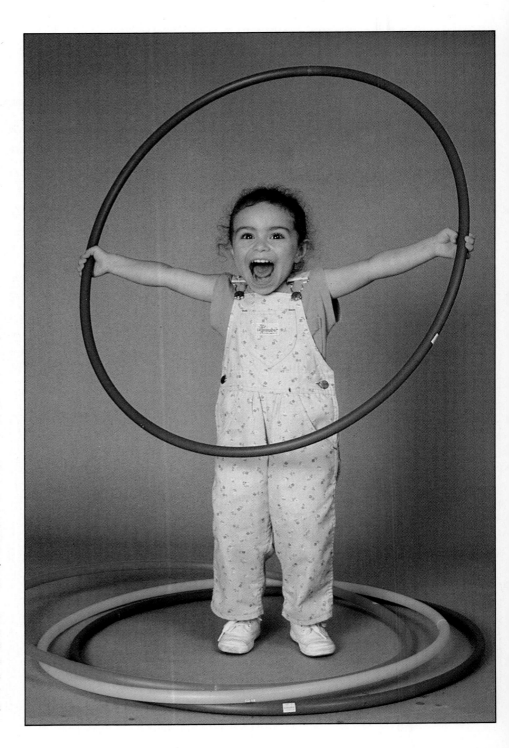

A frequent advantage of toys as
photographic props is that they are
specifically designed to be eye-catching.
One of my favorite toys—and props—
is the Hula-Hoop. The mere effort of
keeping a hoop in motion around the
waist will start even the most sullen child
laughing.

The purpose of this session was to
experiment with softbox lighting. For
the picture reproduced here, I used the
softbox as secondary, fill light.

The main light came from the front. It
was a 200-watt-second electronic flash,
aimed through a translucent umbrella.
To further soften the image, brighten the
background and lighten shadows on the
background, I used the soft box. It also
contained a 200-watt-second flash. I
aimed the softbox down at an angle of
about 60° from the right side of the
camera position.

I relied for most of the impact for this
picture on graphic elements: The strik-
ing stance of the girl, the shape of the
hoops and the variety of color. The
child's exuberant expression added the
final touch. I thought that unnecessary
tonal contrast would only detract from
this simple but vivacious image.□

Be wary of readings your camera's built-in meter provides of subjects with a water background. Sparkling highlights can fool the meter, causing you to underexpose the main subject. Large dark areas of water can also fool the meter, causing overexposure of the main subject.

In situations like this, I take spot-meter readings of my subjects. For this photo, I metered the girl's face and the yellow raft. I gave an exposure halfway between the two readings.

If you have only the camera's built-in meter, take a close-up reading of the palm of your hand. Be sure your hand is in the same light as the subject. If the subject is in direct sunlight, avoid casting a shadow on your hand. Be sure to meter only the hand and not to pick up bright highlights from behind.

Before I shot, I waited until the pool was in open shade, without direct sunlight. To reduce glare from the water even further, I used a polarizing filter. I set the polarizing filter's orientation to eliminate only part of the reflection. Removing all the reflections from water is generally not advisable because it tends to make the water surface appear "dead."

An SLR camera with through-the-lens metering automatically compensates exposure for filter factors. With a different camera type, you must allow for the filter factor—as recommended by the manufacturer of the filter in use. Camera exposure was 1/60 second at *f*-4.□

Portfolio 2

Purpose: For a health publication
Location: Private swimming pool
Camera: Nikon FM
Lens: 85mm *f*-2 Auto-Nikkor
Lighting: Open shade under blue sky
Film: Kodachrome 64
Filtration: Polarizing filter
Exposure: 1/60 second at *f*-4

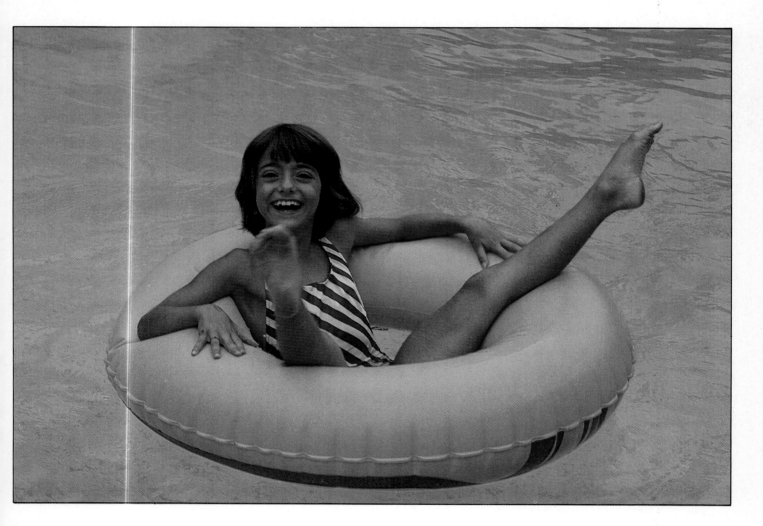

Portfolio 3

Purpose: Candid street shot
with sales potential
Location: On a New York City street
Camera: Nikon FM
Lens: 85mm *f*-2 Auto-Nikkor
Lighting: Overcast day
Film: Kodachrome 64
Exposure: 1/60 second at *f*-4

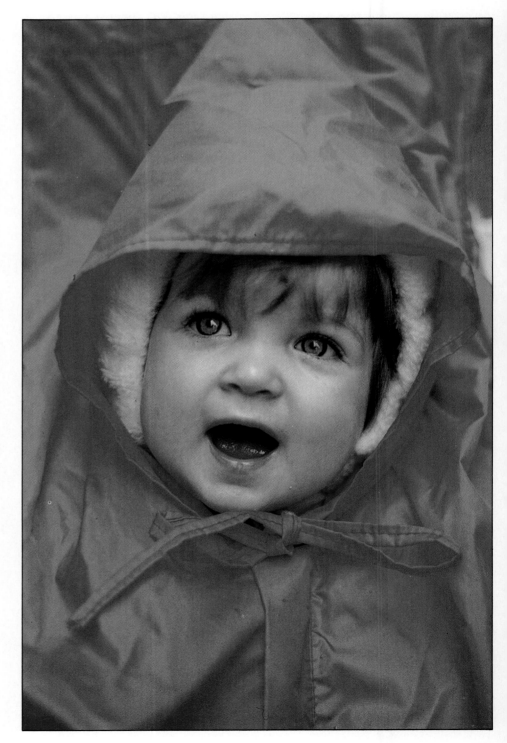

Sometimes just one striking feature can make a photo a success. It may be a splash of color, an expression, the composition or a bit of humor. This image captures the attention mainly because of the large area of dynamic red.

Compositionally, the image is very simple: A baby's face, framed by a huge cloak. There are just enough folds and creases in the garment to give the otherwise uniform red area some life.

Child and garment look almost like a huge flower. Viewer attention is constantly drawn back to the face at the center.

This was a "grab shot," not a carefully thought-out, posed picture. I spotted the situation on a New York street.

For those interested in rainwear, the colorful garment is a waterproof cover that goes over both child and stroller, allowing just the face to poke through.

It was a drizzly day and the light was dim. Exposure on Kodachrome 64 was 1/60 second at *f*-4. I had to hold the camera very steady to avoid camera shake and a blurred image. I also had to focus carefully because depth of field was very limited.

I had spent the entire day shooting an assignment. This final, unexpected and spontaneous shot occurred as I was leaving for home. It proved the most striking and also most profitable photo of the day. Not long after I shot it, a magazine paid me a healthy fee for its use.

The lesson from this experience is simple: Always have your camera ready and always remain alert for that unique image.☐

Purpose: Cover for Baby Talk magazine
Location: My studio, New York City
Camera: Nikon FM
Lens: 135mm *f*-3.5 Auto-Nikkor
Lighting: Two electronic flash units—one in soft box and the other in umbrella
Film: Kodachrome 64
Exposure: *f*-8 (shutter at 1/125 second)

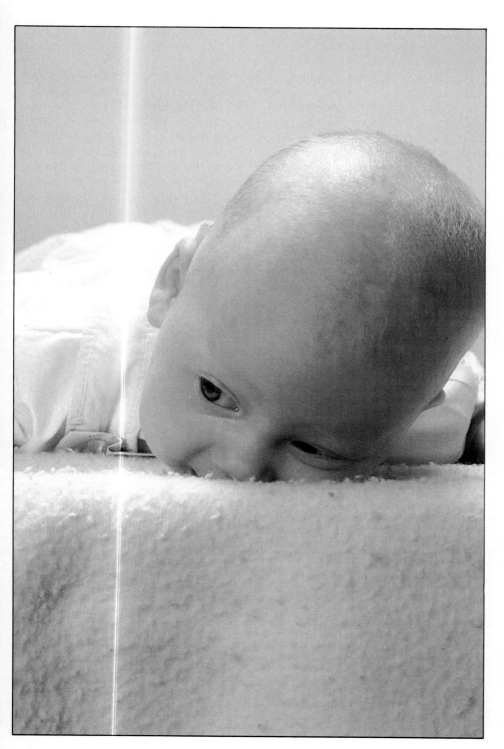

I had taken a series of photos of this baby with his mother and wanted to take some of him alone. I had noticed that, at three-and-a-half months, he was just beginning to try and lift his head. I thought this gallant effort deserved recording.

I placed the baby, face down, on a blanket. To make it easy for me to get a low-angle shot, I had put him on a table rather than on the floor. Mother was nearby, carefully watching him.

From experience I knew that, no matter how gallant and inventive baby's efforts were going to be, they were going to be shortlived. So I worked fast, using the motor drive on my camera. The session lasted barely 15 minutes—but I exposed more than 100 frames.

To get suitably soft lighting, I used an umbrella flash from near the left side of the camera. To add modeling to the head, I aimed a softbox from high up, on the right side of the camera and just behind the baby. Great care had to be taken to balance the lighting from the two sources so the light on the head did not burn out all detail.

I did not want an excess of color, as this would have detracted attention from the baby's head. Therefore, I used a yellow background that approximately matched the color of the blanket.

I am particularly fond of this image. Although the face is still on the blanket, the baby's whole attitude and position clearly indicate imminent plans to get higher up in the world!

When shooting tiny babies, always prepare for short shooting sessions. Make every possible preparation before baby even comes on the scene. Then shoot quickly for as long as you get good results—usually no longer than 10 to 15 minutes.□

Purpose: For stock files
Location: My studio, New York City
Camera: Nikon FM
Lens: 85mm ƒ-2 Auto-Nikkor
Lighting: Two electronic flash units in umbrellas
Film: Kodachrome 64
Exposure: ƒ-11 (shutter at 1/125 second)

Good poses are sometimes the result of careful planning by the photographer. With children, the right moment often occurs spontaneously and fleetingly. The photographer's success depends on his alertness. For consistent success in photographing children, there has to be a balance between preplanning and spontaneity. A photographer must know when to direct and when to let the action happen on its own.

I spotted this father and child on a street. They appealed to me and I asked them to pose for my camera. I took them to my studio because I wanted to use studio lights and seamless background paper. I also wanted access to a variety of props.

I tried several different situations and poses, using assorted props, toys and backgrounds. I directed the interrelationship of father and daughter. Using the motor drive on my Nikon camera, I shot fast and tried to capture on film every changing expression.

The child was very active and seemed interested in everything around her. She had a sparkling personality that really came across.

Toward the end of the session, I asked my subjects to come in front of a white, seamless background—and this picture just happened! After all my directing, this game of peekaboo was the child's spontaneous idea. I just had to be alert enough to capture the occasion on film.

The main light was an umbrella flash near the camera position. Fortunately, it was in the right place to avoid unwanted shadows on the child's face. A second flash was bounced from the ceiling.

I don't know whether the father was supporting the child's arms or trying to loosen her grip, but the juxtaposition of his huge hands with her tiny arms and hands was terrific!

Because the child's head is so much smaller than her father's, and because much of it is hidden, it was fortunate that only one of the child's eyes was visible. Attention seems to be drawn irresistibly to that one focal point.□

With children, the right moment often occurs spontaneously and fleetingly. The photographer's success depends on his alertness.

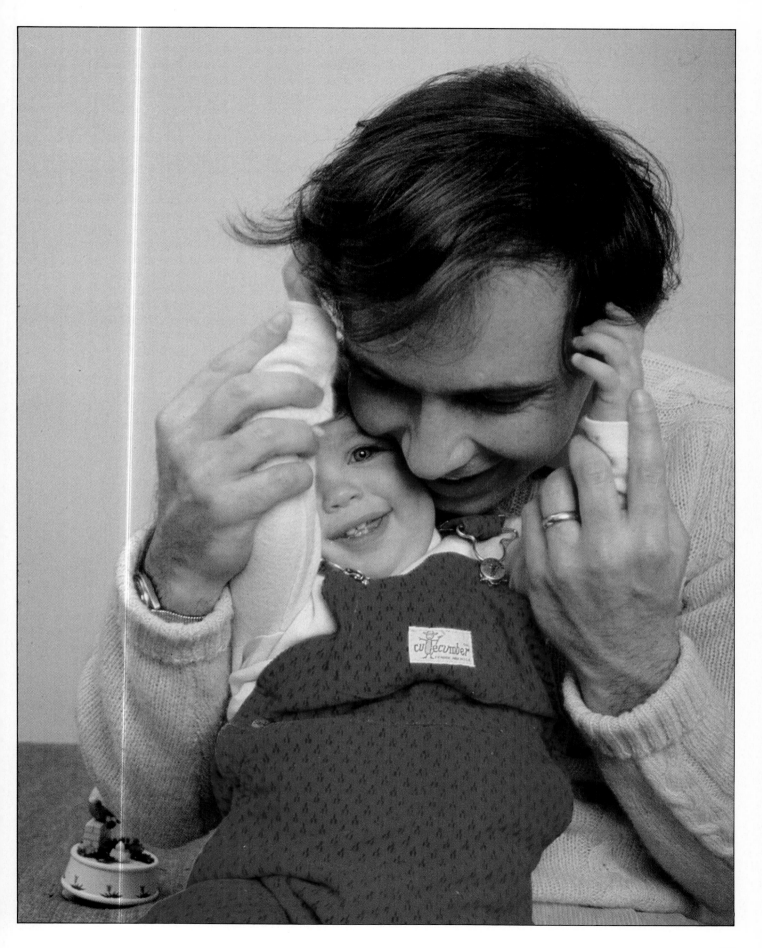

Portfolio 6

Purpose: For a book cover
Location: Subjects' home in Westchester, NY
Camera: Nikon F
Lens: 35mm *f*-2 Auto-Nikkor
Lighting: Hazy sunlight
Film: Kodachrome 64
Exposure: 1/250 second at *f*-5.6

I had been photographing a large family group for more than an hour. The younger members in particular were getting very restless and anxious to move about. At the earliest possible moment, the smaller children broke away from the group and started running about. The child in this photo had clearly challenged daddy to a chase.

I took my camera, with motor drive and wide-angle lens, and followed the chase. I set the lens distance scale and the aperture to give me depth of field over the area in which I expected to "catch" my subjects. All that remained for me to do was to get to the right position quickly, aim and shoot.

I made this photo from a standing position. This gave me a relatively plain background of green lawn. From a lower viewpoint, the background would have been too cluttered with trees, shrubs and houses.

The chase reversed from time to time: Sometimes child chased daddy and sometimes it was the other way about. I chose to shoot child chasing daddy because it enabled me to have daddy closer to the camera. That viewpoint enabled me to emphasize the smallness of the child in relationship to his large "opponent."

Red is a very dominant color, especially against a green background. Having the child wear red made him stand out prominently in spite of his small size.

As with most photos of children, the success of this image is largely due to my having captured the decisive moment. The father's challenging attitude and the child's determined pursuit were recorded more convincingly at this one precise moment than they would have been at any other.□

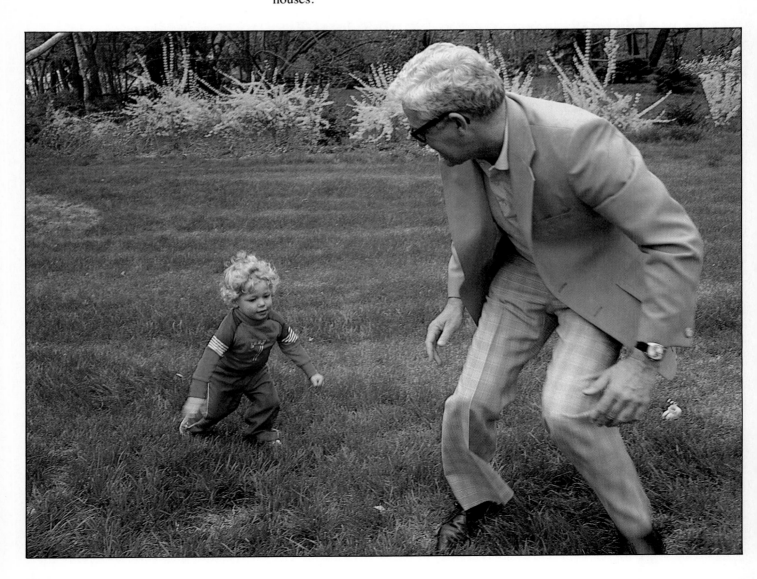

The larger a group, the more difficult it is to pose them. Here, I used a simple device to get a coherent composition. I used a book as central point of interest. It didn't matter what the book was about, but it had to be large enough for each member of the family to be able see into it.

When several subjects are directing their attention to a central point of interest, you have the makings of a good grouping. For a visually pleasing arrangement of several people, try to place each head at a slightly different height, as I have done in this photo.

Four members of the family depicted here have fair hair and the father is dark-haired. This was fortunate for me. I had wanted to place the father in a graphically central position and the dark hair helped to concentrate viewer attention on him. Had he been placed at one end of the group, the blond members would have visually overpowered him and he might have been hardly noticeable.

Although everyone is sitting on the ground, notice that no legs are sticking out toward the camera. I posed each member of the group very carefully to avoid image distortion caused by protrusions toward the camera.

The large pages of the book served as an efficient reflector, directing light into the shadows of four of the five faces. To also lighten the face of the boy on the left and the mother's legs, I directed a foil reflector toward the group from near the camera position.

To keep the image coherent and simple, I had asked all members of the family to wear similar styles of shirts. I was amused at the extent to which they took this request seriously: The photo looks almost like an ad for alligator shirts!□

Purpose: For stock files
Location: Backyard of subjects' home, Long Island, NY
Camera: Nikon FM
Lens: 50mm *f*-1.4 Auto-Nikkor
Lighting: Hazy, late-afternoon sunlight
Light Control: Large foil reflector
Film: Kodachrome 64
Exposure: 1/60 second at *f*-5.6

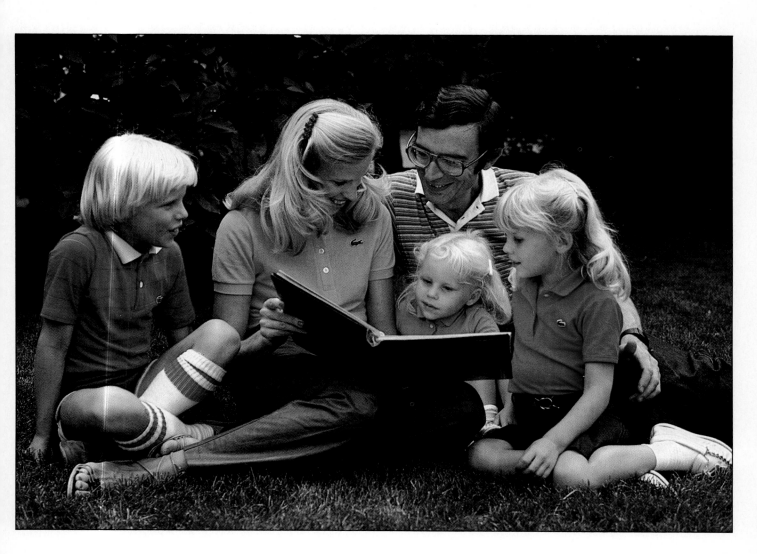

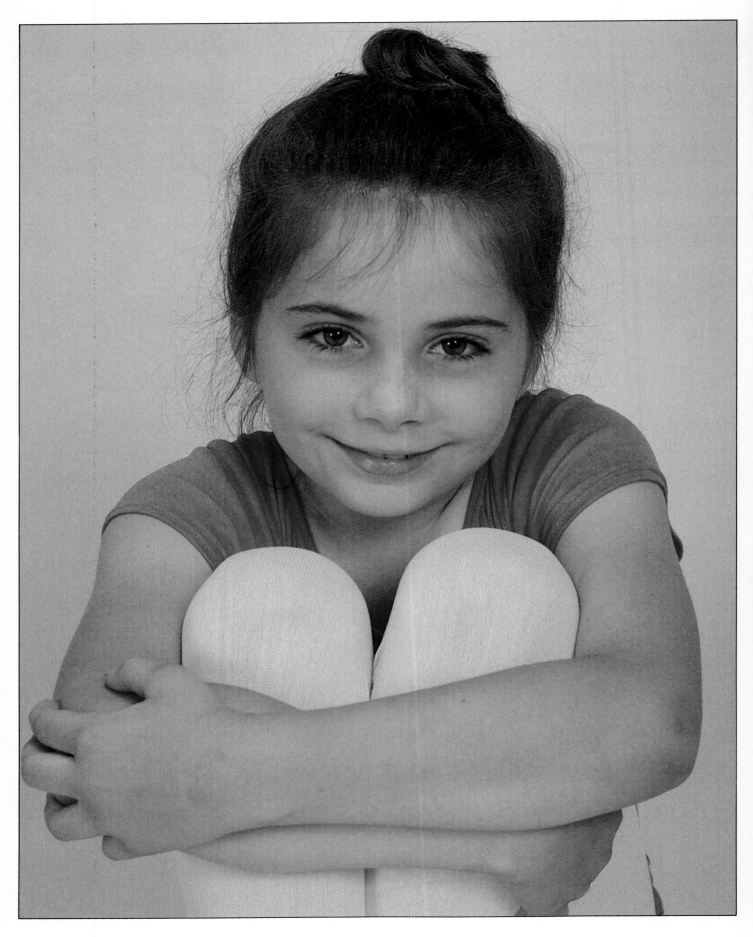

This young would-be ballerina is a wonderful model. She's pretty and cooperative. And, being a little dancer, she is very body-conscious and poses well. I spent several hours with her, shooting a large series of pictures. The three reproduced here show how a subtle difference in pose or attitude can change the whole effect of an image.

In the photo below, left, my subject is just a kid lying on the floor. The photo on the opposite page has the same basic head-on view. However, the pose is quite different. Her legs have now become a prominent part of the image and this helps to suggest to a viewer that she is a dancer—or perhaps a gymnast. For the photo below, right, I had the girl sit up with her back toward the camera. I then asked her to look at me over her shoulder. This is a typically feminine pose. It is also a pose much more typical of adults than children. It makes the little girl look very sophisticated.

By using the natural body language of your subjects, or directing their poses and attitudes, you can elicit a lot of different moods and effects from one model.

The electronic-flash lighting for these shots consisted of two frontal lights and one light on the background. The front lights were balanced to produce virtually shadowless illumination in the photo on the opposite page and the one below, right. For the photo below, left, the fill light was noticeably weaker than the main light, so that distinct shadows are visible. The plain, seamless-paper background was lit by a third light.□

Purpose: For stock files
Location: My studio, New York City
Camera: Nikon FM
Lens: 85mm f-2 Auto-Nikkor
Lighting: Three electronic flash units
Film: Kodachrome 64
Exposure: f-8 (shutter at 1/125 second)

Purpose: Picture story on children and pets
Location: Child's home in Massachusetts
Camera: Nikon FM2
Lens: 85mm *f*-2 Auto-Nikkor
Lighting: Diffused sunlight through light overcast
Film: Kodachrome 64
Filtration: 81B warming filter
Exposure: 1/250 second at *f*-4

Photographers of very young children and of animals have a few things in common. Neither can rely on verbal communication and each works with subjects that aren't likely to stay in one place for more than a few moments. When I shot this picture, I wore the combined hats of child and animal photographer.

To enable me to make this picture, and a few others, of these two young creatures, I needed the constant help of the child's mother. When she wasn't running to retrieve the rabbit, she was retrieving the child from well beyond the image area.

To produce an entire picture story on children and their pets, I photographed cats, dogs, turtles, fish and several other forms of animal life. Except for the fish, safely contained in their tanks, all of the animals were elusive. However, none was as elusive as the rabbit.

The sky was lightly overcast, the penetrating sunlight was diffused and the general illumination had a distinct bluish cast. To regain a more pleasing color balance, I used an 81B warming filter on the camera lens. The warmer light also helped make the scene look more "sunny."

Because of the mobility of my subjects, I set the shutter to 1/250 second. This demanded an aperture of *f*-4—just enough depth of field to give me confidence that the two elusive creatures would be recorded sharply.

Ideally, I had wanted a picture of the child stroking the rabbit. It wasn't to be. However, I was happy to get my subjects as close to each other as you see them in this photo. I captured a moment when they were cautiously scrutinizing each other.□

There's an old piece of advice in theatrical circles: Never work with children or animals. Well, I work with children all the time and love it. Sometimes, to make my work even more challenging, I'll include an animal in a photo of a child.

Animals and small children have a few characteristics in common: They can't take verbal direction, have strong wills of their own, and tend to move unexpectedly. Basically, you face the same problems whether you photograph a couple of children together or a child and an animal. In practice, however, child and animal seem the more difficult combination for a photographer. Maybe it's because your two subjects don't have a common basis for communication between themselves.

As I've said, I find combining children and animals in my photographs very challenging. But it's more than that: It's good business. Editors and advertising agencies are aware of the tremendous appeal of such pictures, and families can't seem to get enough pictures of their young offspring with the family pet.

When I was ready to shoot the picture reproduced here, the dog had already found a comfortable spot on a quilt on a bed. He had warmed his spot and apparently fallen asleep. It seemed prudent for me to bring the child to the dog rather than the other way around.

After I had set up my camera and lights, the mother placed the child next to the dog. The dog woke up and, for a brief moment, dog and child looked at each other in surprise. A fraction of a second later, the dog had jumped off the bed—but not before I got my shot!

The mother placed the dog back on the bed, and he immediately jumped off again. She tried several times more, but to no avail. I had my one shot and had to be satisfied. ☐

Portfolio 10

Purpose: Picture series on children and pets
Location: Subjects' home, Glen Ridge, NJ
Camera: Nikon FM
Lens: 50mm *f*-1.4 Auto-Nikkor
Lighting: Two electronic flash units
Film: Kodachrome 64
Exposure: *f*-8 (shutter at 1/60 second)

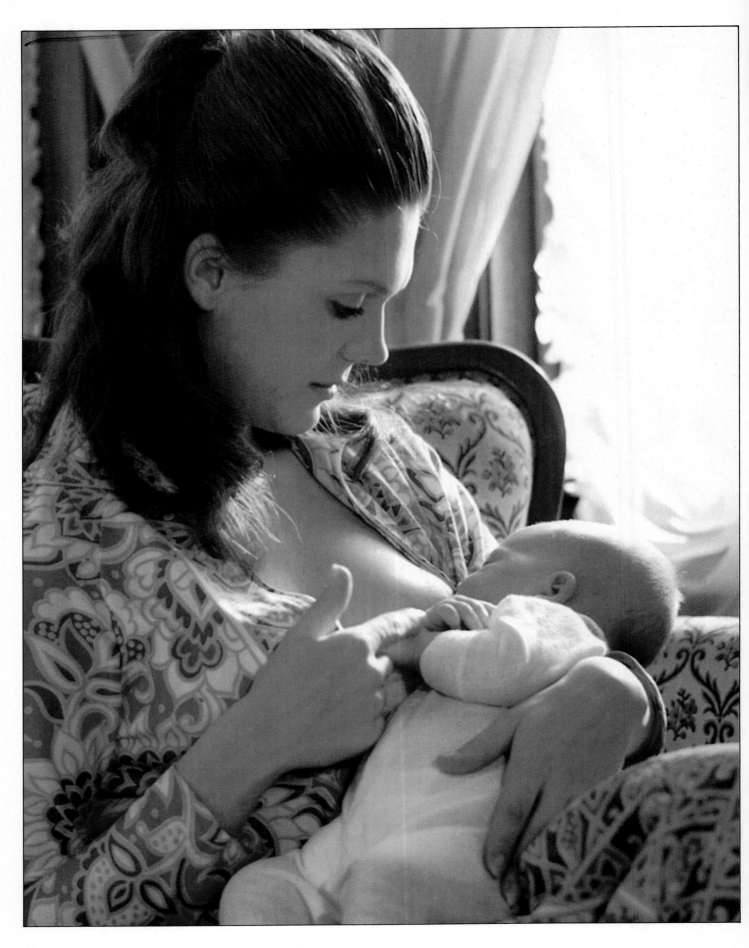

Purpose: Illustration for magazine article
Location: Subjects' home, New York City
Camera: Nikon FM
Lens: 85mm *f*-2.8 Auto-Nikkor
Lighting: Window light; blue photo lamp
Film: Kodachrome 64
Exposure: 1/60 second at *f*-4

I was assigned to produce a single illustration to lead a story on breast feeding. To get the warm, cozy effect I wanted, I shot by window light and chose yellow and red as the dominant colors in the scene.

I scheduled the shooting for a regular, late-morning feeding time. This was also a time at which the daylight coming through the window was at its best.

The sunlight bounced around the walls of the room, giving the setting a golden glow. To strengthen this effect, I asked the mother to wear a suitable warm-colored garment. The red and yellow robe was perfect and also ideally suited for feeding. The baby was also dressed in yellow.

I positioned mother and child so the window light provided attractive rim lighting. To reduce the subject brightness range and avoid "burning out" the rim lighted areas, I had to introduce some frontal illumination.

Instead of electronic flash, I used a tungsten photoflood. It made it easier for me to control the balance between the window light and the fill light—both visually and with a meter. To get good color balance with the daylight film I was using, I used a blue photoflood. The lamp was in a reflector, about seven feet from the subjects.

Breast-feeding pictures must be taken at feeding time. They can't be "posed" at other times. I had about 15 minutes to get his picture. I made several exposures, changing the mother's position and the camera angle slightly between shots.

The photo reproduced here is one of 40 that I took. It was the one the client selected for publication.□

To get the warm, cozy effect I wanted, I shot by window light and chose yellow and red as the dominant colors in the scene.

Purpose: Brochure cover for pharmaceutical company
Location: Subject's home in Connecticut
Camera: Nikon FM
Lens: 50mm *f*-1.4 Auto-Nikkor
Lighting: Hazy late-afternoon sunlight
Film: Kodachrome 64
Exposure: 1/125 second at *f*-4

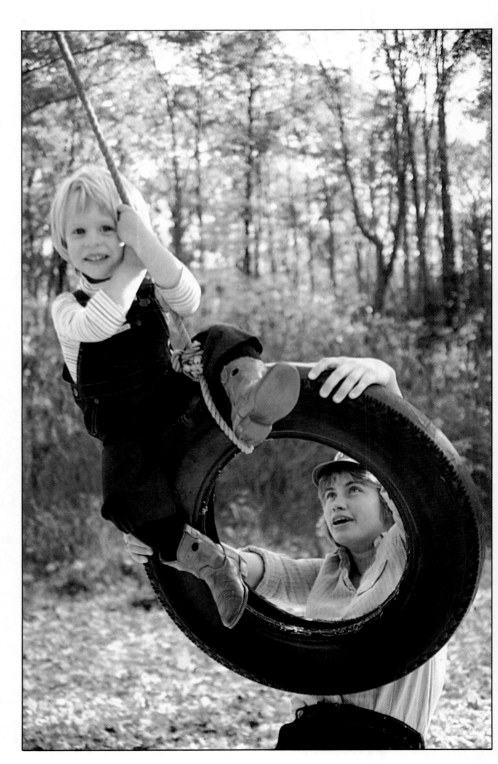

I had not planned to do any shooting on this particular day. I was exploring the possibility of using this family for future photography when I saw this scene—the girl happily swinging her younger brother.

The photo was purchased for use on the cover of a brochure produced for a pharmaceutical company.

The backlight from hazy late-afternoon sunlight added an idyllic atmosphere. I got my camera and started shooting.

The camera's built-in meter indicated 1/125 second at *f*-5.6 to *f*-8. Because of the backlighting, I opened the lens to *f*-4 to ensure enough exposure for the children's faces. Contrast was relatively low because the sky was lightly overcast.

By recording the scene at a fairly static moment, I was able to record it with minimal image blur at 1/125 second.

Compositionally, this image teaches a couple of lessons. Notice the use of the *rule of thirds,* which recommends placing key image elements one third of the way into the image area. The tire is in the lower, right third of the frame, and the older child is even framed within the tire according to the rule. The swinging child is approximately in the upper, left third of the picture.

The picture is also a good example of the use of a diagonal to add a feeling of motion to an image. Because the rope runs across the image at an angle, a viewer gets the clear impression that the swing is in action.

This was my first meeting with a family that has since modeled for me regularly. Not only are they excellent models, but the family offers children ranging in age from three to the teens.□

To make exciting photographs, you don't need an arsenal of expensive equipment. Nor do you need to visit exotic locations or hire professional models. You can take wonderful pictures of people you know, in places you are familiar with, using minimal equipment. For this photo, all I used was my Nikon camera and a wide-angle lens. A similar photo could have been taken with a considerably less sophisticated and expensive camera.

I had met the mother and children at a local lake. We had made an appointment to shoot late in the day, my favorite time for outdoor photography because of the soft, low light.

I had my subjects wear colors that contrasted with the green of the grass. I had them running toward me, with the sun behind them. The backlight provided beautiful highlighting to hair and rim light to the bodies.

Originally, I had wanted all the children running, but the youngest had decided that he was going to be carried. Sometimes a photographer must compromise!

I ran backwards as the group ran toward me. In this field, it was relatively safe. In other situations, I advise you to take a careful look behind you before running "blind" in such a manner.

The Nikon's built-in meter indicated 1/125 second at f-5.6. The shutter speed was fast enough to arrest the motion on film. The 35mm lens at f-5.6 gave adequate depth of field to allow for distance variations between me and my subjects as we moved.☐

Purpose: For stock files
Location: A field in Massachusetts
Camera: Nikon FM
Lens: 35mm f-2 Auto-Nikkor
Lighting: Late-afternoon sunlight
Film: Kodachrome 64
Exposure: 1/125 second at f-5.6

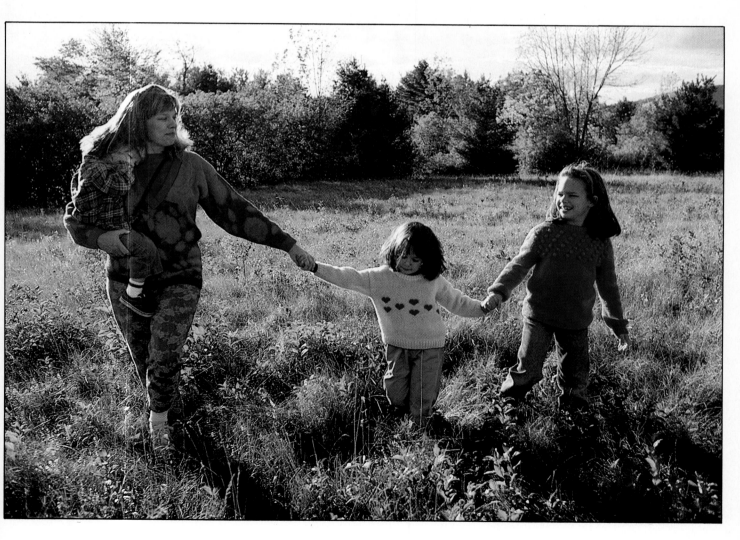

Purpose: Private portrait assignment
Location: A park in New York City
Camera: Nikon FM
Lens: 50mm *f*-1.4 Auto-Nikkor
Lighting: Hazy, mid-afternoon sunlight
Film: Kodachrome 64
Exposure: 1/125 second at *f*-5.6

This is a typical example of a photo that succeeds first and foremost because of the subject matter. Of course, the lighting is flattering, the image is sharp and the colors are well balanced. But those qualities alone don't necessarily produce a picture worth looking at. What makes the picture memorable is the interrelationship between the subjects.

I was fortunate to have as my subjects a father and daughter who, in spite of their age difference, looked remarkably alike. The soft, diffused daylight illuminated both in a similar way so that all features were clearly visible.

To get a frontal view of both heads, close to each other, I asked the father to hoist his offspring onto his shoulders. The little girl was delighted. As both were having fun with each other, I rapidly shot away. I like this image best because father and daughter have a very similar expression. The 90° angle between the orientation of the two heads adds an element of humor.

Notice how the red, green and blue complement each other, not only in hue but also in the different amounts of space they occupy in the composition.

Here's another compositional note: I left enough headroom over the child so that, if she were to sit up straight, she would still be totally in the picture. This is important. If that space were not left, the image would appear crowded, even though both subjects are within the image area.☐

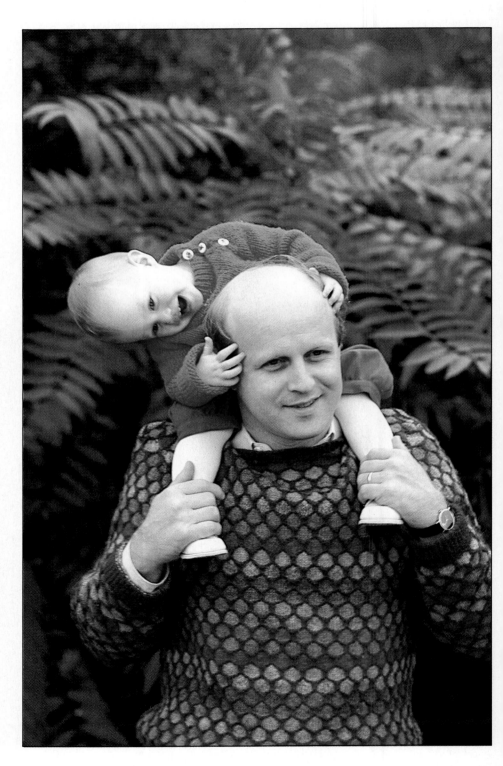

Purpose: Cover for Baby Talk magazine
Location: Stable in New Jersey
Camera: Nikon FM
Lens: 85mm *f*-2 Auto-Nikkor
Lighting: Late-afternoon sunlight
Film: Kodachrome 64
Exposure: 1/125 second at *f*-5.6

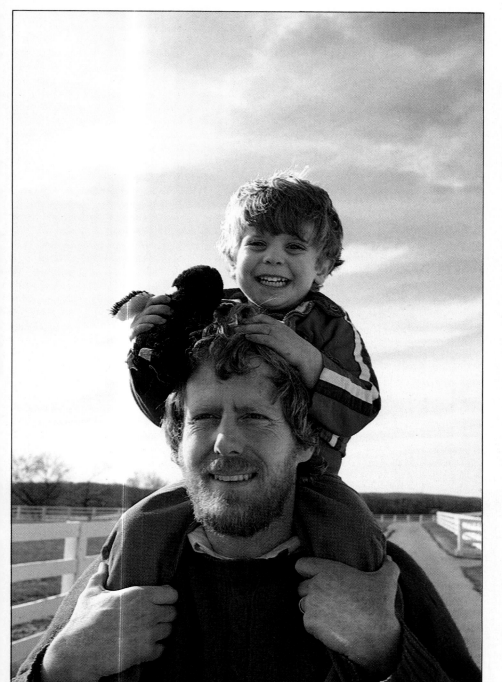

The location where I shot this picture was suggested by the boy's father. Apparently the entire family enjoyed regular visits to the stables located there. I wanted a "masculine," outdoor shot of father and son. However, I wanted to avoid a contrived setting. The stables seemed an ideal place.

Although the stable abounded in atmosphere, it made for a cluttered, unphotogenic background. I found a nice section of fence, subtly suggesting the stable setting. I placed father and son in front of it.

The father raised the child onto his shoulders and I shot up at them from a low angle. This conveyed a little of the "on-top-of-the-world" feeling a child has when sitting high on a person's shoulders.

The stable fence added a humorous symbolism, with the implication that the father was acting as the child's "horse."

The late-afternoon sun was behind the subjects and slightly to the left of the camera. I did not want to lose detail in the shadows on the faces. Spot-meter readings of shadow and highlight areas indicated that the entire subject brightness range could be recorded satisfactorily on Kodachrome 64 film.

During the day of shooting, I took numerous photos that included horses and stables. However, the one reproduced here seemed the best to me because it was so simple. The magazine editors who had assigned me the job must have agreed—they selected it for their cover. □

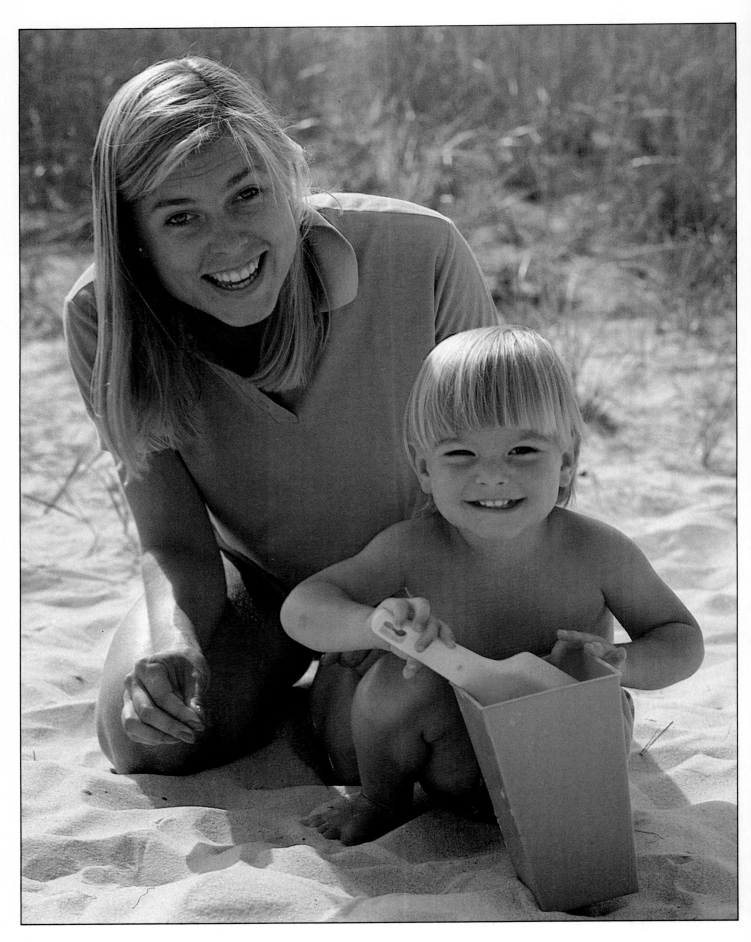

Back lighting usually causes a scene brightness range that is excessive for the film to record satisfactorily. For that reason, fill flash or a reflector is generally needed.

Of course, you can expose a subject's face correctly in back light, even without the help of flash or reflector. All you need to do is take a close-up meter reading of the face and expose accordingly. However, in doing this you would usually overexpose the background to the extent that it would almost totally "burn out."

The background would be so bright as to cause unattractive halation around the subject. The rim light would, in effect, be so strong as to "eat into" the outline of the subject.

If you were to expose correctly for the background, you would avoid the problems just mentioned, but your main subject would record in silhouette.

Why use back lighting, when it causes the need for additional illumination? Because it's a very attractive form of lighting. It can give an image a very convincing three-dimensional effect and is flattering to skin tones and features. It also avoids the unpleasant squinting that is so common in photos of people lit frontally by bright sunlight.

A bright beach scene, such as the one depicted here, acts as an efficient reflector. It directs much of the sunlight coming from behind the subjects back into their faces. However, even with the help of that natural reflector, I needed to use a weak fill flash to get the overall tonal balance I achieved in these two photos.

In the photo on the opposite page, eye contact by both subjects with the camera makes the viewer feel involved in the event. In the photo below, the two subjects are involved with each other, apparently unaware of the camera's presence. This makes the viewer of the photo feel more like a spectator than a participant.□

Purpose: For stock files
Location: Beach on Long Island, NY
Camera: Nikon FM
Lens: 85mm *f*-2 Auto-Nikkor
Lighting: Back light from the sun plus fill flash
Film: Kodachrome 64
Exposure: 1/125 second at *f*-11

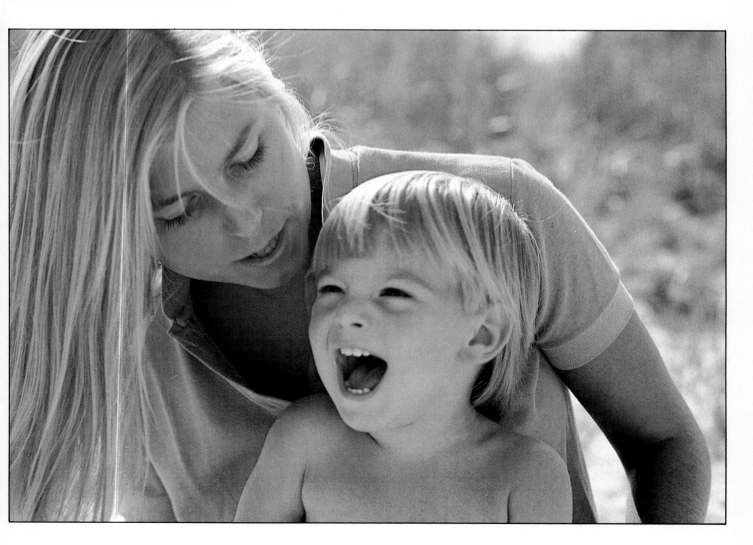

Purpose: For stock files
Location: New York City
Camera: Nikon FM
Lens: 85mm *f*-2 Auto-Nikkor
Lighting: Afternoon sunlight
Film: Kodachrome 64
Exposure: 1/60 second at *f*-5.6

Brent, the little boy shown here, is one of my favorite models. The expressiveness of those dark, almond-shaped eyes under the mop of black hair makes any photograph of him truly appealing. I try to use him whenever I can, and in this picture you can see why.

One of the techniques employed by wise photographers of children may be called *positive reinforcement* by some and *bribery* by others. The important thing is that it works.

I had been working with a group of children. My positive-reinforcement technique consisted of a promise of an ice-cream cone for each child at the end of the session. My models behaved like little troupers and each got his promised treat.

I'm glad that I had not packed my camera away at the end of the official shooting. But then, I would *never* put my camera away when I knew that children and ice cream were to be brought together! A kid's efforts at controlling a treat that apparently has a mind of its own always present wonderful opportunities for photography!

I concentrated on Brent working on his "bribe." The sun was high in the sky, a little to the left of the camera. The highlights on Brent's hair graphically separated his head from the dark background.

A couple of additional factors helped to make this image a special success. One of these is the striking contrast between the white ice-cream beard and the black hair. Another is the trail of ice cream running down my model's chin, leading viewer attention to the cone, directly below.

The only thing that impresses a viewer of a photo is the image itself. The viewer doesn't know, and generally doesn't care, what kind of camera was used. This image could have been made just as easily with a less complex camera than my Nikon—and it would have had just as much viewer impact.□

The viewer doesn't know, and generally doesn't care, what kind of camera was used. This image could have been made just as easily with a less complex camera than my Nikon—and it would have had just as much viewer impact.

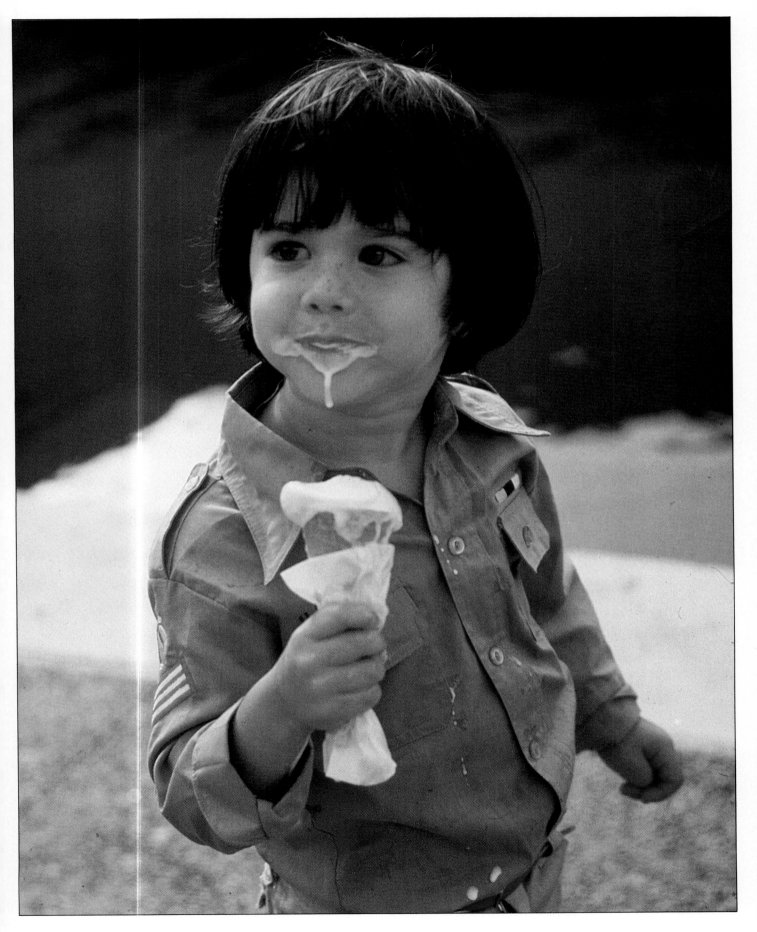

Purpose: Textbook illustration
Location: A meadow in Massachusetts
Camera: Nikon FM
Lens: 50mm *f*-1.4 Auto-Nikkor
Lighting: Early-evening sunlight
Light Control: Large gold-foil reflector
Film: Kodachrome 64
Filtration: Deep-yellow filter
Exposure: 1/125 second at *f*-5.6

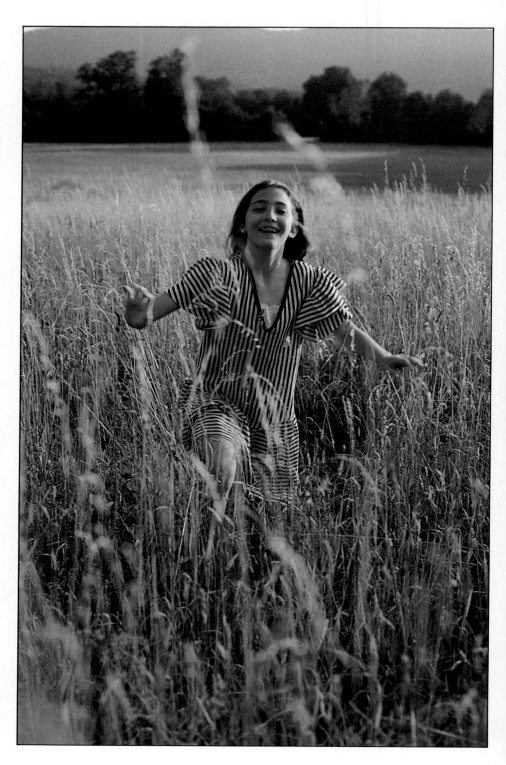

Like any good professional photographer, I plan my pictures as carefully as possible. However, I'm still grateful when a lucky accident helps to make a fine photo even better. It often happens in child photography, where there is so much movement and things happen so quickly.

In the picture reproduced here, a somewhat unusual accident occurred. I wasn't aware of it until I examined the processed slides. I'm referring to the two large, unsharp blades of grass in the foreground, between which the subject is framed.

I shot a series of pictures of this girl running through the tall grass. Some shots were made from a low viewpoint. I knew some blades of grass would occasionally get in the way and was prepared to have some of the pictures spoiled because of this. What I wasn't prepared for was this pleasant surprise of accidental framing.

Nonetheless, a lot of planning went into this shot. I wanted the gold of the grass to be enhanced by the warm, late-autumn sunlight. The sun was low in the sky and gave a beautiful side light. However, the color of the light was disappointing. I took two steps to achieve the golden glow you see in this picture. I used a deep-yellow filter on the camera lens and placed a large gold-foil reflector to the right of the subject to lighten the shadows with a warm glow.

I carefully selected the striped, blue and white dress for the girl. It made her stand out from the grass without making her an overpowering element in the scene.□

Purpose: For use in textbook
Location: New York City
Camera: Nikon FM
Lens: 35mm *f*-2 Auto-Nikkor
Lighting: Late-afternoon sunlight
Film: Kodachrome 64
Exposure: 1/125 second at *f*-5.6

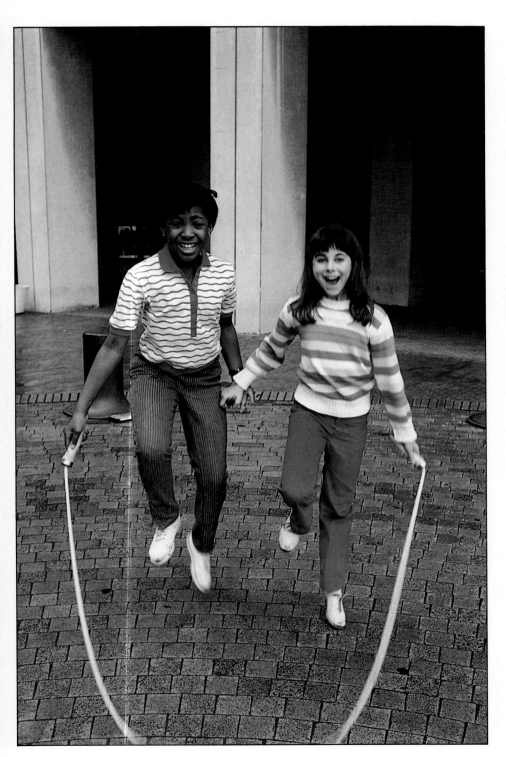

I hired these two young models for a series on interracial friendship. My job was made easy because they demonstrated that friendship immediately and spontaneously. They were a delight to work with.

We went to several locations in New York City, shooting with different props in each place. The girls were having a wonderful time and needed little prompting from me. Photographically, we had the greatest success with the jump rope I had brought along.

It was late afternoon when I found this pleasant, cobblestoned location in front of a building. The girls found it ideal for rope jumping and I just clicked away.

A shutter speed of 1/125 second adequately stopped the motion on film. The aperture of *f*-5.6 was wide enough to record the background slightly out of focus.

Notice how the sweep of the jump rope from the hand of one girl to that of the other graphically unites them. Look for such compositional tools in your own photography.☐

Purpose: Cover for
Family Life Today magazine
Location: Central Park, New York City
Camera: Nikon F
Lens: 85mm *f*-2 Auto-Nikkor
Lighting: Late-afternoon sunlight
Film: Kodachrome 64
Exposure: 1/125 second at *f*-4

This idyllic scene was shot in New York's Central Park. I asked the father to lie on the ground, among the fallen autumn leaves, and hold the baby over him. I shot from a low angle but aimed the camera down enough to avoid showing distant city buildings.

The late-afternoon sun was low in the sky and lengthening shadows were creeping across the park. I positioned my subjects so their heads were lit by the low sun.

A relatively wide aperture of *f*-4 enabled me to record the background foliage softly. It also eliminated the intrusion of scattered pieces of litter on the ground.

Most cities have parks where attractive outdoor photos can be taken in a natural setting. For a New Yorker like me, Central Park is a wonderful location. I'm sometimes asked to produce photographs at short notice, when there isn't time to travel to a rural setting to get a picture by a tranquil lake, under colorful fall foliage or of children tobogganing.

You must be selective when you try to shoot "rural" pictures in a limited natural setting. Frame your pictures to eliminate what you don't want to show. To avoid an undesirable background, perhaps of buildings and cars, aim the camera downward. Or, if the subject allows it, aim upwards and get a background of sky or trees.

If you can't avoid unwanted features in the image, record them out of focus by using a large lens aperture to limit depth of field.□

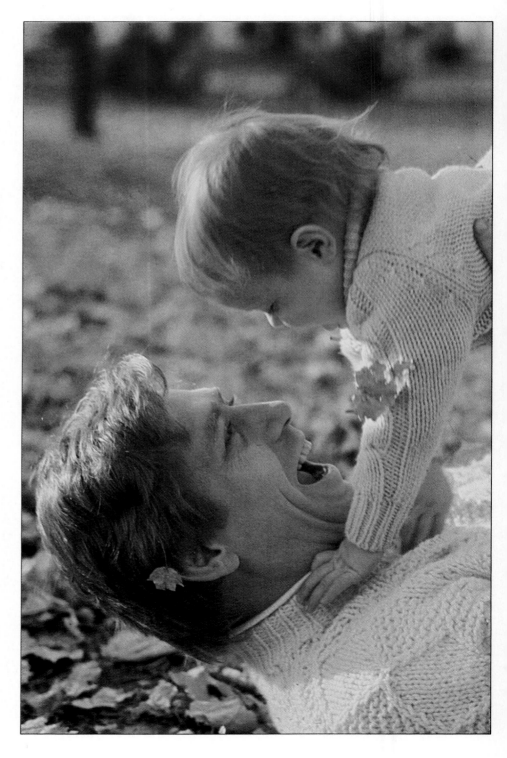

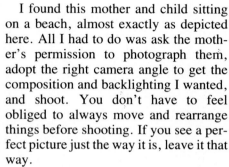

Purpose: For stock files
Location: Beach on Long Island, NY
Camera: Nikon FM2
Lens: 85mm *f*-2 Auto-Nikkor
Lighting: Late-afternoon sunlight
Light Control: Gold foil reflector
Film: Kodachrome 64
Exposure: 1/60 second at *f*-5.6

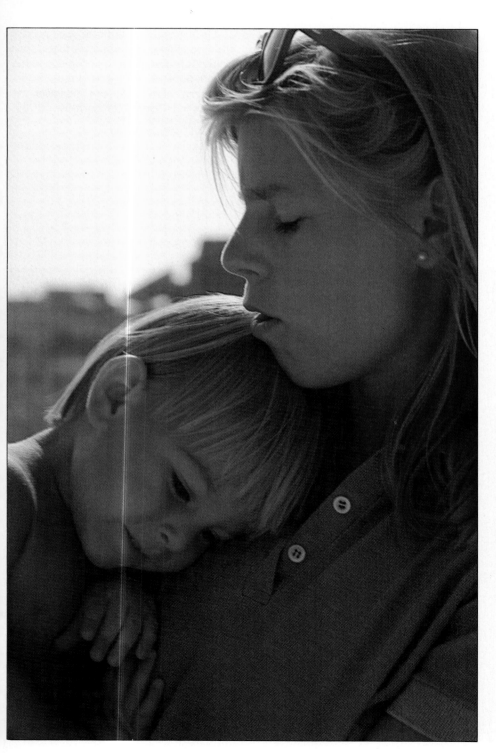

I found this mother and child sitting on a beach, almost exactly as depicted here. All I had to do was ask the mother's permission to photograph them, adopt the right camera angle to get the composition and backlighting I wanted, and shoot. You don't have to feel obliged to always move and rearrange things before shooting. If you see a perfect picture just the way it is, leave it that way.

The low sun backlit the subjects with a golden, warm glow. To enhance this warmth in the faces, I used a gold foil reflector near the camera position. This also enhanced the already golden color of the blond hair of both subjects.

I based exposure on a close-up reading of the faces, with the gold reflector in place.

When everything was set, all I had to do was wait for the right expressions and push the shutter button at the right moment. I believe I captured a moment of great tenderness. Notice the child's contentment in the safety of mother's arms and the mother's downward glance in obvious concern for the child.

A half second earlier or later, the expressions were quite different—and so would the effect of a resultant photo have been. When shooting children, you must work fast. You rarely get a second chance!□

Purpose: For stock files
Location: My studio, New York City
Camera: Nikon FM 2
Lens: 85mm *f*-2 Auto-Nikkor
Lighting: One electronic flash unit in softbox; two electronic flash units in white umbrellas
Film: Kodachrome 64
Exposure: *f*-11 (shutter at 1/125 second)

How can you get the softness of window light and also exposure times short enough to stop rapid movement? Use electronic flash in a softbox! The large, diffuse illuminating surface of the softbox simulates the light coming from a window of the same size. And the short duration of the flash ensures sharp images, even if your subject is as lively as this little girl in a hat.

I choose my models carefully to suit the types of photos I plan to take. For these "dressing up" shots, I needed a lively, expressive child. I had worked with this four-year-old before and had enjoyed her bubbly personality.

Children love dressing up. They get even more of a kick out of the experience when they can admire themselves in a mirror. You can place a large mirror behind the camera so the child can see herself as she poses. Or, the child can have a hand mirror which forms part of the photographic image.

Throughout the shooting session, this little girl was so animated that I just couldn't limit myself to one image of her in this book. From the two pictures reproduced here, you can imagine the wide range of her repertoire of expressions.□

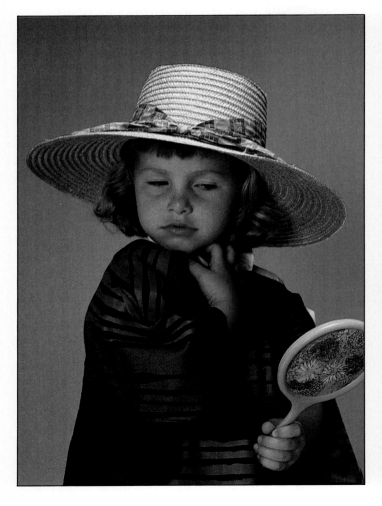

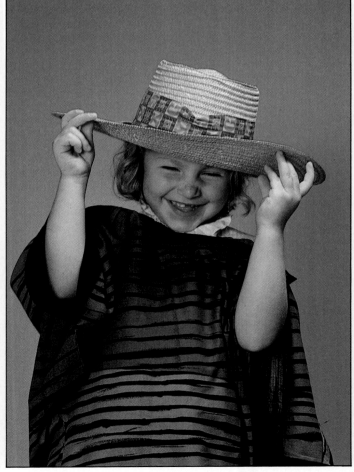

Purpose: An editorial assignment
Location: Yard of subject's home, Long Island, NY
Camera: Nikon F
Lens: 85mm *f*-2 Auto-Nikkor
Lighting: Open shade on sunny day
Light Control: Gold-foil reflector
Film: Kodachrome 64
Exposure: 1/60 second at *f*-5.6

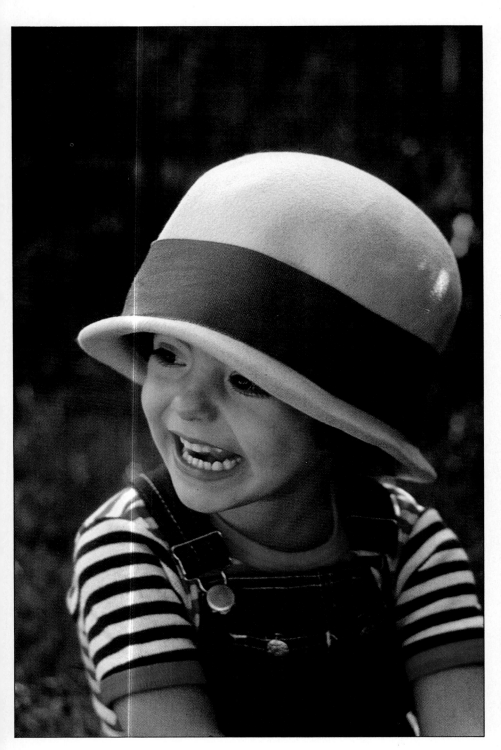

I had been photographing this little girl and her family for several hours to illustrate a feature on siblings. I had made shots dealing with rivalry, friendship and a variety of other situations that typically confront brothers and sisters. Serious business!

Finally, we took a break and all went outdoors to relax under the trees. Suddenly, the four-year-old depicted here appeared in a huge hat. We all loved it and, with our encouragement, she continued to show off. I grabbed my camera and shot away as fast as I could.

Because we had been shooting most of the day, all self-consciousness before the camera had disappeared. We were all at ease with each other and having a lot of fun. The atmosphere was ideal for candid shooting.

After a little while, we encouraged the girl to go indoors and find another hat. She disappeared, soon returned, and paraded her latest model. After this, she made one more change. Each time she appeared, I shot away.

To get soft lighting, I encouraged the girl to go in the shaded area under some trees. In direct sunlight, I would have had to contend with deep shadows under the brims of the hats.

For the picture reproduced here, I had time to place a gold-foil reflector in front of the child. This added more light to the eyes. It also helped to warm up the scene, which had a slight green cast, typical of shaded areas under a mass of foliage.

This image reminds me a little of the picture on page 3, of the little girl under the hair dryer. I find it humorous for basically the same reasons.☐

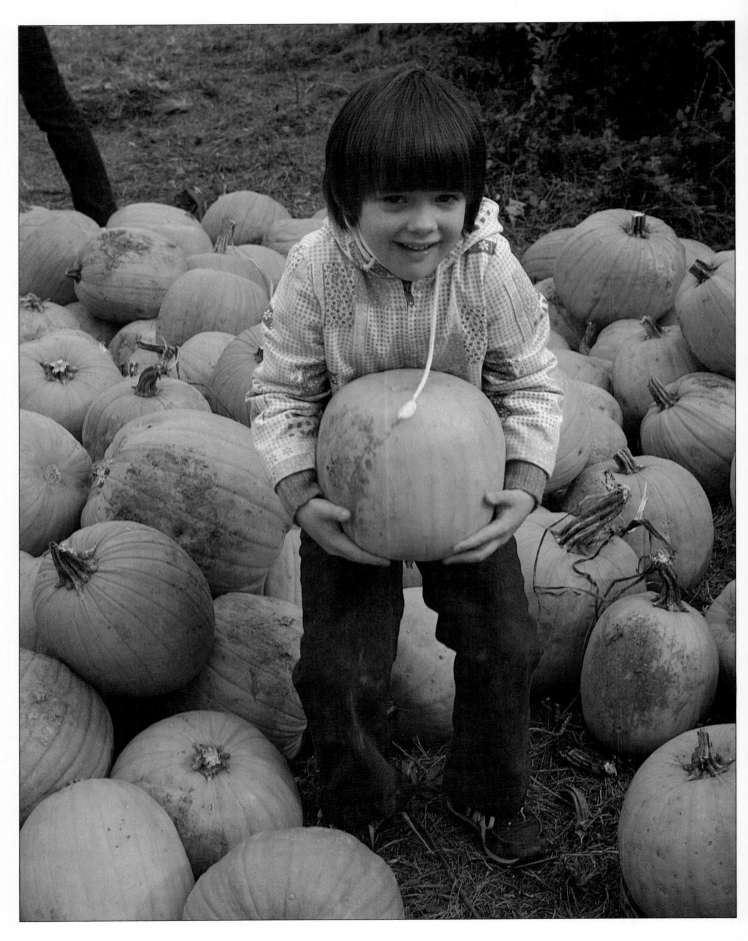

Portfolio **24**

Purpose: For stock files
Location: Upstate New York
Camera: Nikon FM
Lens: 50mm *f*-1.4 Auto-Nikkor
Lighting: Diffused sunlight, overcast sky
Film: Kodachrome 64
Exposure: 1/60 second at *f*-8

This is an interesting composition of circles. The focal point of the image is the pumpkin held by the little girl. Above this is the circle of the child's head and below the dark circle of ground on which she is standing. Behind the main subject there is a background of circles in the form of more pumpkins. The child's head attracts attention because it is graphically divided almost exactly in half by the line of the dark hair.

This was one of the rare occasions when it's effective to place the key component of the image in the center of the frame. The central placement of the girl—and specifically the pumpkin she's holding—gives the image visual balance. A photographer must know instinctively, or learn by experience, when to break the normal "rules" of composition.

The sky was overcast on this fall day and the light was soft. There was just enough direction in the lighting to give subtle modeling to the pumpkins. Direct sunlight would have caused excessively harsh shadows.

By aiming the camera downward, I avoided including the dull, gray sky in the picture. The orange color of the pumpkins helped to give the image a warm glow.□

This was one of the rare occasions when it's effective to place the key component of the image in the center of the frame. A photographer must know instinctively, or learn by experience, when to break the normal rules of composition.

Purpose: Magazine feature on twins
Location: Subjects' home, Long Island, NY
Camera: Nikon F
Lens: 85mm *f*-2 Auto-Nikkor
Lighting: Hazy midafternoon sunlight
Film: Kodachrome 64
Exposure: 1/60 second at *f*-8

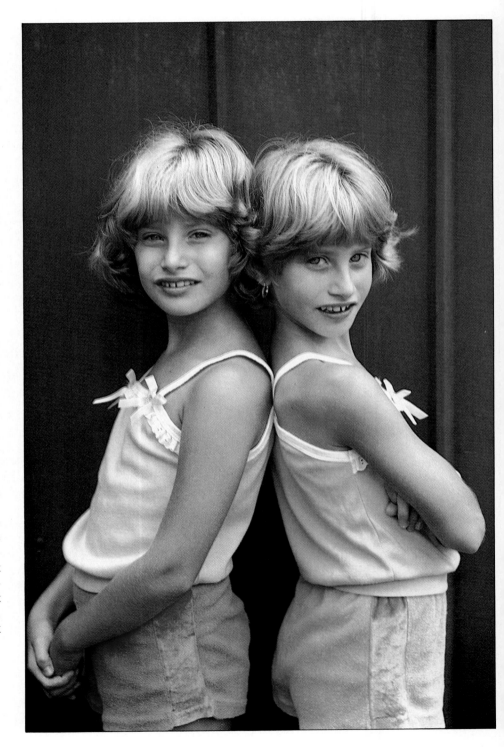

Everyone is fascinated by twins and loves pictures of them. From my own experience, I'm convinced that there will always be a demand for photos of look-alike, dressed-alike twins. Such images have strong graphic as well as emotional impact.

I keep an active file on twins and add to it whenever I can. I approach mothers of twins in parking lots. I inquire about twins at schools and ask my friends to keep their eyes open for photogenic twins.

I have been photographing these two girls since they were babies. In almost every case, it's been in response to specific requests and assignments on the subject of twins.

At the time I made the photo reproduced here, the girls were 10 years old. I followed them with my camera as they engaged in various activities, including playing, cooking and jumping rope. However, the shot I liked best was this simple double portrait. I had the girls wear playsuits that were identical in style but subtly different in their pastel colorings. This told graphically that, although the twins may look alike, each has her own distinct personality.

I chose a plain, dark background to offset my high-key subjects. A haze obscured the midafternoon sun and diffused the light. Such overall, soft illumination is best for high-key photographs. Exposure was 1/60 second at *f*-8—just right to give me a cheerful, bright image against a suitably dark background.□

Purpose: Personal photo
Location: Street in New York City
Camera: Minolta Freedom II Autofocus
Lens: 35mm *f*-3.5
Lighting: Light from overcast sky
Film: Kodachrome 64
Exposure: Programmed (unrecorded)

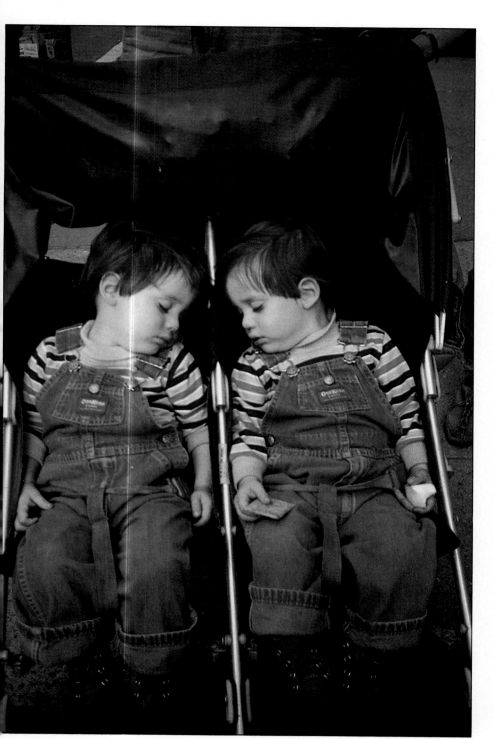

I use Nikon SLR cameras for most of my professional work. However, throughout this book I make it clear that you can also take exciting photographs of children with simple point-and-shoot cameras. Here's a good example. The subject matter—a pair of identically dressed twins taking a nap—"makes" the picture. The technical requirements are well within the scope of an automatic fixed-lens camera.

The camera automatically focused on the subject and set the exposure. The camera's center-weighted meter provided a good exposure even though the upper subject area was dark.

When using easy-to-use cameras of this type, be sure to work within the limitations of the camera. For example, the Minolta camera used for this picture has a 35mm fixed lens. Don't use it for frame-filling head shots.

With an autofocus camera, be sure the camera focuses on the most important image part and not some obstruction that is in the way. For example, if you aim such a camera at a lion behind bars in the zoo, the camera will focus at the closest thing it "sees"—the bars.

Be sure that nothing is included in the image area—and the meter's reading angle—that could lead to a poor exposure. With a large area of bright sky in the picture, even a center-weighted meter can be "fooled" to give underexposure of the main subject.

Automatic point-and-shoot cameras are very popular and can take wonderful pictures easily. However, for the creative photographer even these cameras cannot replace care and thoughtfulness. For example, I had to make the decision to make the exposure when I noticed that the twins' heads had rolled toward each other. The resulting "mirror image" helped emphasize the similarity of the twins.□

Purpose: Assignment on "Teen Love" for textbook publisher
Location: Park on Long Island, NY
Camera: Nikon FM
Lens: 85mm *f*-2 Auto-Nikkor
Lighting: Early-afternoon sunlight
Film: Kodachrome 64
Exposure: 1/60 second at *f*-11

How young does one have to be, to be a child? One of the dictionary definitions of child is simply "a son or daughter." That includes all of us! The popular expression, "children of all ages" is usually intended to include everyone up to the nineties. I certainly regard teenagers as children—and very special children.

Teenagers are faced with many of the responsibilities and pressures of life without having yet all the tools to deal with them. As a photographer, I find it challenging to try recording their sensitivities and vulnerability.

A textbook publisher had assigned me the production of a series of photos on the subject of "teen love." My aim was to produce uncontrived pictures that conveyed the experience in a straightforward manner. I didn't need a star filter, soft-focus lens or orange filter to provide the atmosphere. A young couple, holding hands and gazing into each other's eyes, was all I needed.

Normally, I try to avoid photographing people in sunlight during the middle of the day. The high sun can cause unflattering shadows under eye sockets and under nose and chin. However, having selected this particular couple for the photos, I had to shoot them at a time that fit in with their school and social commitments. We shot about lunch time.

A lake in a nearby park proved an ideal setting. I posed the couple in such a way that a flock of sea gulls occupied an expanse of water in the background.

If this couple had been at all self-conscious, I would have had them hold hands and look out over the lake. That way, I would have avoided showing their faces. Fortunately, I was able to ask them to look in each other's eyes.

To make a general statement about teen love rather than a specific statement about this couple, I avoided drawing attention to the faces. I did this by having the girl's face in shadow and the boy's head turned slightly away from the camera.□

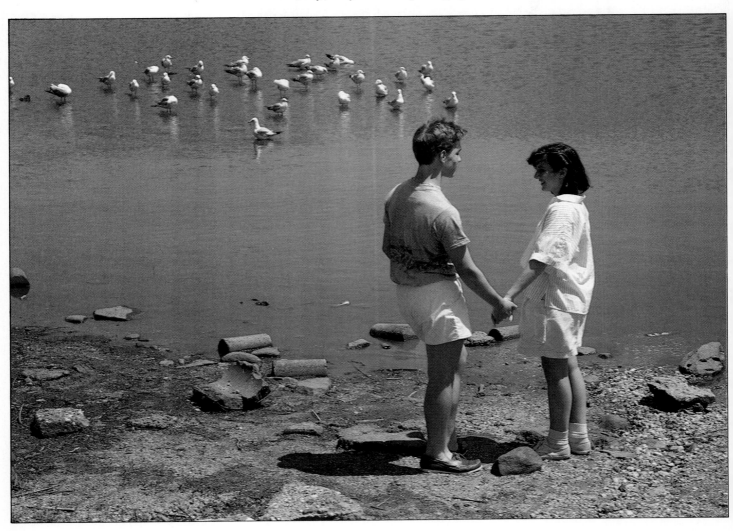

If you want to record a backlit subject with detail, you need to use fill flash or reflectors. Several photos in this portfolio were made using this technique. Sometimes, however, you deliberately want to record your subjects in silhouette, without any tonal detail. Such was the case with the photo reproduced here.

I shot directly into the sun, giving the exposure indicated by my camera's built-in meter. I knew that this would result in a reasonably good rendition of the sky and black outlines of the children. To be sure of getting the exact sky effect I wanted, I bracketed exposures liberally. The best result had an exposure of 1/125 second at *f*-8.

Because silhouettes provide no tonal information, you should only shoot silhouettes of subjects that are readily recognized by their outlines. This means that some subjects do not lend themselves to this treatment at all while others must be shot in suitable positions and from specific angles. For example, the children in this photo are easily recognizable as children. You can see their arms, legs and heads. In different poses, and from other angles, they may have appeared as meaningless black masses.

Kite-flying is a particularly suitable subject to record in silhouette. You can create beautiful visual contrast by having black figures fly a colorful, transilluminated kite, as in this image.

When the sun is low in the sky, the direction and quality of the light change rapidly. To make the best possible photos, you must be alert and observant and shoot at the right moment. For example, the beautiful highlights on the rocks in this picture existed for only a short time.

One more thing: For kite flying you need a good wind. I knew that I would find it on this Connecticut coastline—and I wasn't disappointed!☐

Purpose: For stock files
Location: Seashore, Connecticut
Camera: Nikon FM
Lens: 85mm *f*-2 Auto-Nikkor
Lighting: Late-afternoon daylight
Film: Kodachrome 64
Exposure: 1/125 second at *f*-8

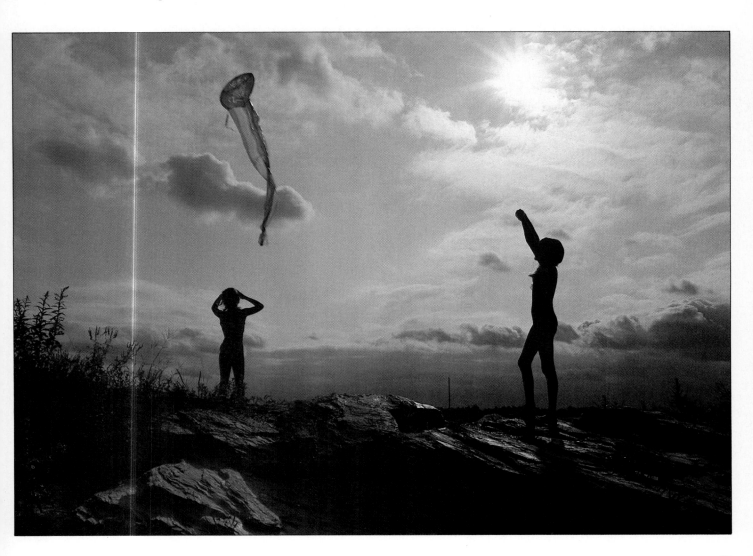

Purpose: For stock files
Location: My studio, New York City
Camera: Nikon F
Lens: 85mm *f*-2 Auto-Nikkor
Lighting: Two electronic flash units
Film: Kodachrome 64
Exposure: *f*-5.6 (shutter at 1/125 second)

Good photography often involves the art of judicious elimination. I wanted to say certain things with the image reproduced here. I wanted to show the relationship between mother and child. That relationship is seen, not only in the faces, but also in the hands. I wanted to dramatize the difference between the profile of an adult and that of an infant.

To show those aspects of this mother and child, all I needed to show was each face in profile and the united hands. As you can see, I didn't even consider it necessary to include the entire heads.

To enhance the warm skin tones, I used a contrasting, blue background. The lighting on the background was balanced to give a tone considerably darker than that of the faces. To get shadow-free illumination on both faces, the main-light flash was reflected from a large white sheet near the camera position.

When you photograph two people facing each other, there's an understandable temptation to leave a large empty space between them. Resist that temptation. It may not seem natural to put two faces that close together, but it usually looks fine in a photograph. It certainly looks better than a vast empty space between two people. Notice that, in this photo, not only did I bring the faces close together, but I also posed the hands in such a way that they filled much of the remaining space. □

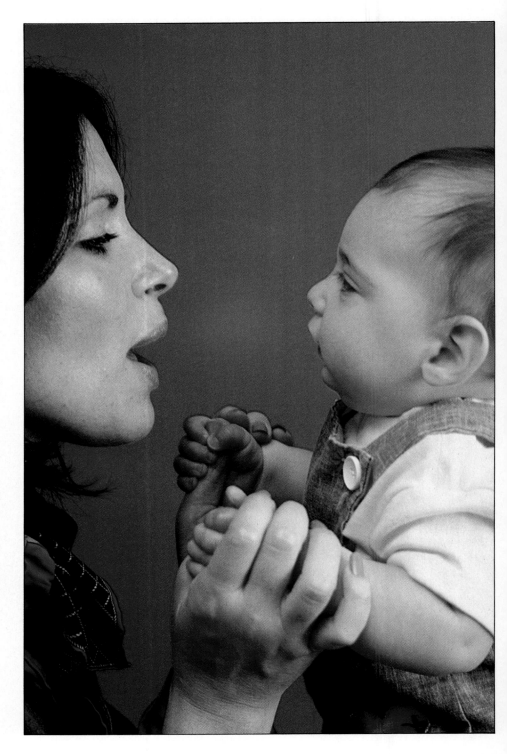

Purpose: For editorial use
Location: Subject's home in Connecticut
Camera: Nikon FM2
Lens: 85mm *f*-2 Auto-Nikkor
Lighting: Two 200-watt-second electronic flash units
Film: Kodachrome 64
Exposure: *f*-8 (shutter at 1/125 second)

I wanted a cheerful, warm setting for photographing this baby in her home. Fortunately, the red color of the carpet in baby's room was ideal. The baby's pink outfit complemented the carpet beautifully and maintained the warm atmosphere of the scene.

I asked the mother to keep baby amused by holding a clown puppet over her. To show what is holding the baby's attention, I included part of the hovering puppet in the picture. The puppet's bright, yellow yarn hair adds another warm color to the scene.

I was very happy with this picture because it conveys so beautifully the cozy atmosphere of the home and the baby's obvious comfort and happiness.

For soft, shadow-free illumination, I bounced the light of a 200-watt-second flash from the white ceiling. The light from a second 200-watt-second flash was bounced from a wall.

When using color film, you should bounce light only from white surfaces. Light reflected from a colored surface will impart that color to the subject, sometimes with highly undesirable results. When I want to soften the illumination in a room with colored walls and ceiling, I use umbrellas or white reflector cards from which to bounce the light.□

Purpose: Private portrait assignment
Location: Subject's home,
Danbury, CT
Camera: Nikon FM2
Lens: 85mm *f*-2 Auto-Nikkor
Lighting: Soft window light
Light Control: Silver-foil reflector
Film: Ektachrome 200
Exposure: 1/15 second at *f*-8

For detailed head shots, I like to use natural light whenever possible. Perhaps the most flattering natural light is diffused daylight through a window. I like it so much that I am sometimes tempted to cheat and simulate it indoors with a large softbox!

For this photo, the window—a *real* window—was about 45° to the right of the lens axis. This gave a sufficiently directional side light to provide fine modeling to the face. However, the window was large enough to give a beautifully soft gradation to the shadows.

To further lighten the deepest shadows and to add highlighting to most of the hair, I used a silver-foil reflector near the camera position. It also helped to add a sparkle to the blue jacket.

Exposure was 1/15 second at *f*-8, so it was necessary to have my camera mounted on a tripod. The boy's head was resting on his hand and this made it easy for him to remain still for the relatively long exposure.

Esthetically, I consider this a good portrait for several reasons. The color scheme is wonderful. Just look at the matching blue of the jacket and the eyes and the color uniformity between sandy hair and freckles. Also, the blue and golden key colors of this image complement each other perfectly.

The diagonal pose of the head is attractive. The head is graphically contained in the frame by the piece of blue collar on the right and the boy's hand on the left. Notice that everything is approximately in one plane so that distortion is avoided. If the boy's hand were outstretched toward the camera, there would be an ugly size distortion between head and hand.

A final word of advice: No close-up head shots will be a success, no matter how excellent the photographic technique, if the subject isn't interesting. Don't shoot from an uncompromisingly close viewpoint unless a child is beautiful, mischievous, full of character or appealing in a variety of other ways. The boy in this picture certainly "had what it took"!☐

The color scheme in this portrait is wonderful. Just look at the matching blue of the jacket and the eyes, and the color uniformity between sandy hair and freckles. The blue and golden key colors of the image complement each other perfectly.

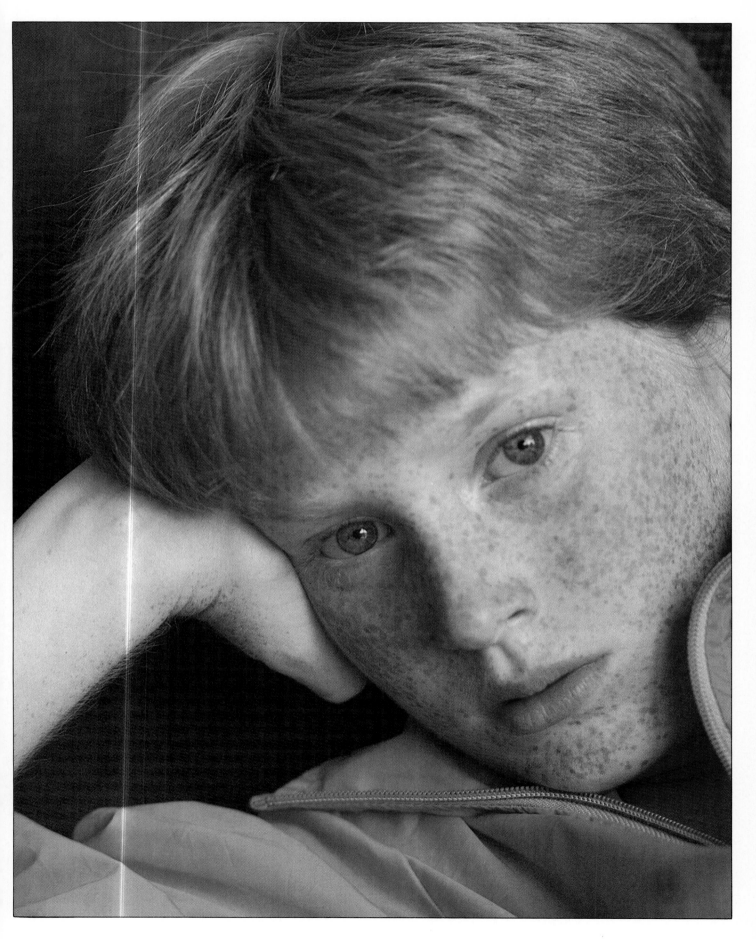

Purpose: Picture story about siblings
Location: Subjects' home in New York City and a Long Island boardwalk
Camera: Nikon F
Lens: Below and top, right—85mm *f*-2 Auto-Nikkor; Bottom, right—50mm *f*-1.4 Auto-Nikkor
Lighting: Below and top, right—One electronic flash bounced off ceiling; Bottom, right—Daylight from overcast sky
Film: Kodak Tri-X Pan, developed in Kodak D-76
Exposure: Below and top, right—*f*-8 (shutter at 1/60 second); Bottom, right—1/125 second at *f*-11

The photos on these two pages are part of a picture story I shot about siblings. Specifically, the story was about a child's adaptation to a new arrival in the family. I shot the series over several months, starting when the mother was still expecting the new arrival.

In the photo on this page, the older child is pondering the effect on her of a new little brother in the house. In the picture below, right, the mother is reassuring her daughter by treating her as an equal. They share similar responsibilities—one for a baby and the other for a doll.

When the upper, right picture was taken, the little girl had begun to accept her little brother without misgivings or jealousy. In fact, she had started to enjoy his presence.

I took the indoor photos with a camera-mounted flash that was aimed at the ceiling. This bounce light gave pleasant, uniform illumination. High-speed Tri-X film enabled me to use an aperture of *f*-8—small enough for adequate depth of field.

Here's a simple way to calculate bounce-flash exposure without a meter: Estimate the distance the flash beam travels from the flash unit to the white ceiling and then on to the subject. Divide the flash guide number by that distance to get an *f*-number. To allow for light absorption and diffusion by the ceiling, set the lens to two *f*-stops wider open.

Because room size, wall tone and ceiling texture all affect exposure, it's wise to bracket exposures when working in rooms that are unfamiliar to you.

Exposure for the outdoor photo was 1/125 second at *f*-11. The shutter speed was fast enough to stop the motion of the walking subjects and depth of field was adequate to get most of the boardwalk reasonably sharp.□

Purpose: For stock files
Location: Central Park, New York City
Camera: Nikon FM
Lens: 50mm *f*-1.4 Auto-Nikkor
Lighting: Late-afternoon sunlight
Film: Kodachrome 64
Exposure: 1/125 second at *f*-8

A general reading of the scene would cause underexposure on the subject. If you want to record the snow itself, with its typical brilliance, take a meter reading of the snow and increase the indicated exposure by about 1-1/2 exposure steps. If you don't, the snow will record as a dull, medium gray.☐

How do you photograph non-visual qualities such as wind, tiredness, boredom, heat—or cold? You can't depict them directly, so you have to allude to them in your images. This photo is an excellent example.

I did everything possible to convey the sensation of extreme cold to the viewer of this picture. I chose a snowy scene with bare trees in the background. I shot when the sun was low and shadows were long—a typical winter phenomenon.

Out of necessity, as well as for the effectiveness of the picture, the child was wrapped in heavy overcoat, scarf and woolen hat with ear flaps. The rosy glow in the child's cheeks and on her nose emphasized the coldness of the air. So did her expression, which was quite natural and needed no encouragement from me! A few bits of snow on the scarf added a final touch.

When I shoot small children outdoors on cold winter days, I keep the sessions short. Therefore, I need not take any special precautions with my equipment.

If I were assigned to accompany a group of teenagers on a cross-country trek at sub-zero temperatures, I would make sure to keep my camera, meter and any accessory with batteries as warm as possible while I wasn't using them. Batteries lose their efficiency at low temperatures, although they regain their effectiveness again on warming up.

Camera shutters can also become sluggish after extended exposure to extreme cold, so that their effective speeds slow down. However, my cameras have never been subjected to conditions that brought on such effects.

Here are a couple of useful tips on exposure in snow: To expose a person correctly in front of a large snow scene, take a close-up meter reading of the face.

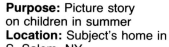

Purpose: Picture story
on children in summer
Location: Subject's home in
S. Salem, NY
Camera: Nikon FM2
Lens: 85mm *f*-2 Auto-Nikkor
Lighting: Late-afternoon sunlight
Film: Kodachrome 64
Exposure: 1/125 second at *f*-4

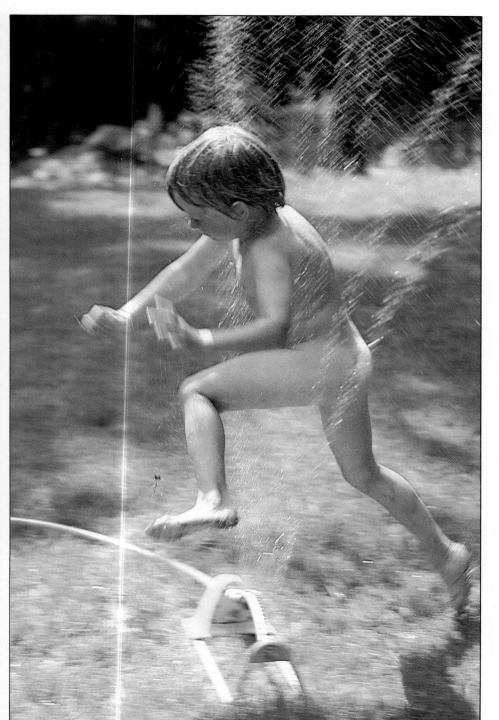

The late-afternoon sun was low in the sky. This was ideal because it enabled me to use backlight—on the boy for dramatic rim lighting and on the spraying water for optimum visual clarity. Normally, the time of day would have been disadvantageous because it forced me to shoot in dim light. However, in this case the exposure indicated by the camera's meter—1/125 second at *f*-4—was just what I wanted.

The relatively slow shutter speed enabled me to record just a little motion blur in the child's image. It also prevented "freezing" the motion of the water. I wanted the water to appear as a continuous spray rather than individual globules suspended in the air. Ideally, a shutter speed of 1/30 second would have been even better for the water. However, it would have been too slow for the boy, causing excessive image blur. As is the case so often in photography, a compromise was called for.

The back light could have easily fooled the meter in my camera, giving me a wrong exposure. To ensure correct exposure for the boy's skin tone, I made a close-up reading of the boy while he was stationary and based my exposure on that reading. Of course, such a close-up reading must be made in the same light as when you shoot. In this case, the reading had to be made with back light.

It was a beautiful summer's day and, although late in the afternoon, still hot enough for the little boy to delight in running through the sprinkler repeatedly.☐

Purpose: For stock files
Location: Subject's home, Pennsylvania
Camera: Nikon FM
Lens: 35mm *f*-2 Auto-Nikkor
Lighting: Window light
Light Control: Large, white reflector
Film: Ektachrome 400
Exposure: 1/15 second at *f*-8

I had spent several hours photographing this seven-year-old for a magazine assignment. As I became aware of the would-be ballerina's large collection of antique costumes and admired the family's meticulously kept Victorian living room, I wanted to create some pictures for my own stock files.

What I envisioned was an old-fashioned girl in an old-fashioned setting. The girl and her mother were most cooperative. I was especially impressed by the young girl's staying power.

After a lengthy and strenuous shooting session, she still behaved like the perfect professional. She put on the dress, shoes and hat I had selected. Her mother prepared her hair. I posed her in a beautiful, old wicker chair and gave her an old book to hold. She sat still until I had everything set up—and then even held perfectly still for a 1/15-second exposure. I didn't trust the steadiness of my hand that much, so mounted my camera on a tripod.

A beautifully soft, yet directional light came through the window on the right side. Exposure was based on the high-key tones of the girl. The dark wallpaper of the room provided a contrasting background. To lighten the shaded side of the girl and throw much-needed light onto her legs, shoes and the draped part of the tablecloth, I used a large, white sheet as a reflector. I mounted it on two light stands and placed it on the left side of the camera.

To avoid a large, distracting bright area in the picture, I excluded the window from the image. However, the character of the lighting clearly indicates the window's presence just to the right side of the table.

I switched on the light hanging over the table. The glowing, golden tassles of the shade add an important element to this old-fashioned scene.

Because the scene was very contrasty, I took meter readings from the brightest and darkest parts in which I wanted to record detail. The readings assured me that the brightness range was not excessive for the Ektachrome film I was using.☐

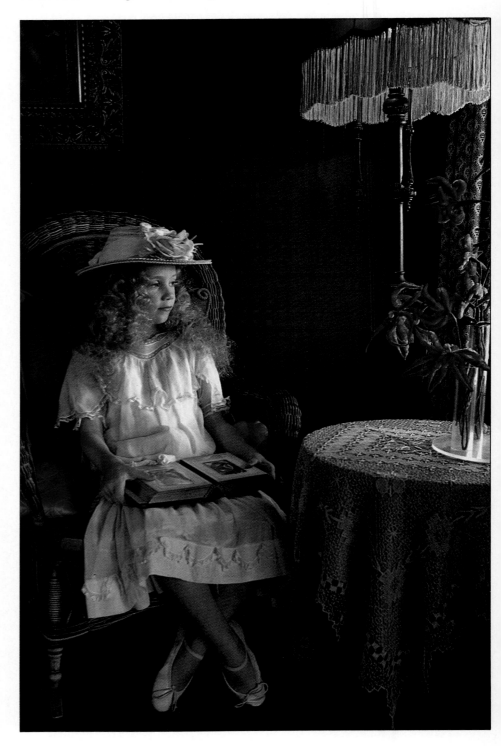

In photography, you can be creative in many different ways. The more familiar you are with your tools, the more creative scope you'll have. Your tools include not only camera, lenses, filters and lights, but also films. This photo is a good example of a film selected deliberately to achieve a specific effect.

As you look through the technical data accompanying the photos in this portfolio, you'll notice that I love to use Kodachrome film. It gives sharp images and good color rendition—consistently. However, I would be foolish to remain familiar only with the one film of my preference. When I get the opportunity, I experiment with other color films.

One of the characteristics I have found, and admire, in Fujichrome 100 film is its tendency to favor yellows. For this photo of a dreaming girl, I wanted just the kind of golden-warm effect this film could give me.

If, instead of using this film, I had used a gold-foil reflector, it would have affected the shadow areas, nearest the camera, more than the highlight areas. Had I used a warming filter, it may have added unwanted color to the white dress. These are all subtle differences, but sometimes they are important when you know exactly what you want to see in the finished image.

I did use a silver-foil reflector near the camera position to brighten the shadows. To further soften the effect of the image, I used a weak diffusion filter on the camera lens.□

Portfolio **36**

Purpose: For stock files
Location: Subject's home, Milford, CT
Camera: Nikon FM
Lens: 135mm *f*-2.8 Auto-Nikkor
Lighting: Light from one window
Light Control: Silver-foil reflector
Film: Fujichrome 100
Filtration: Weak diffusion filter
Exposure: 1/30 second at *f*-5.6

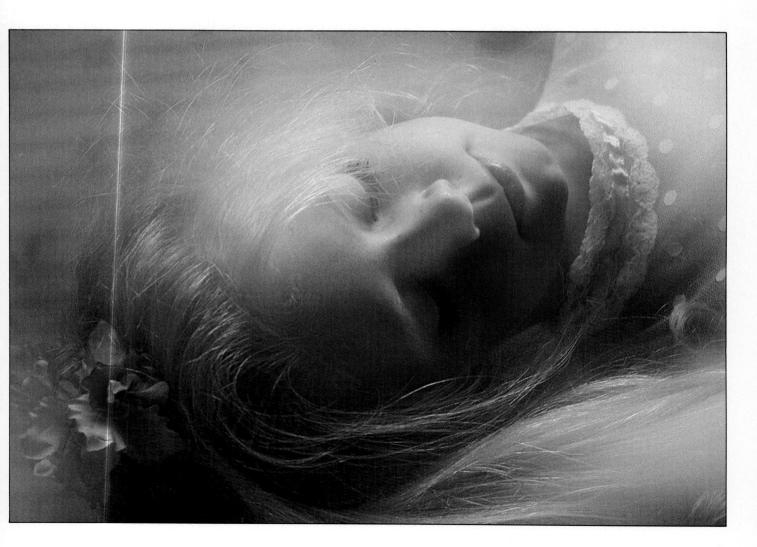

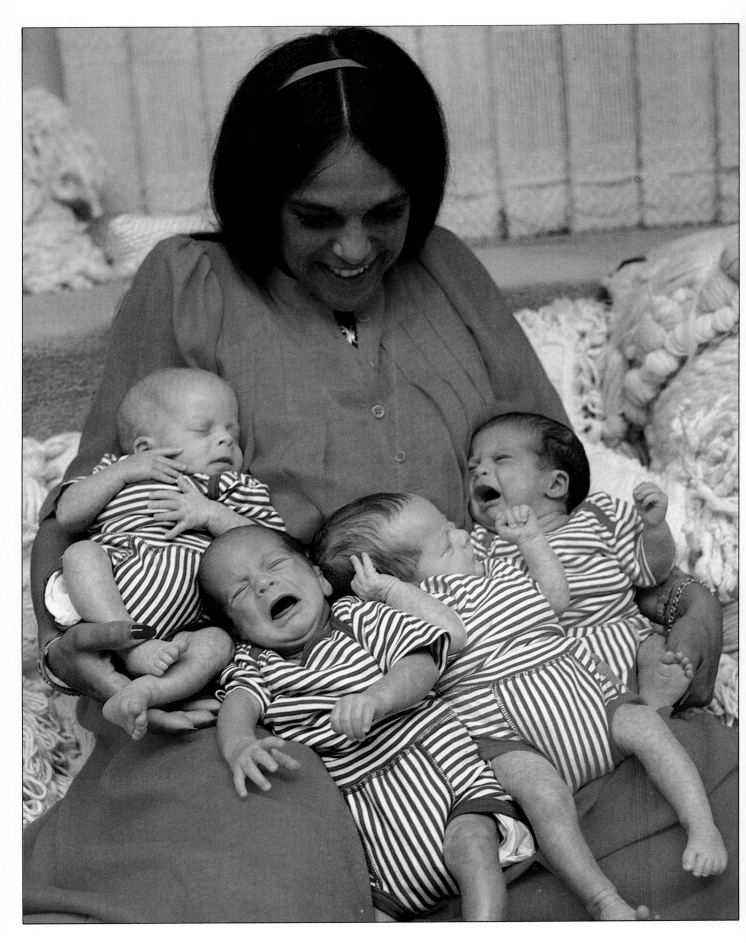

Purpose: Cover for Baby Talk magazine
Location: Subjects' home, New Jersey
Camera: Nikon FM
Lens: 85mm *f*-2 Auto-Nikkor
Lighting: Two portable flash units on stands
Light Control: Flash bounced off white ceiling
Film: Kodachrome 64
Exposure: *f*-4 (shutter at 1/125 second)

This is a clear case of a photo whose impact comes mainly from the subject matter. With one of the other photos in this portfolio, I indicate that twins are sure to make eye-catching pictures. Well, here we have quads!

When I first thought of making this shot, my planning ahead went to the extreme: Even before the babies were born, I had determined to have this session! Having learned from a friend that this mother was expecting quadruplets, I immediately suggested an assignment to a baby magazine. This cover shot was only one of several pictures I shot for the feature.

To give me maximum mobility when working in the family's home, I used two lightweight, battery-powered flash units. For overall, soft illumination, I bounced both flashes off the white ceiling. My flash meter indicated an aperture of *f*-4, which was just right to put the background out of focus and make it less distracting.

I wanted to graphically unite the mother with her offspring. I asked mother to spread out her dress and then placed all the babies in front of her. Notice how the red triangle formed by the dress contains all the babies and draws viewer attention upward to the mother's face. The babies were in striped suits, which separated them visually from the solid-red dress.□

Notice how the red triangle formed by the dress contains all the babies and draws viewer attention upward to the mother's face.

Purpose: Picture series of young actress and dancer
Location: Subject's home, Pennsylvania
Camera: Nikon FM
Lens: 50mm *f*-1.4 Auto-Nikkor
Lighting: One 200-watt-second electronic flash in white umbrella
Film: Kodachrome 64
Exposure: *f*-8 (shutter at 1/60 second)

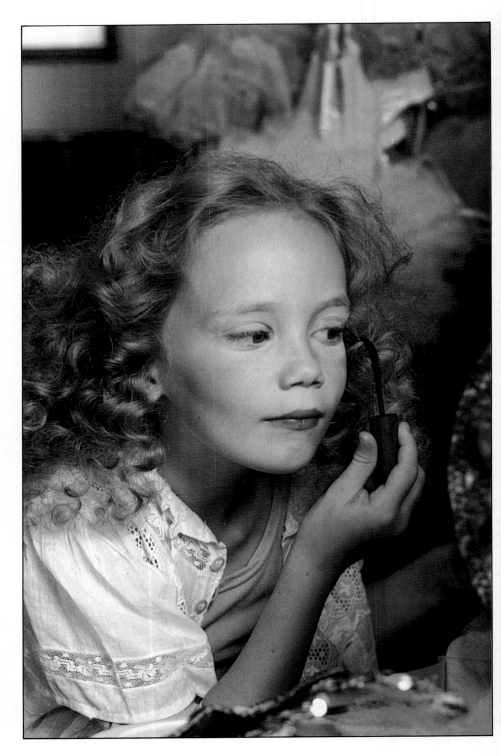

One of the more unusual photo sessions I've had was with this little actress and dancer. It's hard to believe that, at the time I made this shot, she was only seven years old.

I met her and her mother at a ballet class, and she was such a stand-out that the idea for a picture series immediately suggested itself to me. I packed up my equipment and drove to Pennsylvania, as I sensed it would be best to photograph her in her own environment.

The journey was well worthwhile. The basement of the child's home had been turned into a practice studio and contained all the necessities for a budding young performer, including parallel bars and a makeup table laden with cosmetics.

The place was filled with props. There were old-fashioned hats, ballet dresses, slippers and antique gowns. I had some ideas on how I wanted to do the picture series but didn't want to make specific preparations until I had explored the setting.

As it turned out, I didn't need to do much more than follow the child as she showed me around her house. In addition to her other talents, she was a natural model.

As main light, I used one 200-watt-second Dynalite in a white umbrella at five feet from the subject. I exposed Kodachrome 64 film at *f*-8. The ambient light in the dressing area was soft and warm. With the shutter at 1/60 second, the film registered that ambient light in the background.

The *f*-8 aperture slightly softened focus on the ballet dress hanging behind the subject, giving it a misty, clouded quality. □

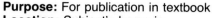

Purpose: For publication in textbook
Location: Subject's home in
New York City
Camera: Nikon FM
Lens: 50mm *f*-1.4 Auto-Nikkor
Lighting: One 60-watt
tungsten table lamp
Film: Ektachrome 160 (Tungsten)
Exposure: 1/15 second at *f*-4

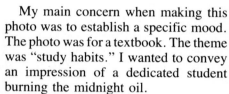

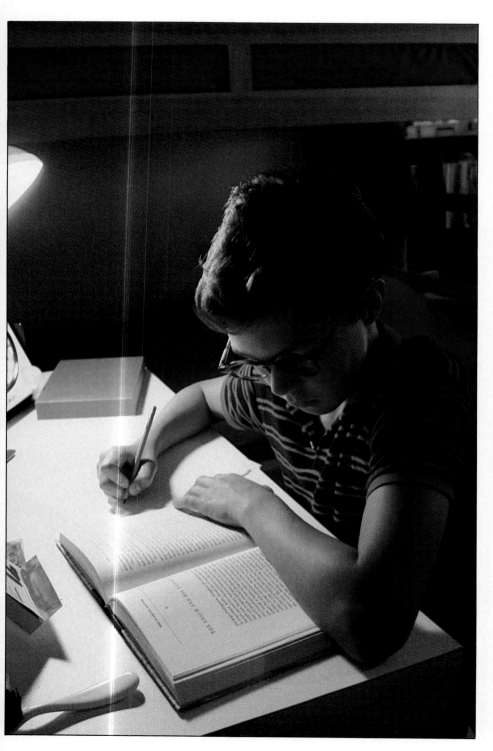

My main concern when making this photo was to establish a specific mood. The photo was for a textbook. The theme was "study habits." I wanted to convey an impression of a dedicated student burning the midnight oil.

I had selected this young model from my files because his head shots showed intellectual characteristics. I find it useful to not only collect images of photogenic children, but to also keep a file on assorted "types."

To create an overall dark and low-key picture, I used the tungsten lamp on the desk as the only illumination. I used a color film balanced for tungsten photo lamps. Normally, I should have used a bluish light-balancing filter because the light from a 60-watt bulb is more reddish than that from a photo lamp. However, I wanted to retain some of the reddish glow to enhance the late-night, indoor atmosphere.

Because of the dim light provided by the 60-watt bulb, I put the camera on a tripod and used a cable release. This permitted me to give relatively long exposure times without fear of camera movement.

I based exposure on spot-meter readings from the shaded side of the subject's face and the book pages. A compromise exposure of 1/15 second at *f*-4 recorded detail throughout the brightness range of the scene. The white desk top acted as a useful reflector, directing much-needed light into the shadows. To ensure the exact effect I wanted, I bracketed exposure from 1/4 second to 1/30 second.

I asked the subject to stay quite still during the exposures—something I wouldn't try with a younger child.□

Portfolio **40**

Purpose: For stock files
Location: Beach on Long Island, NY
Camera: Nikon FM
Lens: 50mm *f*-1.4 Auto-Nikkor
Lighting: Late-afternoon sunlight
Film: Kodachrome 64
Filtration: 85B warming filter
Exposure: 1/125 second at *f*-8

This picture is a good example of tight cropping for visual impact. I cut out the horizon and excessive foreground area, concentrating only on the subjects. The immediate surroundings that remained—beach and foamy surf—told the entire story.

Some photographers like to pre-visualize a composition by viewing the scene through a cardboard frame, a rectangular opening formed by their hands or an empty 35mm slide mount. I like to do it through the camera viewfinder, consciously eliminating everything I don't feel contributes to the impact of the image.

In this photo, I wanted to emphasize the look-alike aspect of my two subjects as they enjoyed the same experience. I photographed them next to each other, their legs running parallel and their toes outstretched toward the incoming surf. The identical facial expressions further emphasized the sharing of an exciting experience.

The low afternoon sunlight gave a flattering light and a warm glow to the skin tones. I warmed up the image further by using an 85B warming filter on the camera lens.

With the sun behind me, there was no specular reflection from the damp beach toward the camera. Because of this, and because there was no sky within the camera's angle of view, I gave the exposure indicated by the in-camera meter. The little underexposure that I expected from this reading—because of the brightness of the beach—was desirable because it enhanced the saturation of the colors.□

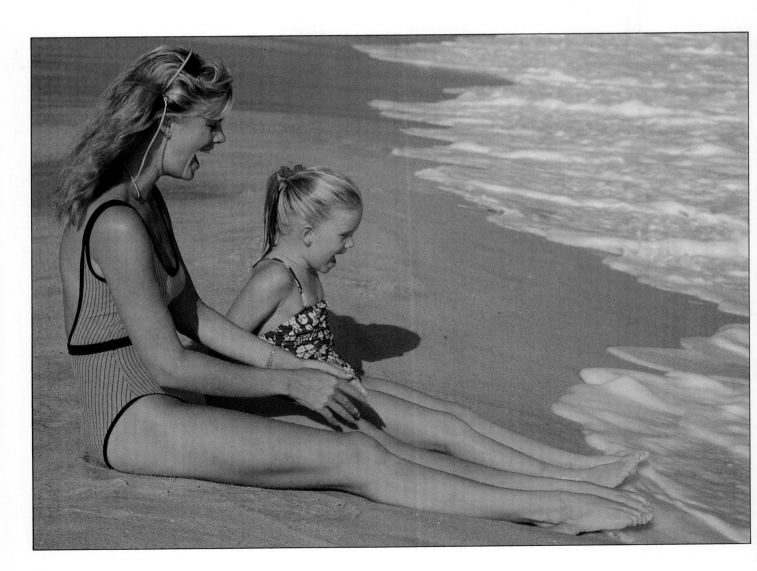

As you can see from many of the photos in this portfolio, I like to use back lighting outdoors. However, sometimes frontal sunlight is advantageous. The image reproduced here is a typical example.

I wanted to convey the radiance of the sunlight and give the viewer of the picture a feeling of warmth. I realized that, to use direct sunlight, I would have to shoot early or late in the day, when the sun was low.

This photo was made in the late afternoon and, as you can see, the lighting is flattering to each of the faces. Had I shot at noon, there would have been long and ugly shadows.

Direct sunlight must be used with discretion. It can be cruel to any but the best-looking people. I dared to use it with this group because I was confronted with beautiful and handsome faces and excellent skin textures. My normal rule is: Direct sunlight, because of the detail it brings out, makes good-looking people look better and plain-looking people worse.

The low sunlight on this afternoon had a nice, warm glow to it. However, to enhance the beautiful tan of the group to the utmost, I added an 85B warming filter to my camera lens.

Because my main concern was the best possible rendition of my subjects, I took close-up meter readings of the skin tones. On a bright beach—or in a snow scene—you should always be very careful with meter readings taken from an entire scene that includes the background. Unless you interpret *light* readings provided by a meter into practical *exposures,* you can end up with very disappointing results.☐

Portfolio **41**

Purpose: For stock files
Location: Beach on Long Island, NY
Camera: Nikon FM
Lens: 50mm *f*-1.4 Auto-Nikkor
Lighting: Late-afternoon sunlight
Film: Kodachrome 64
Filtration: 85B warming filter
Exposure: 1/125 second at *f*-8

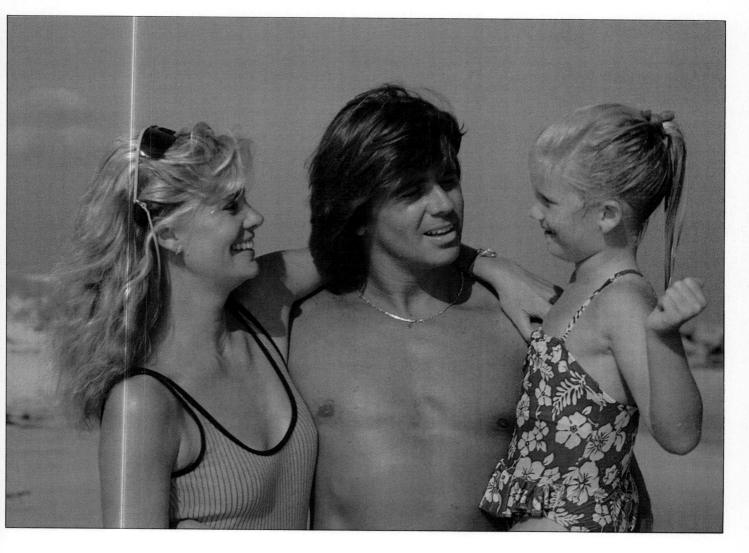

Purpose: For stock files
Location: Central Park, New York City
Camera: Nikon FM
Lens: 35mm *f*-2 Auto-Nikkor
Lighting: Late-afternoon sunlight
Film: Ektachrome 400
Exposure: 1/500 second at *f*-8

Even when I'm out walking, I like to be prepared to capture special images. In this case, I was in New York's Central Park. My Nikon was loaded with high-speed Ektachrome 400 film. I needed that film speed to stop fast movement in the late-afternoon light.

I found a group of teenage boys tossing a Frisbee back and forth with an appealing balletic grace. I asked if I could take a few shots of them playing and they were happy to oblige.

I singled out one boy and photographed him in a series of swooping and soaring catches. My camera's meter indicated an exposure of 1/500 second at *f*-8. The fast shutter speed stopped the action on the film.

The late-afternoon sunlight gave the picture a nice rosy glow that effectively conveys the warm summer feeling I wanted.

Notice that I recorded the peak of the action. The Frisbee was still in the air, just about to be caught. If the Frisbee had reached the boy's hand, much of the feeling of action would have been lost.

Capturing the decisive moment is a vital part of candid child photography, where there's generally motion and activity.

I got a background of dark trees rather than bright buildings or open sky. This clearly outlined the bright arms and shirt of the boy and the Frisbee.☐

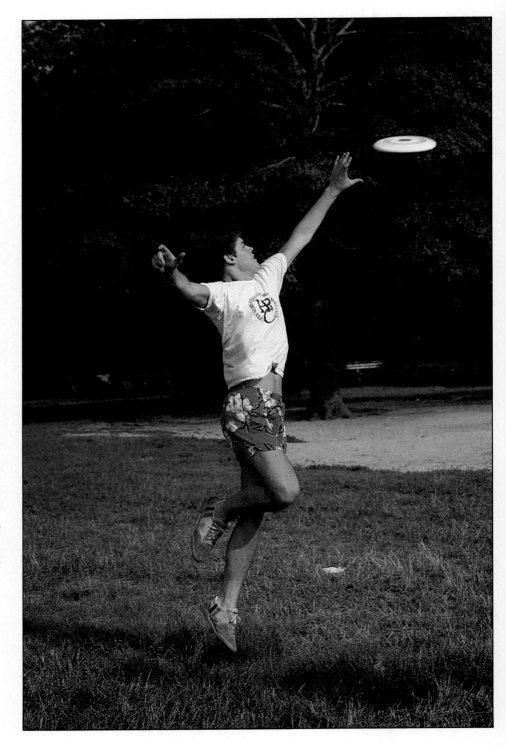

Purpose: For stock files
Location: Connecticut
Camera: Nikon FM2
Lens: 50mm *f*-1.4 Auto-Nikkor
Lighting: Late-afternoon sunlight
Film: Kodachrome 64
Filtration: Polarizing filter
Exposure: 1/250 second at *f*-4

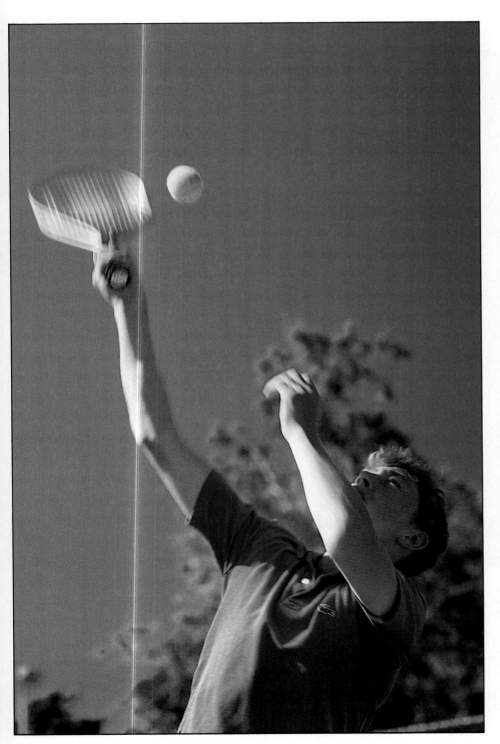

My work as a photographer of children sometimes overlaps into sports photography. This is especially true when I'm photographing teenagers. There's potential for fine photos in football, hockey, soccer, athletics, gymnastics and many other sports.

To take good sports photographs, you should be familiar with the sport you're shooting. Know where the best camera positions are likely to be. Be equipped with the right lenses—or use a zoom. Anticipate key actions before they happen so you can record them.

When I planned to photograph this youngster playing tennis, I knew exactly what I wanted. I wouldn't photograph him while he was actually playing but would pose the shot. I would record the power of his serve. To emphasize this, I would aim up from a low angle. This had the added advantage of giving me clear sky as background.

I asked the young man to pose for me as if he were serving. While he was in this position, I got the best possible lighting by asking him to rotate a little and by finding the best camera position. The low afternoon sun gave attractive rim lighting to the subject's body and arms and to the tennis racket.

I used a polarizing filter on the camera lens to darken the blue sky. This made the subject stand out better from his background. Notice that the foliage of a tree surrounds the outline of the blue shirt. Without this, the shirt and sky would have merged too much.

When everything was ready, I asked the youth to serve. I asked him to serve many times and made an exposure each time.

At a shutter speed of 1/250 second, I got sharp overall images with just enough blur in the racket to suggest fast action.□

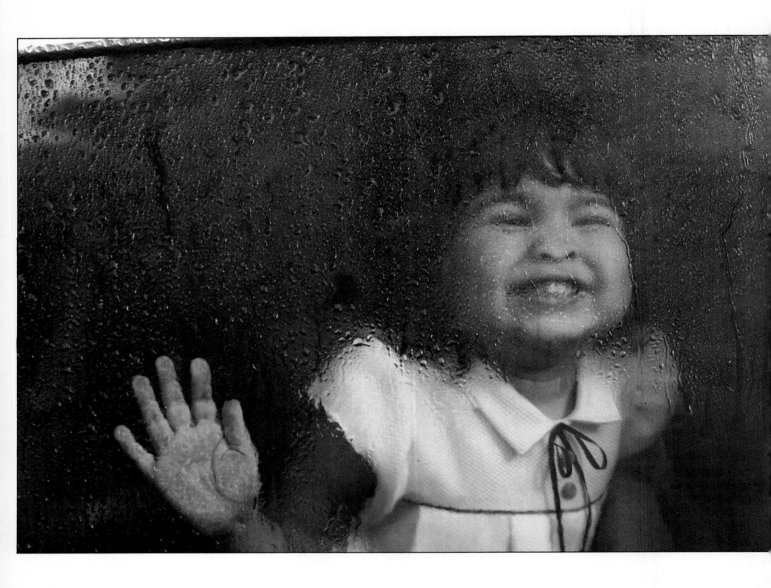

Purpose: Feature for a baby magazine
Location: Subject's home, Ridgewood, NJ
Camera: Nikon FM
Lens: 50mm *f*-1.4 Auto-Nikkor
Lighting: Soft daylight in rain
Film: Kodachrome 64
Exposure: 1/30 second at *f*-4

When a baby magazine asked me to shoot a picture story on activities for small children on rainy days, I knew exactly which model I wanted to use and what the theme of one of the key pictures would be.

I had been shown a photo of this absolutely irrepressible two-year-old, whose tremendous energy could not be contained or limited by bad weather.

The picture I had in mind was simple and straightforward: I would have the child press her nose against a rain-spattered window. I felt that this simple situation would best convey the essence of the story.

I waited for an appropriately dismal day. The setting was the girl's own home. When I reached the house, I walked around it, analyzing the avail-able light reaching each ground-floor window. I selected the window that was least obstructed by trees or walls and offered the brightest illumination.

Before I went outside to shoot, I told the mother exactly what I wanted from the little girl. Whatever further directions were needed, I gave by hand signals from outside. To get as complete an image of the child as possible in the dark conditions, I had her wear a white dress.

At a signal from me, the mother told the little girl to lean forward and press her nose to the glass. Shutter speed was as slow as I dared to use handheld: 1/30 second. The camera's built-in meter indicated an aperture of *f*-4. Fortunately, I didn't need great depth of field because the important image parts—rain-spattered window pane and child's face—were approximately in the same plane. I focused on the raindrops on the glass. Condensation on the inside of the window helped to soften the image of the face.

It was important to make the meter reading with the child close to the window. With the child away from the window, the entire pane appeared much darker. This would have led the meter to indicate overexposure.

My assistant made a funny face at the child—and I made the exposure. The delightful image shown here is the result.

To protect my camera from the rain, I had my assistant hold an umbrella over it as I shot. My assistant and I both got soaked, but we dry out much more easily than a camera would!□

Before I went outside to shoot, I told the mother exactly what I wanted from the little girl. Whatever further directions were needed, I gave by hand signals from outdoors.

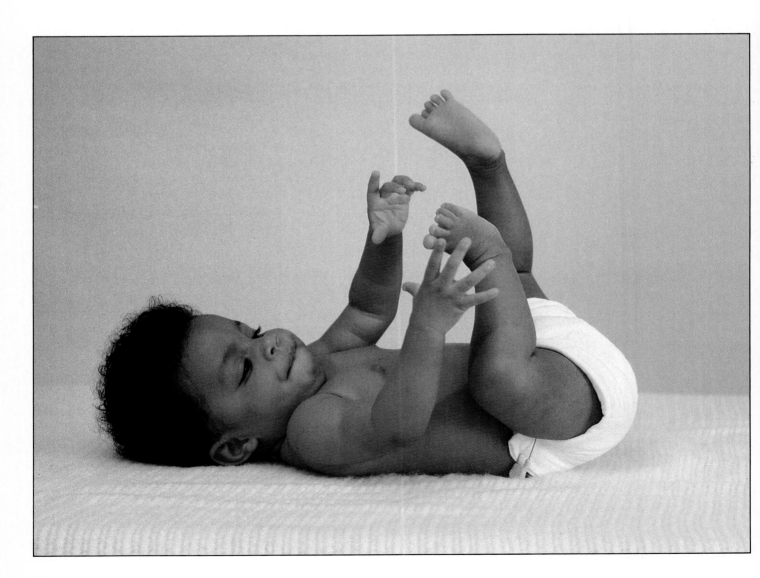

Portfolio 45

Purpose: For Baby Talk magazine
Location: My studio, New York City
Camera: Nikon F
Lens: 50mm ƒ-1.4 Auto-Nikkor
Lighting: Two electronic flash units
Film: Kodachrome 64
Exposure: ƒ-5.6 (shutter at 1/125 second)

To get good, believable action photos of babies, it's important to let them do what they do naturally at each developmental stage. This baby had just discovered her feet. I didn't need any toys or props to keep her entertained. For the moment, her toys were attached to the far end of her own body!

To be happy—and therefore photogenic—a baby must be comfortable. I turned up the heat in my studio and allowed the baby to play, clad in nothing but diaper. To focus viewer attention on the little brown body, I kept the remainder of the image white.

In my experience, there's a basic difference between proper illumination for light skin and dark skin. To get modeling in the face of a light-skinned person, I rely on the creation of shadows. To achieve modeling in a dark-skinned person, I rely much more on the creation of highlight areas.

To create soft highlight areas on this baby, rather than harsh ones, I bounced the light from a flash unit off a large white sheet. A second, diffused flash lit the background.

The ultimate success of this photo, as of so many other photos of active children, depended on capturing the right moment. At the moment this image was recorded on film, the baby's hands and feet were approaching each other while the eyes kept a concentrated control of the effort.□

86

Purpose: Personal, experimental photo
Location: My studio, New York City
Camera: Nikon FM
Lens: 50mm *f*-1.4 Auto-Nikkor
Lighting: One 200-watt-second and two 100-watt-second electronic flash units
Film: Kodachrome 64
Exposure: *f*-8 (shutter at 1/125 second)

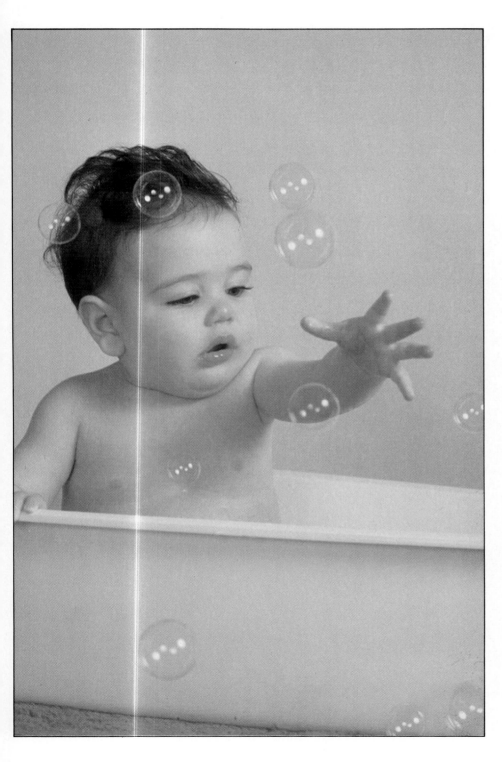

I was shooting speculatively, hoping to produce an image suitable for a baby-magazine cover. My model was the youngest member of a photogenic family, several of whose members have posed for me.

I knew the session would have to be short because I wanted the baby in bath water, where his patience would be limited. He would get cold, uncomfortable and tired. To keep him as contented as possible, I heated the studio to the point where we fully dressed adults were flushed and perspiring!

A 200-watt-second flash in umbrella, to the left of the camera, established the modeling. A 100-watt-second flash, slightly to the right of the camera, lightened the shadows. I directed a third flash, also at 100 watt-seconds, at the background. This lighting setup gave a high-key image and also highlighted and emphasized the bubbles. The bubbles were so subtle that they would have been hard to see without reflected highlights.

I used the motor drive on my Nikon camera and rapidly shot a sequence as the baby was engrossed with the bubbles blown by the mother. I'm glad I worked fast because the session was soon cut short by baby's discomfort.

When shooting photos of this kind, and also editing them at a later stage, avoid pictures in which a bubble obstructs an important image part. For example, from this series I would automatically have eliminated a photo in which a large bubble was right in front of baby's eye. ☐

Portfolio 47

Purpose: Textbook illustration
Location: Church in New York City
Camera: Nikon FM
Lens: 50mm *f*-1.4 Auto-Nikkor
Lighting: On-camera electronic flash
Film: Kodachrome 64
Exposure: f-8 (shutter at 1/60 second)

A textbook publisher asked me for a photograph of a baptism. I could have set up the scene in my studio but felt that a photo made that way just wouldn't look believable. I wanted to shoot in a church, with a real priest and the authentic atmosphere of the event. So I found an attractive couple who were about to have their baby baptized. I explained what I wanted and they readily agreed to be my subjects.

I planned to take several photos, shooting from different distances and angles, and having the people at the ceremony grouped in different ways around the font. I couldn't do this during the ceremony. However, everyone, including the priest, was prepared to pose for me after the ceremony. During the baptism, I watched carefully to get possible ideas for shots.

I used direct, on-camera flash. In the large church, possible reflective surfaces were too distant from the scene to be effective for bounce flash. Multiple studio lighting would have given a slick-looking result. However, I decided against it because I thought it would make the scene look too much like a studio setup. I preferred the "reportage-style" lighting of direct flash.

To avoid hot-spot reflections from the shiny surroundings, I shot from a relatively low angle. Notice that one such hot spot was shielded by the shoulders of the mother and father.□

Purpose: For stock files
Location: My home, New York City
Camera: Nikon FM
Lens: 50mm *f*-1.4 Auto-Nikkor
Lighting: One candle and one electronic flash unit in umbrella
Film: Ektachrome 200
Exposure: 1/30 second at *f*-4

You can produce wonderful pictures by candlelight, especially of children. The glow of a candle seems to enhance the look of innocence and wonderment in a child. Unfortunately, such photos are not easy to take.

It's possible to shoot by candlelight alone. However, this can lead to dark shadows and black backgrounds. It also calls for the use of very fast films, especially when you're shooting someone as active as a child. Such films tend to give grainy images of less-than-optimum quality.

Mixing candlelight with general illumination is better but requires a careful balance of the lights to retain the candlelight effect.

Another question that has to be considered is whether a daylight-balanced or a tungsten-balanced color film should be used. I prefer daylight film because it records the warm, orange glow of candlelight. A tungsten-balanced film would "correct" the light and thereby eliminate one of the more attractive characteristics of that illumination. Daylight film is advantageous for another reason: It enables me to use electronic flash as additional illumination.

I wanted to use electronic flash to add highlight to the child's hair, lighten the background and brighten the facial shadows caused by the candlelight. The exposure-meter reading for the candlelight alone was 1/30 second at *f*-2.8 to *f*-4. To allow for the additional light of the flash, I closed the lens down to *f*-4.

I reflected the flash from an umbrella, aimed down from a high position. By reducing the power-output setting of the flash, I gave about 1/6 the flash exposure that would have been necessary for full flash exposure. □

Purpose: Picture story
on children playing
Location: My studio, New York City
Camera: Nikon FM
Lens: 85mm *f*-2 Auto-Nikkor
Lighting: Two 200-watt-second
electronic flash units—one in a softbox
and the other in an umbrella
Film: Kodachrome 64
Exposure: *f*-11 (shutter at 1/125
second)

I made this shot to accompany a magazine article on children at play. The client's layout required a horizontal format. This is also a typical example where an art director needs a specified empty area for the addition of type. When such requirements are set, a photographer must satisfy them precisely.

Because type reads most clearly on a plain background, I used seamless background paper. At the time of shooting, it had not been decided whether dark type or light type was to be used. To be sure that either would show up well, I lit the yellow paper to give a medium-toned background image.

Sometimes you can draw attention to a color by contrasting it with the complementary color. For example, red stands out well against blue. However, as in this case, there are occasions when a color is best emphasized by its own color. Notice how the large yellow background draws your attention to the re-latively small area of yellow in front of the girl.

To complement the basic yellow theme of the scene, I asked the girl to wear a blue smock. The red heart adds more color but also serves another purpose: It graphically directs viewer attention down to the painting.

To avoid harsh shadows on subject and background, I used soft, bounced light. Thanks to my subject's patience and staying power, I was able to make test shots on Polaroid film. These tests helped me balance the lighting to get the best possible separation between the blond hair and the background.

I have often used this model because of her expressive face and charming personality. I can always depend on her to be relaxed and natural in front of the camera. She obviously had great fun with her finger painting.

The outstretched fingers show dramatically that this was, indeed, finger painting rather than brush painting.☐

Purpose: Nursery-school feature for a magazine
Location: Nursery school in New York City
Camera: Nikon FM
Lens: 50mm *f*-1.4 Auto-Nikkor
Lighting: One 200-watt-second electronic flash
Film: Kodachrome 64
Exposure: *f*-5.6 (shutter at 1/60 second)

Shooting an assignment on nursery-school activities turned out to be a photographer's paradise. During the morning I spent at this school, the children were free to pursue their own interests. There were stimulating things going on everywhere and picture possibilities presented themselves as fast as I could grab them.

I disrupted the children's activities as little as possible. Initially, of course, they were all fascinated by my own strange and wonderful "toys." However, they quickly got used to my presence— and that was when I really started shooting!

To remain as unobtrusive as possible, I took most photos with a camera-mounted flash. However, when I saw this little girl in her long, white smock against her artwork, I ran to get one Dyna-Lite 200-watt-second flash and umbrella. I set the light up on a stand as quickly as I could and bounced the light off the ceiling. This enabled me to achieve soft, natural-looking illumination rather than getting the harsh shadows characteristic of on-camera flash.

This photo proves very convincingly that you don't always have to show a face to produce a good "portrait." The determined, upstretched hand on the incomplete "canvas," the dirty smock, and the spilled paint on the floor tell the story beautifully. It is, in essence, a portrait of the typical child, rather than of a specific child.

Assignments like this are clear evidence of the value of cooperative teachers to photographers of children. If you're interested in keeping in touch with children's activities in your area, establish a rapport with your local schoolteachers.☐

Purpose: Magazine feature on
little-league baseball
Location: Ridgefield, Connecticut
Camera: Nikon FM
Lens: 50mm *f*-1.4 Auto-Nikkor
Lighting: Uniformly overcast sky
Film: Kodachrome 64
Exposure: 1/125 second at *f*-5.6

One of the main challenges for a photographer of children is the art of distracting them. It can be as much fun as the technical aspects of photography. However, for this photo no distraction on my part was necessary. This is a truly candid shot of a child genuinely engrossed in what he is doing.

Because little-league games are usually played after school, I expected to be shooting in the late afternoon. The light was even dimmer than it might have been because the sky was overcast. To get a sharp image at 1/125 second, I chose a physically static—although visually dynamic—moment in the play.

To isolate the boy and concentrate attention on him, I shot from a high viewpoint. This eliminated distracting background matter such as buildings, trees, soccer goals and parked cars.

This image is a good example of simple story telling photographically. All you see is one little boy, but the picture clearly says "baseball."☐

This image is a good example of simple story telling photographically. All you see is one little boy, but the picture clearly says "baseball."

Purpose: Illustration for
a textbook cover
Location: Redding, Connecticut
Camera: Nikon FM2
Lens: 85mm *f*-2 Auto-Nikkor
Lighting: Daylight from overcast sky
Film: Kodachrome 64
Filtration: Deep-yellow filter
Exposure: 1/125 second at *f*-5.6 to *f*-8

In addition to getting an appropriate and attractive picture, the art director for this book-cover shot had specific graphic requirements. He needed space at the top of the image for type.

Normally, I would avoid including in a picture a uniform, light-gray sky, such as we had on this overcast day. However, in this case it served perfectly as background for the type that was to be added later.

I deliberately selected the railroad track as the setting. It enabled me to use the converging lines of the receding track as a graphic tool to direct viewer attention to the heading. This aspect of the image was not specifically asked for by the art director. It is something a good photographer should provide as a creative "bonus."

I have used this family as models many times. Their auburn-haired good looks and the rustic New England setting of their home have been ideal for varied assignments. When I first saw the railroad track, long ago, I made a mental note of it, expecting I would be able to use it some day.

The overcast sky gave a bluish, cool light. To produce a more cheerful image, I put a deep-yellow filter on the camera lens.

To get an accurate meter reading of the scene, I pointed my reflected-light meter downward to exclude the bright sky from its view.□

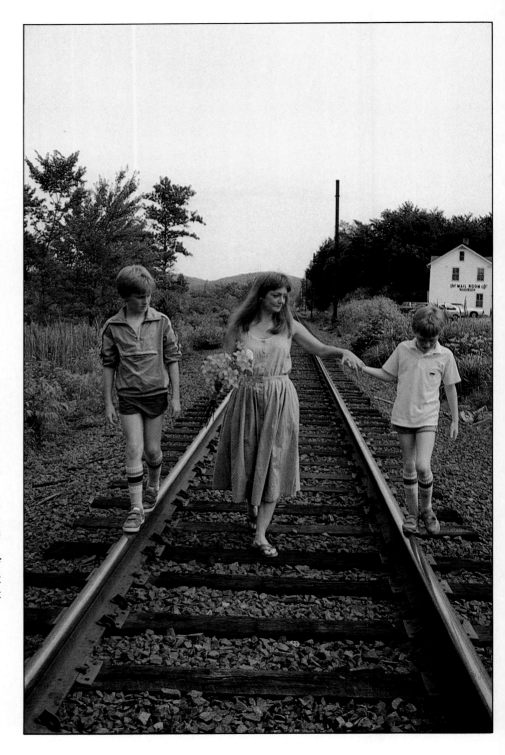

Purpose: For stock files
Location: Playground in Rockport, Maine
Camera: Nikon FM2
Lens: 35mm *f*-2 Auto-Nikkor
Lighting: Overcast sky
Film: Ektachrome 64
Exposure: 1/125 second at *f*-8

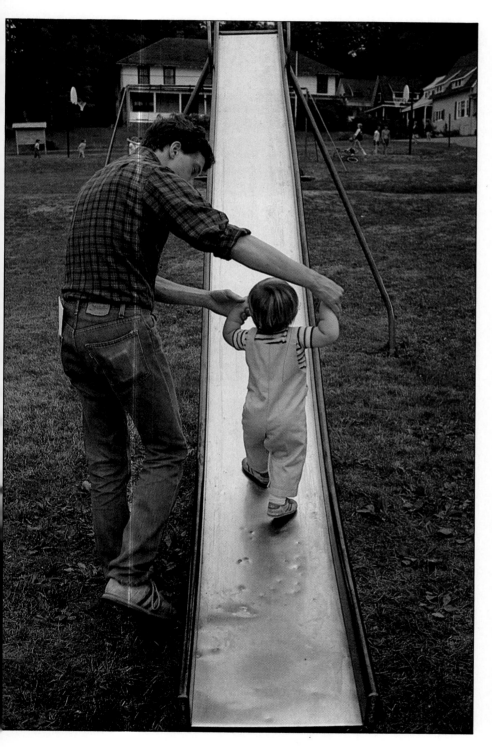

I never put my cameras away, even on vacation. If you make a habit of carrying a camera wherever you go, you'll soon amass a wealth of beautiful pictures that would otherwise have escaped forever. Many attractive photos—such as the one reproduced here—can be taken with simple, point-and-shoot cameras.

I always tend to gravitate toward children, as I did in this playground in Rockport, Maine. It was on a weekend and a lot of families with children were out. Amid the plentiful activity, my attention was caught by this father and son. The child loved the slide and seemed to like walking up better than sliding down.

I liked the relationship between father and son. The father seemed to support the child while at the same time allowing him to take the initiative. I ran to the slide and started photographing.

Camera position plays a decisive part in making a photograph effective and giving it visual impact. I tried some shots from a crouching position and some while I was standing. I prefer this photo, taken from a standing position. It tends to dwarf the child, making the slide appear a formidable obstacle.

Shooting up from a low angle made the child appear much larger. It also made the slide appear impossibly high, rising up toward the sky. This might have made the child's ascent a seemingly impossible task and would have belied the obvious tenderness and concern in the father's stance.

To maintain graphic continuity along the bright slide, I took care that the father's head did not obstruct the slide.

The even illumination from an overcast sky gave the reflective slide a uniform tonality. In direct sunlight from a dark-blue sky, I might have had to contend with bright catchlights and dark areas on the slide.□

Purpose: For stock files
Location: Subjects' home, Massachusetts
Camera: Nikon FM
Lens: 85mm *f*-2 Auto-Nikkor
Lighting: Open shade on sunny day
Light Control: Fill flash
Film: Kodachrome 64
Exposure: 1/125 second at *f*-5.6

Throughout this portfolio, you'll see several pictures that I shot specifically for my stock files. It's surprising how often I can satisfy a client's needs without a special shoot but simply by going to my stock files.

I like to keep a large selection of pictures and update the files regularly. Styles in clothing, hair and furnishings change, and it's not easy to sell a picture with an old-fashioned look.

Stock-file photos come about in several ways. Sometimes I go out specifically to shoot them. On other occasions I'll take additional shots for myself when doing an assignment. Of course, these "outtakes" must not bear any resemblance to the photos the client will use.

There are also times when test shots turn out suitable for my stock files. I have frequent testing sessions. They may be for checking out new equipment, a new film, new models or a special lighting technique.

When I took the picture reproduced here, I had just finished a session with this family for a magazine assignment. The children were still running around full of pep, the location was attractive and the light was suitable. It seemed an ideal situation for grabbing a few extra shots. The mother agreed to pose with her daughter, and to sign a model release form, in return for a few prints.

I worked in open shade, adding weak fill flash to lighten the shadows. To retain viewer attention on the subjects, I recorded the background unsharply by using the fairly wide-open aperture of *f*-5.6.

The key to producing good pictures of children is to see the right expressions and be fast enough to capture them on film. I think I achieved that in this image.□

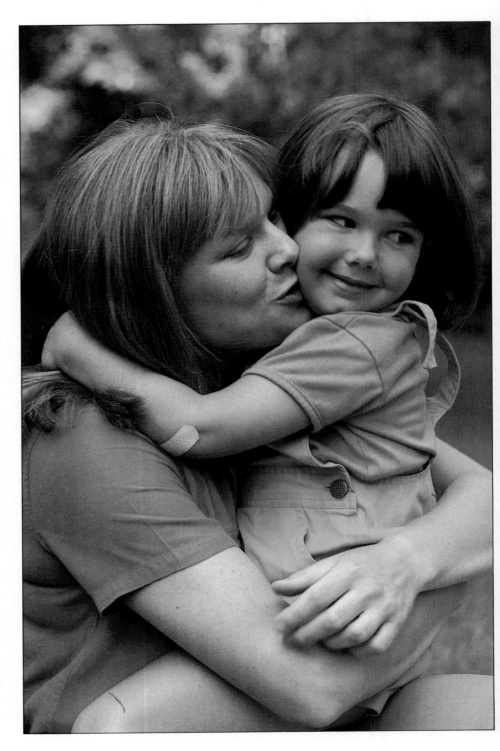

Purpose: Unplanned, candid photo
Location: A beach in Connecticut
Camera: Nikon FM
Lens: 85mm *f*-2 Auto-Nikkor
Lighting: Hazy mid-afternoon sunlight
Film: Kodachrome 64
Exposure: 1/125 second at *f*-5.6

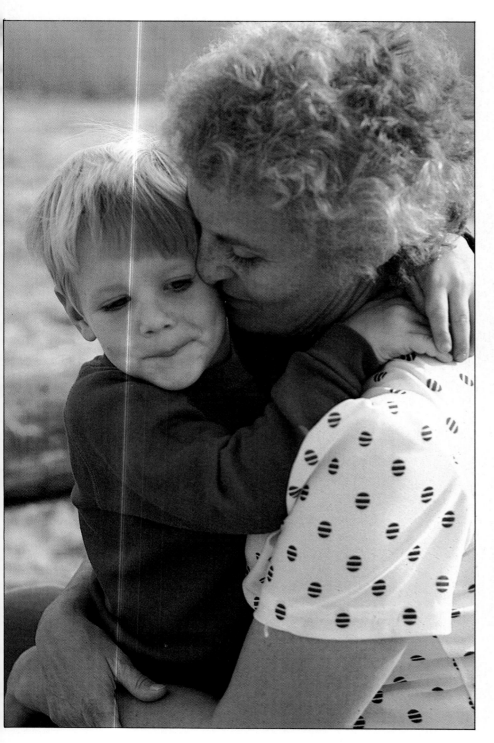

Unless I'm taking formal portraits, I don't like photographing children in a social vacuum. I like them involved in their normal activities and relating to their human environment. That often means including other people in pictures of children. There may be a mother, brother, sister, a couple of friends or—as in this case—a grandmother.

After a day's shooting, I was walking on a Connecticut beach when I spotted this small boy being hugged by his grandmother. Both looked so obviously sincere about their affection for each other that I photographed them instantly. I could never have "directed" or reconstructed the atmosphere that emanates from this natural, candid shot.

After shooting, I spoke to the grandmother, explaining why I had simply aimed my camera and fired away. She was very understanding and agreed to sign a model release form. I, in turn, promised to send her some prints of the photo I had taken.

The sun was low in the sky and the sky was hazy. This gave me ideal lighting. The areas that were not lit directly by the sun were brightened by reflection from the beach and by diffused light from the lightly overcast sky.

Working at an aperture of *f*-5.6 limited depth of field sufficiently to enable me to record the background out of focus. Thus, viewer attention is concentrated on the main subjects.

The simple combination of two main colors—blue and gold—works well in this image. And, the expressions on the two happy faces tell the whole story beautifully!□

Purpose: For a greeting card
Location: Meadow in Lenox, Massachusetts
Camera: Nikon FM
Lens: 85mm *f*-2 Auto-Nikkor
Lighting: Late-afternoon sunlight
Light Control: Diffuse, gold-foil reflector
Film: Kodachrome 64
Filtration: Diffusion filter
Exposure: 1/30 second at *f*-5.6

I photographed this attractive teenager for a greeting-card company. I had been asked to produce some "mood" shots. I love photographing older children who are making the transition to adulthood. There is something very special about their sensitivity and vulnerability.

To convey the newfound sense of freedom of this teenager, I chose a large meadow as the scene for this picture. To envelop the subject in an aura of mystery, symbolic of the puzzlement with which teenager and world often see each other, I used a diffusion filter on the camera lens. It softened the entire scene, giving it an ethereal quality.

I softened the late-afternoon sunlight with a diffuse, gold-foil reflector near the camera. The sun, to the right of the camera, yielded a rim light on the subject that graphically separated her from the background.

The warmth of the subject, with her pensive, sensitive expression, was matched by the golden warmth of the scene—provided by late sunlight, gold reflector, and golden meadow and flowers.

To bring graphic relief to the image, I asked the subject to wear a dress with a fairly bold graphic design. If she had worn a flower-patterned dress or a uniform pastel-colored blouse, she would have merged too drastically with the background. An alternative would have been for her to wear a dress of a strong, bright color, such as blue or red. I avoided that because I did not want an excessively colorful image.□

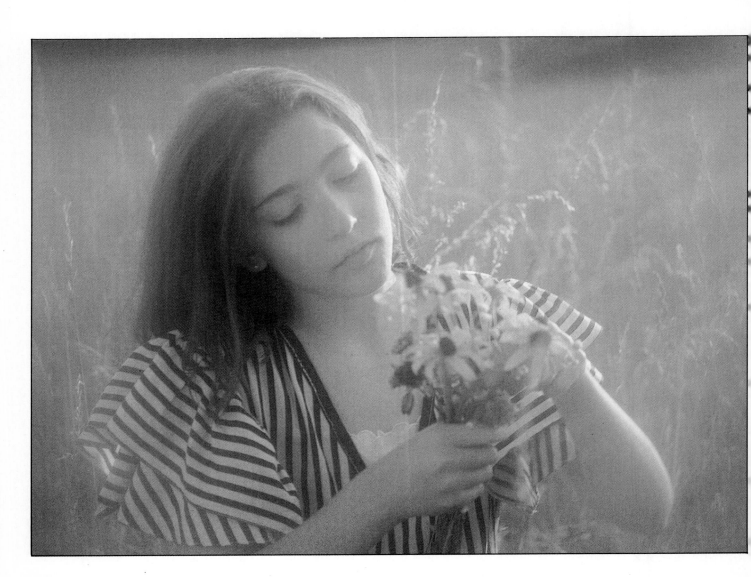

When you plan a photograph, the first step is to evaluate what you want to convey to the viewer. The second step involves using the tools and skills at your disposal to realize your message as an image on film.

I was shooting a series of pictures for this young model's portfolio. In this picture, I wanted to show a well-tanned girl enjoying the cool indoors on a hot summer's day. The girl's tan already existed. It was for me to add the cool atmosphere. I did it by choosing an almost uniformly bright scene—white dress, hat, bed and curtains, and a light-colored wall. The light tones conveyed the feeling of coolness and also contrasted well with the girl's tanned skin.

Daylight entered the room through two windows. The window visible on the left side let in light from an overcast sky. That's why the area of bed below that window looks relatively white. A window just outside the picture on the right side let in light from a mainly blue sky. That's why the part of the bed nearest that window, and the front of the dress, have a distinctly blue appearance.

I didn't want to eliminate the bluish appearance of the picture because it helped enhance the feeling of coolness that I wanted to convey.

I used Ektachrome 400 film, not only because it's fast but also because experience has shown me that it tends to yield a relatively cool image. Even with the high speed of this film, exposure was 1/15 second and I had to use my camera on a tripod.

Because everything in the room was of such bright tones, I needed no additional fill light or reflectors. The window light alone achieved exactly the effect I wanted. The young model's relaxed pose completed a fine image.□

Purpose: For model's portfolio
Location: Subject's home, Connecticut
Camera: Nikon FM
Lens: 35mm *f*-2 Auto-Nikkor
Lighting: Light from two windows
Film: Ektachrome 400
Exposure: 1/15 second at *f*-8

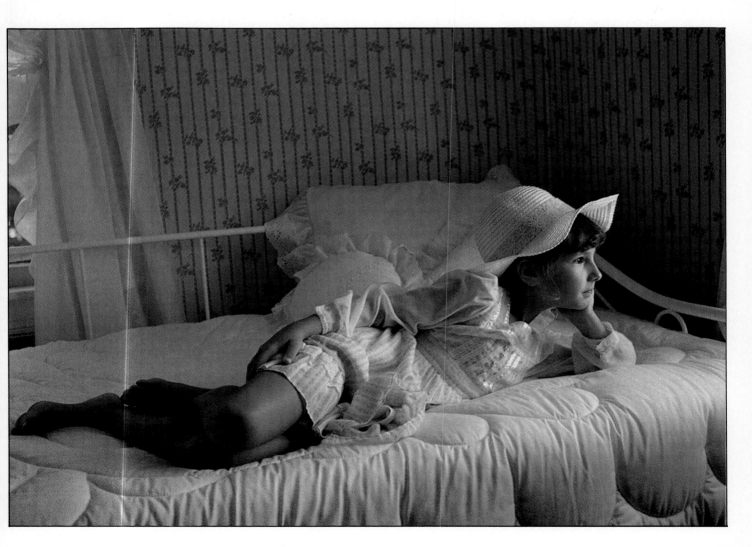

Purpose: Fashion series for a children's publication
Location: Garden of a friend's home, Alpine, NJ
Camera: Nikon FM
Lens: 50mm *f*-1.4 Auto-Nikkor
Lighting: Daylight from overcast sky
Film: Kodachrome 64
Exposure: 1/60 second at *f*-8

I was asked to shoot children's rainwear for a fashion feature in a magazine. Of course, raincoats and boots should be featured in an appropriately bleak setting. I was delighted when given this bright-red outfit. It would enable me to introduce color and cheer into that setting and make an eye-catching image.

To complement the red, I chose a green background. As a prop, I gave the girl an umbrella to hold. The umbrella contained some red, too, which helped to graphically "hold the image together."

I had taken a flash unit with me, thinking I might use it to highlight the shiny coat. However, the uniformly overcast sky provided ample glow to the coat.

Just before I took the picture, I asked the girl to tilt back her head and the umbrella. The skylight lit her face beautifully. If she had looked toward the camera, the overhead skylight would have caused deep, unflattering shadows on her face and below her chin.

When you pose a subject, always be aware also of the background. Notice, for example, that for best tonal separation I placed the light umbrella against the dark trees, and the darker coat and boots against the brighter grass.

When you're shooting on location, especially in poor weather conditions, you must have a flexible attitude. The weather may not be precisely the way you had anticipated it, or it may change abruptly. Adapt yourself to the circumstances. Use flash, reflectors, different camera angles and backgrounds, and varying subject poses to give you a result nearest to what you had anticipated.

If conditions are such that there simply isn't any sense in shooting, come back another day. If you stay to shoot, remember to protect your equipment from the elements.□

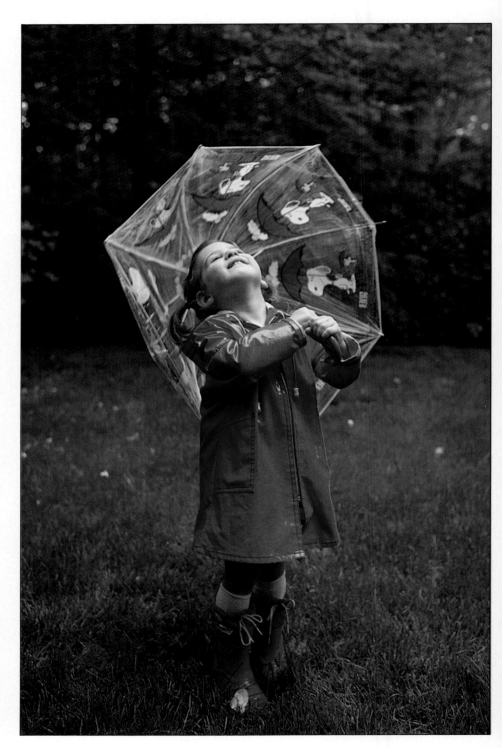

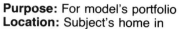

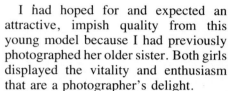

Purpose: For model's portfolio
Location: Subject's home in Milford, Connecticut
Camera: Nikon FM
Lens: 85mm *f*-2 Auto-Nikkor
Lighting: Hazy sunlight through overcast sky
Film: Kodachrome 64
Exposure: 1/125 second at *f*-8

I had hoped for and expected an attractive, impish quality from this young model because I had previously photographed her older sister. Both girls displayed the vitality and enthusiasm that are a photographer's delight.

The day was muggy and uncomfortable, but the haze and overcast gave the light a quality suitable for portraiture. Enough sunlight penetrated the haze to cause distinct shadows, yet there was an overall softness in the illumination.

I had noticed the pink umbrella lying in a corner in the girl's home and suggested we try some shots with it. I wanted the girl and umbrella to record sharply but to have the background foliage out of focus. Using the depth-of-field preview button on my camera, I selected an aperture of *f*-8.

On a dull day, when the sky is gray and the light soft, you can add life and sparkle to an image by introducing colorful and bright elements. In this case, the pink umbrella and the white dress did the job. A similar image with the girl in a blue dress, against a background of dark-green foliage, would have had considerably less impact.

Sometimes an unexpected, funny statement can elicit laughter or a smile for a photo. Just before making the exposure, I said "Hey, why that open umbrella when it's not raining?" You can see the response in the photo.

This, as many of the photos in this book, could have been made by any one of the many autofocus, point-and-shoot cameras available today. You don't always need sophisticated SLR equipment to take impressive pictures.□

Purpose: Playground story for Daycare magazine
Location: Playground in New York City
Camera: Nikon F
Lens: 85mm *f*-2 Auto-Nikkor
Lighting: Daylight; light overcast
Film: Kodachrome 64
Exposure: 1/125 second at *f*-5.6

Many of my photographs are made for specific assignments. Others are the result of my own plans. On some occasions, a location, person or prop inspires a photo on the spur of the moment. The photo reproduced here was made on assignment. However, the manner in which I handled the assignment was largely determined by the location, which I found quite by chance. The character of the picture was also largely influenced by the special young model, whom I had photographed very successfully before.

I had been asked to produce a playground picture for a children's publication. I immediately thought of one of my favorite models—dark-eyed, black-haired Brent. His outgoing personality would be ideal in a playground setting.

On the way to Brent's home in New York City, I happened to see a brilliant-red Jungle Gym in a playground and knew right away that this was the place to do the shooting.

When I got to Brent's home, I asked to look through his clothes. I wanted bright colors and simple shapes. I was delighted to discover that Brent had a cap of the same bright-red color as the jungle gym. I also picked out solid yellow overalls to complement the red.

To concentrate attention on Brent and the red structure closest to him, I shot with the lens fairly wide open, at *f*-5.6. This put the background out of focus. Had the leg behind Brent's head been in focus, it would have drawn attention from the main part of the image. Recorded in a soft blur, it helped to indicate activity around the Jungle Gym without "taking over" the image. The blue also brought some additional color to the scene.

Soft lighting from an overcast sky eliminated the need for fill flash or reflectors to brighten shadows. Compositionally, I achieved the best graphic effect by shooting straight on, with Brent framed in the red metal hoop.□

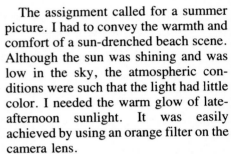

Purpose: Assignment on "Baby in Summer"
Location: Beach on Long Island, NY
Camera: Nikon FM
Lens: 50mm *f*-1.4 Auto Nikkor
Lighting: Late-afternoon sunlight
Film: Kodachrome 64
Filtration: Orange filter
Exposure: 1/250 second at *f*-5.6

The assignment called for a summer picture. I had to convey the warmth and comfort of a sun-drenched beach scene. Although the sun was shining and was low in the sky, the atmospheric conditions were such that the light had little color. I needed the warm glow of late-afternoon sunlight. It was easily achieved by using an orange filter on the camera lens.

If I had been pressed to produce a bright, summer picture on a lightly overcast day, the orange filter could still have worked wonders. On a really bleak day, with heavy overcast, the filter would have warmed the light but the absence of shadows would have indicated that the day was not, in fact, sunny.

In such conditions, you can make good use of flash to simulate sunlight. However, you must avoid showing the gray sky in the picture. Also avoid showing distant parts of the scene because they will have a giveaway soft appearance. Your flash will generate shadows only on nearby areas.

To maximize the effect of shadows and get the best modeling in your subjects, use the flash off camera, if possible.

In the image reproduced here, the filter actually served two purposes. In addition to warming the illumination, it gave the child a healthy, tanned appearance.

Notice that I protected the child's eyes from the direct sunlight by having him walk away from the sun. This enabled him to be relaxed as he strolled along the beach for the benefit of my camera.□

Purpose: For model's portfolio
Location: Subject's home, Milford, CT
Camera: Nikon FM
Lens: 85mm *f*-2 Auto-Nikkor
Lighting: Window light and one electronic flash unit
Film: Kodachrome 64
Exposure: 1/60 second at *f*-5.6

An important and satisfying part of my work involves taking head shots for young models' portfolios. I like doing this type of photography because the subject is usually well motivated and cooperative. She wants to be a professional and does everything she can to behave like one. Because of past experience before a camera, such subjects are usually also relaxed at a shooting session.

Besides the satisfaction derived from the actual photography, this kind of work also satisfies me because I'm doing something concrete to help a young person enter a difficult but satisfying career.

This little girl, one of my favorite models, has a distinctly "old-fashioned" look about her. To augment this look, I chose a Victorian type of wallpaper and asked the young lady to wear a delicate, lacy dress. As a final touch, the mother gave the girl a serene and classic on-top-of-the-head hairstyle.

The two dolls added interest without in any way detracting attention from the model. This is largely because she is looking directly at the camera and thus establishes eye contact with the viewer of the photo.

The main light came from a window behind the camera and somewhat to its left. To brighten shadows, I bounced the light from one flash off the white ceiling.

Shooting for a model's portfolio is particularly challenging because the subject has to be shown in a series of pictures, each depicting a different situation, wardrobe and mood. The portfolio must demonstrate that the child has the versatility to handle a variety of assignments. Each shot must also show something of the child's own personality.

A portfolio photo, such as this one, should show an art director or editor at a glance whether a model is suitable for a specific assignment.

There's one important difference between a portfolio shot and a personal home portrait. In the home portrait, things can often be shot as they actually are. For example, if a girl's dolls are a little worn with years of handling or clothing looks a little more than just informal, that's OK. It's authentic. When you shoot for a portfolio, slickness is usually—although not always—more important than authenticity. Everything should look as beautiful as possible.☐

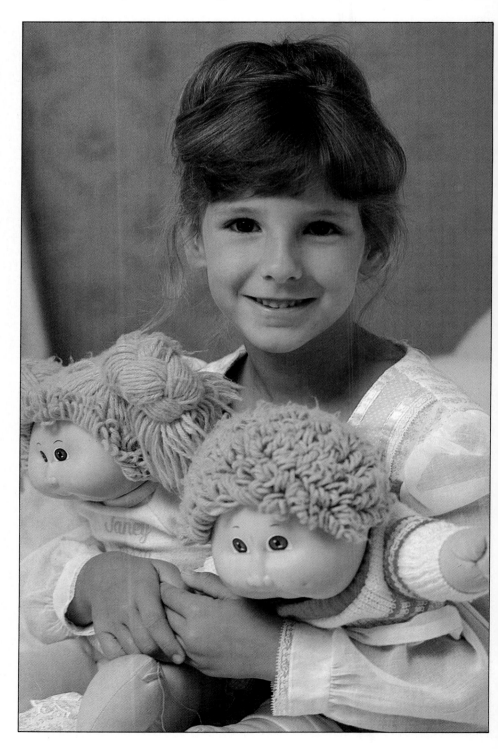

A medical publication needed an appropriate illustration for an article on adolescence. I was asked to produce a suitable "mood" shot.

I had this young model on my files and considered her ideal for the assignment. A preliminary visit to her home convinced me that her bedroom would make a better setting for the shot than my studio.

The room had a quaint look. The wallpaper bore an old-fashioned floral print. There were ruffled, white curtains at the windows and below one window was an old-fashioned radiator.

The day was bright and light poured in through two windows, across the bed. Because I couldn't move the light sources—the two windows—I had to position the subject carefully for suitable lighting. The window to the right of the camera provided the main light. It gave beautiful modeling to the face and highlighted the hair on the left side of the girl's head.

The window visible in the picture provided rim lighting to the right side of the model's hair and her right arm. It also gave a nice sheen to the girl's gown.

The side and back light from the two windows was contrasty and left some deep shadows. To brighten them, I bounced the light from a small flash unit from the ceiling area behind the camera.

I believe this image is a fine record of the poignancy of the transition from childhood to adulthood. Notice that the girl is not so much *playing* with the doll as *reminiscing* about the days when she *did*. Capturing moments like this has little to do with photographic technicalities. It requires good directing abilities, a keen eye and, of course, a sensitive model.□

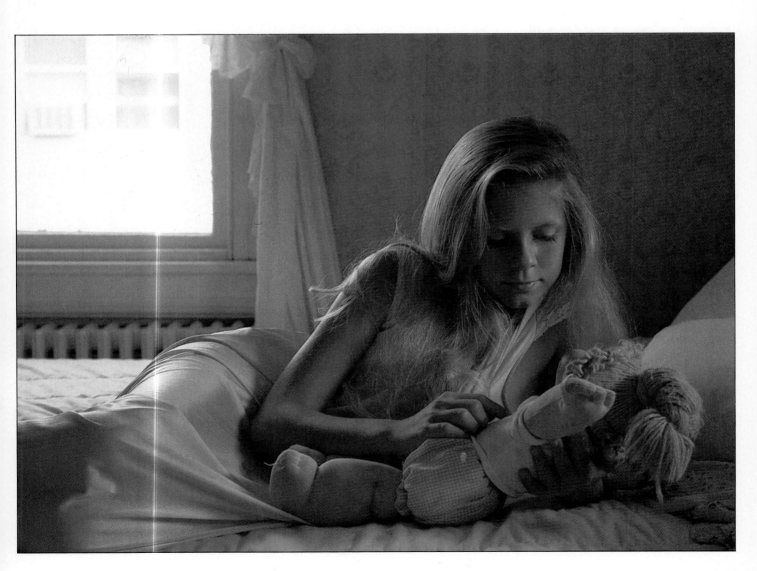

Portfolio 63

Purpose: Illustration for medical publication
Location: Subject's home
Camera: Nikon FM
Lens: 50mm *f*-1.4 Auto-Nikkor
Lighting: Daylight through two windows and bounced flash
Film: Kodachrome 64

Purpose: Feature for
Mother's Manual magazine
Location: My studio, New York City
Camera: Nikon FM
Lens: 85mm *f*-2 Auto-Nikkor
Lighting: Three electronic flash units
in umbrellas
Film: Kodachrome 64
Exposure: Between *f*-5.6 and *f*-8
(shutter at 1/125 second)

I was assigned to produce the cover photo for a fashion supplement for a magazine. So that I could shoot fast and at the same time freeze all movement on the film, I used electronic flash and the motor drive on my camera. The 85mm lens was ideal, enabling me to get far enough from my subject to avoid image distortion and also prevent "crowding" my subject by getting too close.

I placed one Dyna-Lite flash, set at 200 watt-seconds, to the right of the camera, aiming it down at about a 30° angle. A second Dyna-Lite flash of equal power was farther from the child and aimed from near the camera position. The background was illuminated by a third electronic flash, bounced from an umbrella.

My flash meter indicated a setting halfway between *f*-5.6 and *f*-8. To be sure I got just the image density the art director wanted, I exposed at *f*-5.6 and *f*-8, as well as at the meter-indicated aperture. Of course, a child's expression changes constantly. A photographer can only hope that best exposure and best expression will coincide on one film frame.

The art director and picture editor wanted the little girl involved with the tulips in some way. We tried some shots of her smelling them, touching them, and just admiring them. However, the best shot was this one, in which she simply delighted in their colorful spectacle.

To be quite truthful, the enthralled expression wasn't really evoked by the tulips, but by a funny face made by my assistant!□

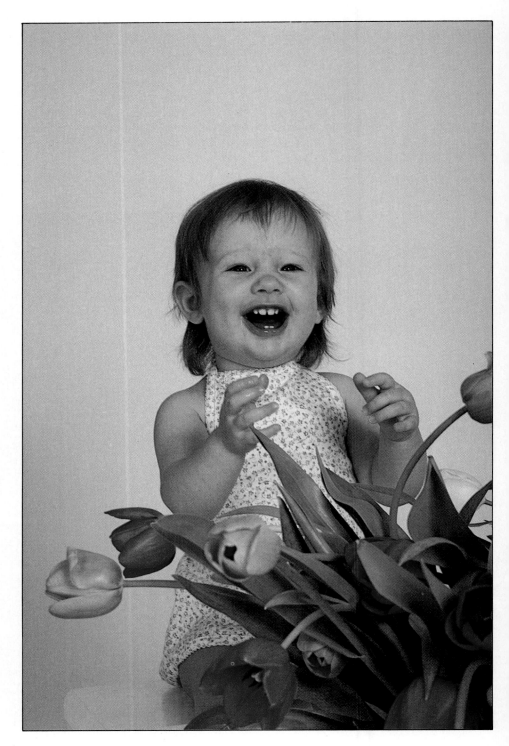

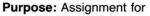

Purpose: Assignment for
a baby magazine
Location: My studio, New York City
Camera: Nikon FM
Lens: 50mm *f*-1.8 Auto-Nikkor
Lighting: Two electronic flash units
in umbrellas
Film: Kodachrome 64
Exposure: Between *f*-5.6 and *f*-8
(shutter at 1/125 second)

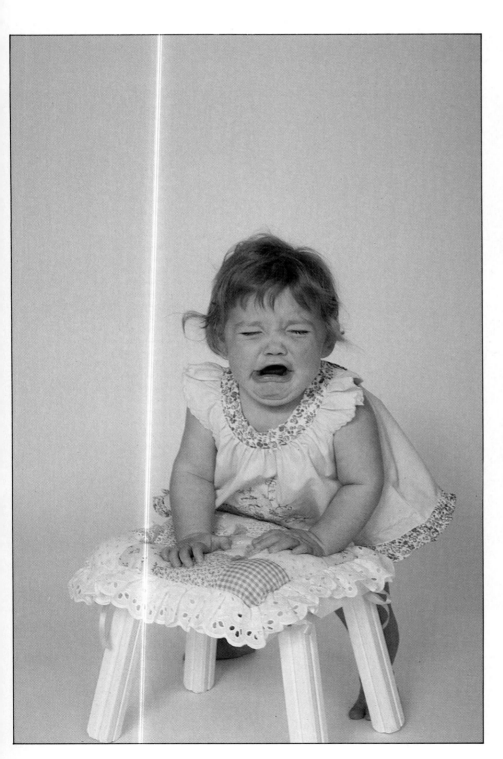

Sometimes, as in this case, expression is everything in a picture. Genuine expressions, such as this child's distress, can't be elicited or directed. They have to be seen and "grabbed" when they occur.

Actually, the assignment had nothing to do with unhappy children. I had been hired to shoot a children's fashion sequence for a magazine. Fortunately, we had hired a large team of child models, so when this one fell by the wayside, she wasn't missed.

As a matter of fact, I was delighted that she "dropped out" in this manner, because she thereby provided me with what I considered the shot of the day. Although the child's eyes are closed, she seems to be appealing directly to the viewer for sympathy because her head is directed toward the camera.

The lighting was just as I had set it up for the fashion shots. Two umbrella flashes secured a high-key effect, with a bright, shadowless background.

Notice the ample headroom above the child, to emphasize her smallness.☐

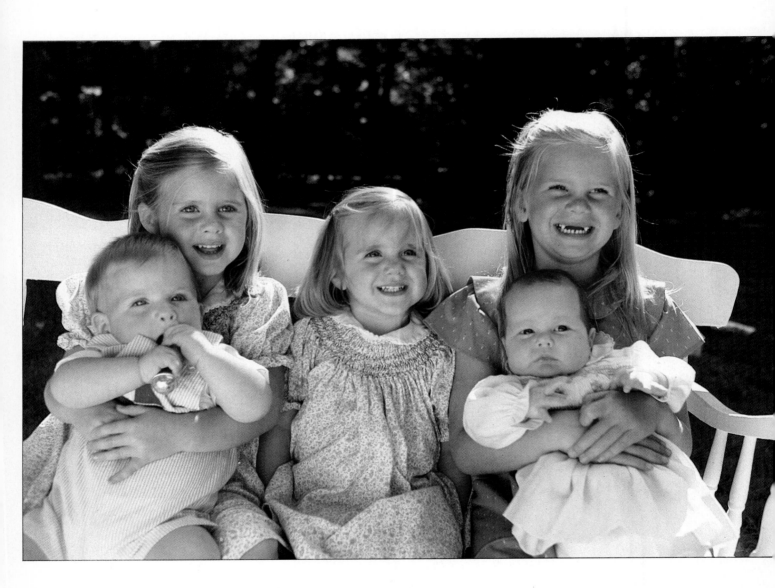

Purpose: Private portrait assignment
Location: Subjects' home, Long Island, NY
Camera: Nikon FM
Lens: 50mm *f*-1.4 Auto-Nikkor
Lighting: Reflected late-afternoon sunlight
Light Control: Large aluminum-foil reflector
Film: Ektachrome 200
Exposure: 1/125 second at *f*-8

A mat, white reflector can be an efficient secondary light source, suitable as fill light. A silvered reflector, such as was used here, can play the part of main light. If I had used the low, late-afternoon sun as direct main light, my subjects would have squinted uncomfortably. I would not have been able to make the attractive group photograph reproduced here.

Posing the subjects with their backs to the sun, I lit them from the front with sunlight reflected from a large aluminum-foil reflector. They felt comfortable and were able to oblige me with these lovely smiles. The sunlight coming from behind added beautiful rim lighting to the blond hair.

At subject position, the reflector constituted an effectively larger light source than the distant sun. Therefore, it gave a softer light with less-harsh shadows—a condition more flattering to portraits of children. The low sun had a reddish glow that added a feeling of warmth to the image.

I had to be sure that my exposure-meter reading was not affected by the rim light on the hair because that would have led to underexposure of the faces. I made spot-meter readings from the faces.

Keeping one child happy in front of a camera is a challenge. Holding the enthusiasm of five children borders on the impossible. So as not to lose the children's interest and cooperation too soon, I did not seat them until I was ready to shoot. I shot for just a couple of minutes before the group disintegrated, with a couple of the children crying. Fortunately, I had worked fast enough to capture this "500%-satisfactory" image!□

Keeping one child happy in front of a camera is a challenge. Holding the enthusiasm of five children borders on the impossible. Don't seat your subjects until you're ready to shoot—and then work fast.

Portfolio 67

Purpose: Picture series on children in summer
Location: Subject's home, Westchester, NY
Camera: Nikon FM
Lens: 85mm *f*-2 Auto-Nikkor
Lighting: Sunlight through glass door
Film: Kodachrome 64
Exposure: 1/60 second at *f*-5.6

The boy in this photo is lit by direct sunlight from the front and has a shaded, indoor area behind him. In spite of this potentially contrasty situation, I needed neither fill flash nor portable reflectors. As you can see, there are no deep shadows.

There are several reasons why this picture "worked" with sunlight alone. You'll notice that the areas lit by direct sunlight are relatively small: Rim lighting on arms, hand and face, a small patch on his cheek and a larger one on his chest. In addition, the blond hair is highlighted.

All the areas lit by direct sunlight could stand some overexposure because the burn-out that would result was in limited areas. Knowing this, I was able to base my exposure on the skin tones in the shaded areas.

The contrast between the sunlit areas and the shaded areas was limited because the walls surrounding the boy were very close and very bright. They acted as effective reflectors, limiting the burn-out just mentioned. The reflective walls were yellowish. This gave an attractive, warm glow to the skin tones.

The boy's interest in the sunshine and warmth of this summer day is shown graphically by his outstretched hand on the glass door leading to the outdoors. It is enhanced by his upward glance, toward the bright-blue sky.☐

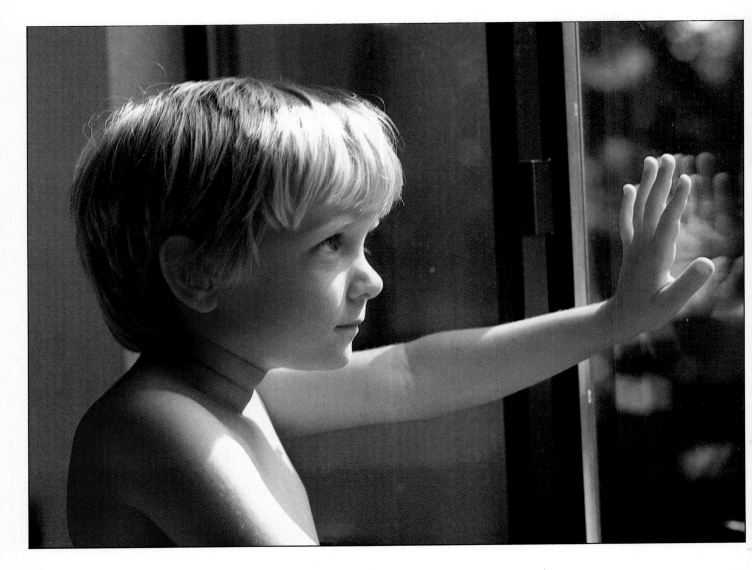

Purpose: Illustration on active children for a magazine
Location: Yard of subject's home, Lenox, MA
Camera: Nikon FM
Lens: 50mm *f*-1.4 Auto-Nikkor
Lighting: Daylight, open shade
Film: Kodachrome 64
Filtration: CS-V special-effect filter from Spiratone
Exposure: 1/125 second at *f*-5.6 to *f*-8

Many special-effect filters are available, including star filters, multiple-image filters, rainbow filters and graduated filters. They can be fun to use. However, no discussion on these filters should be without a word of warning: Don't overuse them!

Don't use a filter simply because you want to prove that you own it. Evaluate each photographic subject and determine whether use of a special-effect filter is appropriate. Choose the right filter for the subject. For example, don't use a multiple-image filter on an elaborate, "busy" subject. Use it in photos where the main theme is one easily recognizable unit.

Similarly, don't use a rainbow filter in back light—when the sun is in front of you. In nature, you see a rainbow only when the sun is behind you. Using such a filter in other lighting conditions will make your photos appear phony.

For the picture reproduced here, I used a CS-V filter, available from Spiratone, to create an effect that is totally appropriate. I wanted to produce the impression of the little girl dancing around in a circle. The filter, as you can see from the photo, gives a sharp image center, surrounded by a blurred, vortex-like trail. It truly creates the impression that the subject is rotating rapidly.

For my subject, I selected a little girl I knew from previous experience to be very active and outgoing. I played some lively music on a portable radio and coaxed her into dancing.

For the filter to work most effectively, I needed a simple background without strong highlights. I shot in open shade, with a background of lawn and trees.□

Purpose: Personal photo
Location: My home, New York City
Camera: Minolta Freedom II Autofocus
Lens: 35mm *f*-3.5
Lighting: Camera's built-in automatic electronic flash
Film: Kodachrome 64
Exposure: Automatic (unrecorded)

I took this photo one evening when a friend and her baby were visiting me. While we were talking, my friend played with the child, occasionally tipping him upside down in the way all children seem to love.

I saw an opportunity for photography and realized this was a perfect time to use my autofocus Minolta Freedom II camera. I simply pointed the camera and pressed the shutter button—something I'm not used to doing as a professional. In spite of virtually no effort on my part, I got some lovely pictures, as the one reproduced here shows. The camera focused automatically on the subject and also provided the flash exposure automatically.

A word of advice to those who want to use this camera with color slide film: There are only three film-speed settings—100, 200 and 400. Also, this type of camera is designed primarily for use with color negative film. With slide film, there's a tendency to overexposure. That's because negative film is best exposed for shadow areas and slide film for highlight areas.

I got a well-exposed slide by using 64-speed Kodachrome film and setting the camera for a film speed of 100. This gave the underexposure I needed.□

Purpose: For stock files
Location: My studio, New York City
Camera: Nikon FM
Lens: 50mm *f*-1.4 Auto-Nikkor
Lighting: Two 200-watt-second electronic flash units in umbrellas
Film: Kodachrome 64
Exposure: *f*-8 (shutter at 1/60 second)

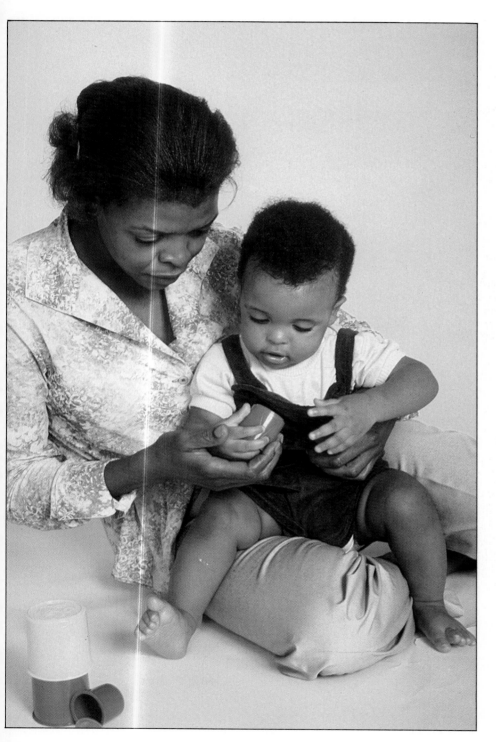

This young boy, like most small children, knows his mother better than anyone else. When I photograph a child with a parent, I often hand over my directing job to the parent for that reason. I told this mother exactly what I wanted and depended on her to make it happen. She knew what would make her child comfortable, what interested him and how to encourage him when he got restless.

When an adult feels nervous in front of a camera, giving him or her some responsibility in the picture-taking process can work wonders. I've seen many mothers transformed into radiant models by becoming a creative part of the session.

Many periodicals and textbooks, and a lot of advertising, are directed specifically at the black community. I constantly get requests for photos of black and other minority-group children and use every opportunity I can to work with them. I happened to see this mother and child walking along the street where I live. I saw an appealing, serene quality in them and asked the mother if she would agree to my photographing them. We arranged a session in my studio.

A yellow background seemed appropriate because it complemented and enhanced the attractive, warm-brown skin tones. Two electronic flash units in umbrellas provided a soft light on the subjects and a uniformly lit background.

I asked the mother to concentrate on the baby and play with him, just as she would do at home. She soon became totally absorbed in her activities with the baby and I was able to shoot away for a full hour. I ended up with several rolls of film of baby with mother and baby alone. When baby was alone in the picture, mother still played with him and retained his attention, but from just beyond the picture area.□

Purpose: Personal photo
Location: Central Park, New York City
Camera: Minolta Freedom II Autofocus
Lens: 35mm *f*-3.5
Lighting: Afternoon sunlight
Film: Kodachrome 64
Exposure: Automatic (unrecorded)

While walking through Central Park in New York City, I noticed the graphic possibilities presented by this long, curved bench. I decided to take a picture of it but wanted to include some human interest. A boy, walking home from school, passed me. I asked him whether he would oblige me and walk along the bench while I took a photo.

The sun was behind me and the scene was average in tonality. It was an ideal subject for the automatic Minolta Freedom II camera.

Point-and-shoot cameras of this type are intended mainly for use with color negative film. The Minolta Freedom II has film-speed settings of 100, 200 and 400—conforming to the more popular color negative films. When color slide film is used, slight overexposure usually results. As I indicated earlier, this is because color negative film is best exposed for shadow detail and slide film for highlight detail.

To overcome this problem, I used 64-speed Kodachrome film and set the camera for a speed of 100. It gave me a good exposure on slide film.

Red is a very dominant color. Notice how the small area of red on the boy helps to make him stand out. When photographing children in a landscape, they often occupy a small part of the image. If you want to draw viewer attention to them, have them wear something red.□

This is just one of many pictures I shot for a story about the life of a country baby. I followed the family around as various members, together with an assortment of pets and other animals, engaged in typical "country" activities.

One of the more spectacular photos—reproduced here—included the family's largest "pet," their horse. The baby was obviously familiar with the horse because she wasn't at all nervous when placed high on its back.

The low afternoon sunlight, shining from the left side, provided beautiful modeling for the subjects. The bright sky provided enough fill light to retain detail in shadow areas.

Posing people of very different sizes, together with a large horse, can present quite a compositional challenge. Notice how I positioned the humans to contain, or frame the horse. Also notice how the heads of the four family members follow the lines of the sloping roof behind them. This helps draw attention to the home in the background.□

Portfolio 72

Purpose: Picture story about a country baby
Location: Subjects' home, Connecticut
Camera: Nikon FM
Lens: 50mm *f*-1.4 Auto-Nikkor
Lighting: Late-afternoon sunlight
Film: Kodachrome 64
Exposure: 1/125 second at *f*-8

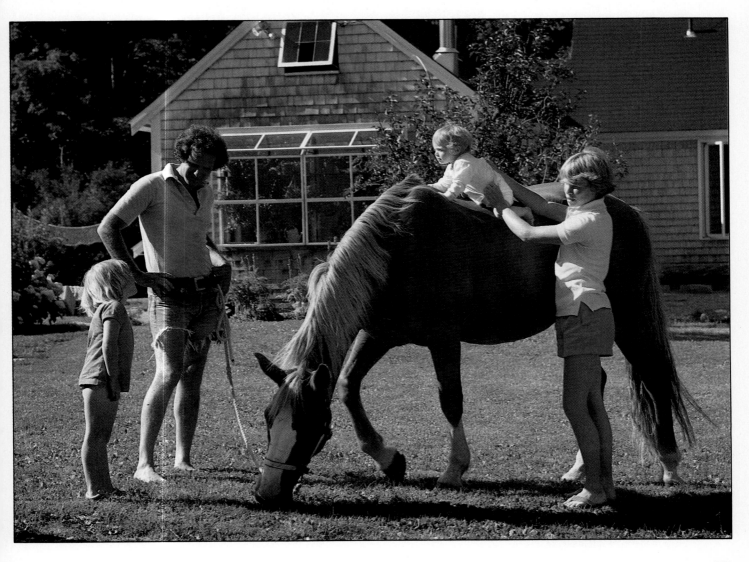

Purpose: For stock files
Location: My studio, New York City
Camera: Nikon FM 2
Lens: 85mm *f*-2 Auto-Nikkor
Lighting: One softbox
Light Control: One foil reflector card
Film: Kodachrome 64
Exposure: *f*-8 (shutter at 1/60 second)

One of the most flattering types of portrait lighting is soft window light. However, window light is very variable. Its brightness and character depend on weather conditions. The light coming through a window also varies with the direction the window faces, the size of the window and obstructions outside that hold back light.

Fortunately, soft window light is easily simulated in the studio. It lies somewhere between the directional light of flash in a reflector and the shadowless illumination produced by a large bank of lights.

My "window light," which is soft but subtly directional, comes from a large softbox containing a flash head. By changing the power of the lamp in the softbox, or altering its position in the box, I can modify the character of my window light. And I can repeat the same lighting effect at will.

The window light for the photo reproduced here consisted of a 200-watt-second flash head in a 24x32-inch softbox. The girl was seated about four feet from the softbox.

I achieved beautiful modeling of the girl's face, with distinct shadows and highlights. To lighten the shadows a little, I placed a foil reflector card to the right side of the subject.

I chose a blue-gray background to contrast with, and emphasize, the warm skin tone of the child.

Notice that I asked the child to look slightly upward. This helps to establish the smallness of a child in relationship to taller adults and larger surroundings. To emphasize her smallness further, I left plenty of headroom in the frame. □

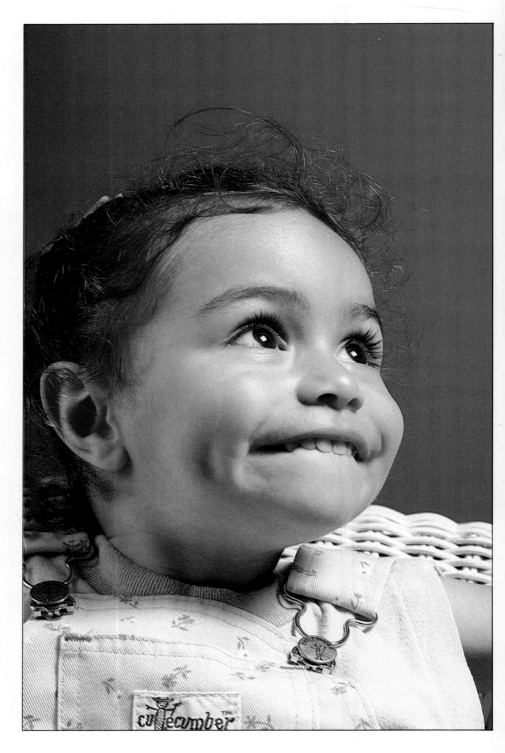

Purpose: For stock files
Location: Subject's home
Camera: Nikon F
Lens: 50mm *f*-1.4 Auto-Nikkor
Lighting: Late-afternoon sunlight
Light Control: Foil reflector
Film: Kodachrome 64
Exposure: 1/125 second at *f*-5.6

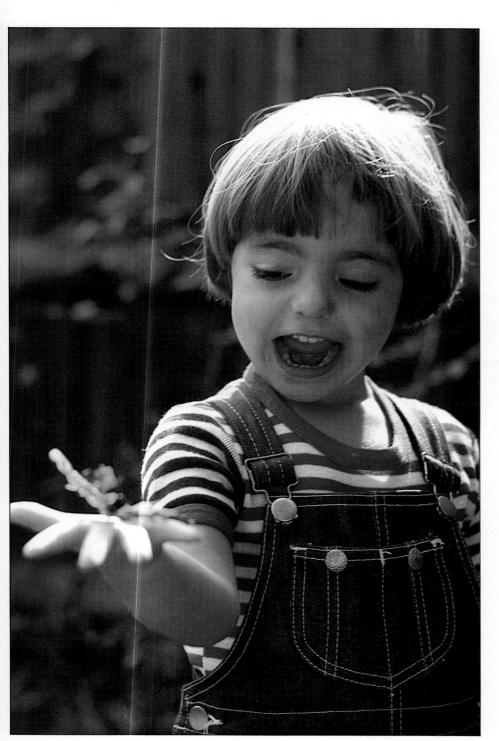

If you can manage to get a photo of a butterfly alighting on the hand of a delighted child, take it. If there are no butterflies about, or if they simply won't cooperate, don't despair. Do what I do and keep a fund of artificial props—including butterflies—for such occasions.

Of course, there are disadvantages to artificial props. I don't like the idea of my pictures being anything but totally authentic. I diligently avoid plastic replacements when I can use the real thing. I prefer the *real* look of delight on the face of a child who is holding a *real* butterfly.

However, when I decided to photograph this little girl with the inanimate butterfly, I faced some interesting challenges. How could I ensure that the butterfly would not look phony? I did it by recording hand and butterfly somewhat out of focus.

How would I get a genuine expression of delight on the child's face? I had the child hold out her hand. Just before taking the picture, I had the girl's mother place the butterfly on the hand. When I made the exposure, the child hadn't had time to realize that she wasn't holding a living butterfly. Before the shoot, she hadn't been told anything about butterflies—living or artificial.

I used backlighting from the late-afternoon sun. The rim-lighted head and the sunlit hand stand out well from the dark background. A foil reflector near the camera lightened the shadows on the subject.

The butterfly may be artificial, but the child's expression of surprise and excitement is very real. A fraction of a second after I made the exposure, the startled hand had recoiled and the plastic prop had fallen to the ground!□

Purpose: For stock files
Location: Park in Riverdale, NY
Camera: Nikon F
Lens: 85mm *f*-2 Auto-Nikkor
Lighting: Afternoon sunlight
Film: Ektachrome 200
Exposure: 1/125 second at *f*-8

This is one of my regular models. I've photographed her since she was three months old. During this session, I wanted to make head shots with a summery feeling. I did this by emphasizing the brightness of the scene. By having the girl backlit by the sun, the shaded face contrasted well against the highlighted hat and shoulders and the slightly overexposed background.

Although I wanted the face shaded, I wanted to show clearly the girl's bright-blue eyes, her delicate facial structure, her freckles and her soft hair. The white dress helped to throw some light into the shaded areas, and so did the translucent rim of the hat. Exposure was based on a close-up reading of the girl's face.

I made numerous photos of the girl in this basic pose, her expression changing from shot to shot. Sometimes she was smiling, sometimes laughing, and in some of the pictures she was serious. I particularly liked the delicate, pensive expression in the photo reproduced here, as well as the appealing eye contact with the camera, and hence the viewer.☐

I particularly like the delicate, pensive expression of the girl and the appealing eye contact with the camera, and hence the viewer.

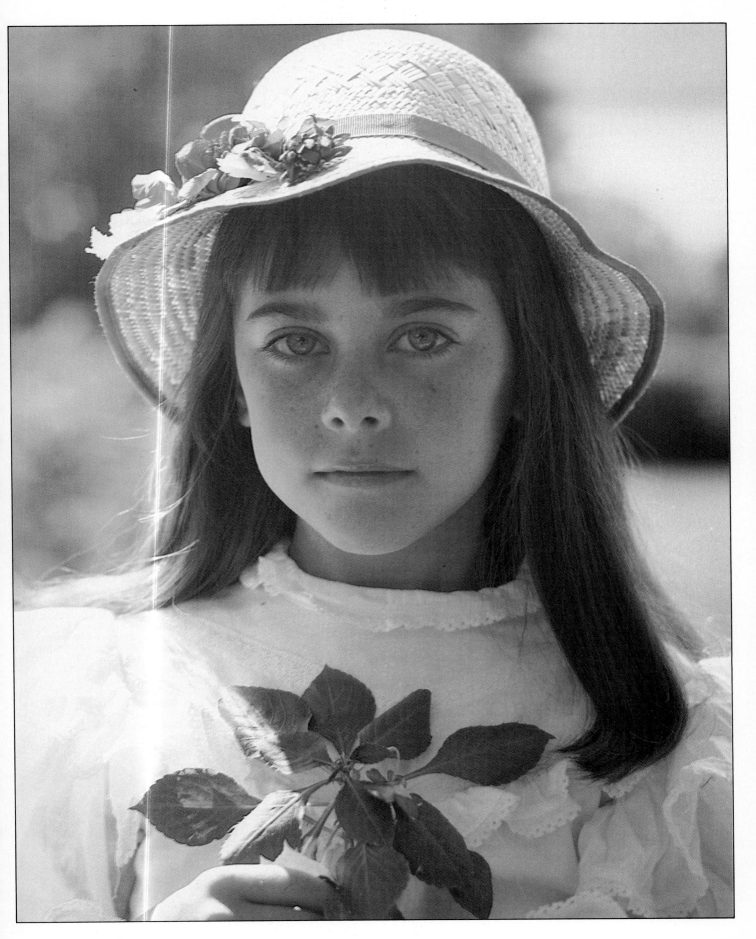

Purpose: Model's head sheet
Location: My studio, New York City
Camera: Nikon FM
Lens: 85mm *f*-2 Auto-Nikkor
Lighting: Two 200-watt-second electronic-flash units in umbrellas; one small flash on background
Film: Kodachrome 64
Exposure: *f*-11 (shutter at 1/125 second)

A model agency asked me to produce some good head shots of this little girl for her portfolio. As soon as she walked into my studio, I knew what I wanted to do.

I selected a green, seamless-paper background because I thought it would nicely complement the pink outfit and her soft, blond hair.

A main light was to the right of the camera. A fill light was near the camera position. These two lights gave flattering overall illumination and also highlighted the hair nicely. I used a third flash, hidden behind the child, to brighten the background.

I bracketed exposures between *f*-8 and *f*-16 to provide images of various densities. The picture reproduced here was shot at *f*-11.

The child was remarkably patient and professional, so I was not obliged to hurry, as I often must with younger or less-experienced subjects. The mother helped the session along by talking to the child and encouraging her.

Notice the low placement of the child in the frame. It often helps to leave plenty of headroom over a child to emphasize the smallness of the child. The small size of the child is further indicated by her upward glance—presumably at a taller adult.□

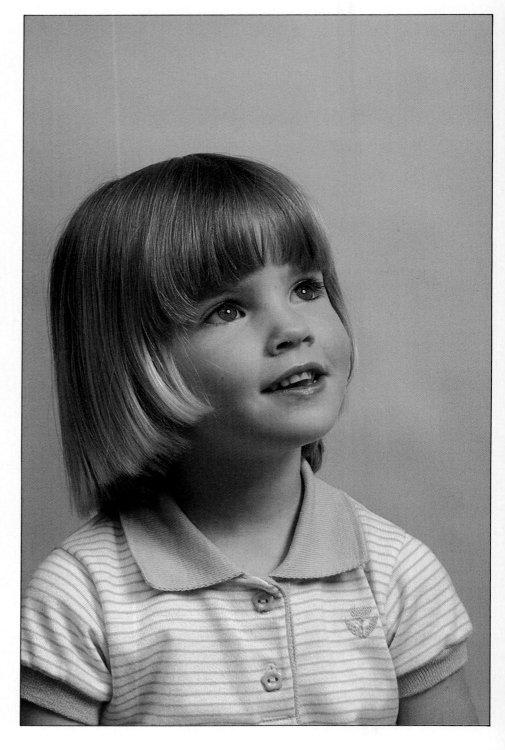

Purpose: Illustration for a book
Location: My studio, New York City
Camera: Nikon FM
Lens: 85mm *f*-2 Auto-Nikkor
Lighting: Two electronic flash units in umbrellas
Film: Kodachrome 64
Exposure: *f*-8 (shutter at 1/125 second)

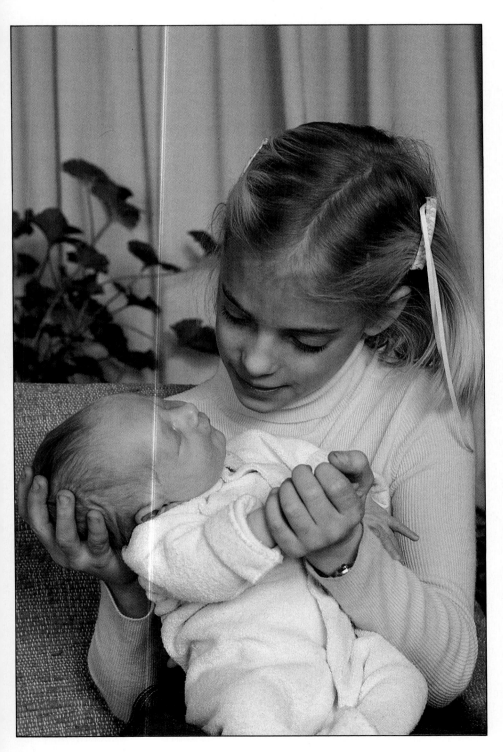

It isn't easy to book newborn babies as models. Mothers love to have private portraits of, and with, their newest family members but generally don't want to subject them to the hustle of commercial photography.

When I was asked to make the photograph reproduced here, to illustrate an article, I was lucky. A family I photograph regularly had a newborn baby and an older girl—just what I needed. Because the parents know me well, they entrusted me with their baby and gladly permitted me to use both children as my models.

The girl was nervous about holding the baby and the baby sensed it. My challenge was to get just one shot in which both the baby and the little girl seemed comfortable and at ease.

After making each exposure, the baby squirmed and the mother would have to "rescue" him. She would soothe him and return him to the little girl's arms. There, the baby would appear comfortable just long enough for me to take another shot.

I worked fast, and the entire session took only about 20 minutes. Among all the frames I exposed during that time, I got one that really satisfied me—the one reproduced here. In it, the little girl looks comfortable and confident and the baby seems to sense it. The baby looks relaxed.

The right moment lasted for just a fraction of a second, but I managed to capture it on film. A viewer of a picture such as this one may be excused for believing that child photography is easy. It isn't! Often, when I admire the one shot I succeeded with, I also think of the many that got away!□

Portfolio 78

Purpose: Series on educational toys for a book
Location: My studio, New York City
Camera: Nikon F
Lens: 50mm *f*-1.4 Auto-Nikkor
Lighting: Two 200-watt-second electronic flash units in umbrellas
Film: Kodachrome 64
Exposure: *f*-8 (shutter at 1/125 second)

I try to satisfy three basic requirements when shooting on assignment. First and foremost, I must fulfill the client's needs. Second, I must produce something that satisfies my own standards. Third, I try to do something a little different on every new shoot.

To satisfy a client's needs, a photographer must find out precisely how a picture is to be used and what it is intended to convey to the user. Before I shot the series of which this picture is only a part, I did some research on the book in which the photos were to appear.

When a child is photographed at play, he should look natural. That's why I wanted this boy to remain tousle-haired, just as you see him here. For a formal portrait I would, of course, have made sure that he was neatly groomed.

Because the photo was taken as part of a series on educational toys, I waited for an appropriately thoughtful expression. The boy was clearly concentrating on his actions. A bright smile toward the camera—no matter how attractive—would have been inappropriate.

To emphasize that even "serious" play can be fun, I chose a cheery, yellow background. The yellow also complemented the green shirt and orange blocks nicely.

I used a standard two-light setup, with a main umbrella-flash to the front of the boy and a weaker fill flash near the camera position.

The boy's total involvement in his activity gave me time to shoot plenty of pictures and offer the client a generous selection.☐

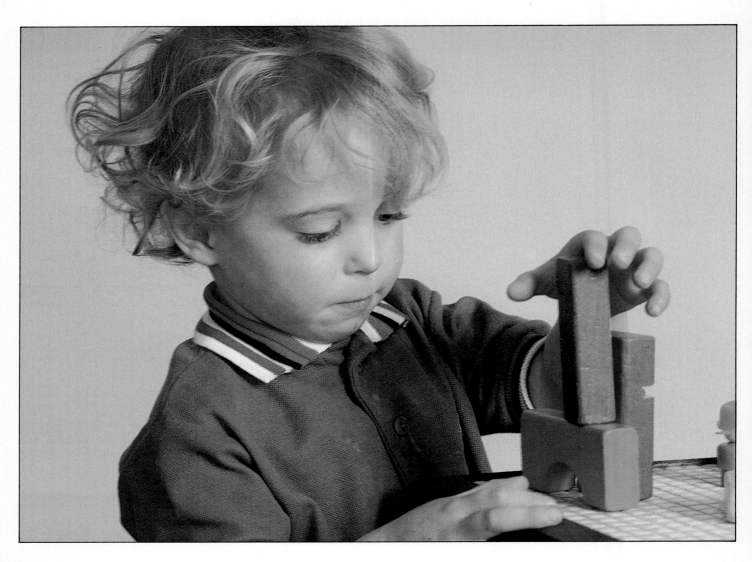

Purpose: For stock files
Location: Subjects' home, New York City
Camera: Nikon FM
Lens: 85mm *f*-2 Auto-Nikkor
Lighting: Two 200-watt-second electronic flash units
Film: Kodachrome 64
Exposure: *f*-11 (shutter at 1/60 second)

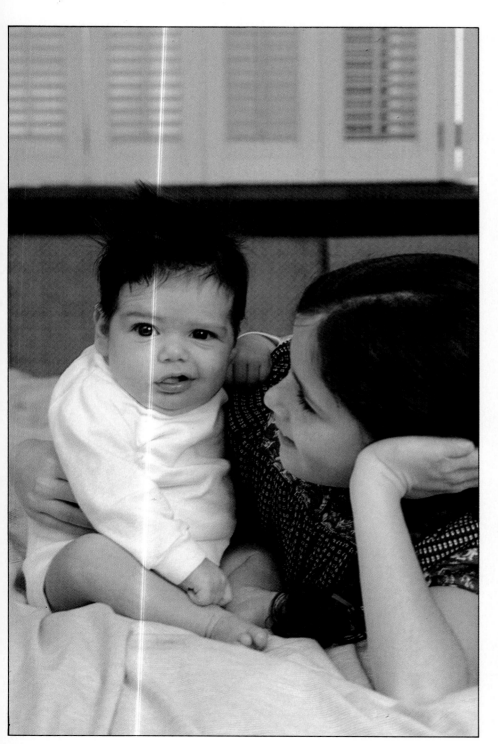

Babies and small children are much less flexible than adults. Each child has specific needs at specific times. Times for feeding, sleeping or being fully alert vary from child to child. To be successful, a photographer of children must realize this fact, and respect it. You can ask an adult to change his normal routine to fit into a specific shooting schedule but you can't do this with small children. Study their habits—and respect them.

The best source for finding out when a child is likely to be at his best is, of course, the mother. Listen to her and plan accordingly. The difference between photographs of an alert and cooperative baby and of the same baby when irritable or tired is enormous. Often, you would think the pictures are of different babies.

When you have a baby at his best time, keep him happy. One important factor in achieving this is to keep your shooting session short. Set up your lights and camera and prepare everything in the shooting area before the child is brought on the scene.

Before I brought the two children, depicted here, into the room, I had determined exactly where I was going to place them. I had arranged one umbrella flash for direct illumination and directed a second flash toward the ceiling for bounce light. I had made an exposure assessment.

When I started shooting, I did it with a motor-driven camera. In the photo reproduced here, the baby looks contented. However, the contentment didn't last long—simply because small babies have very limited staying power. To capture the best expressions in babies, work fast and with an alert eye.□

Purpose: For stock files
Location: Garden in Westchester, NY
Camera: Nikon FM
Lens: 85mm *f*-2 Auto-Nikkor
Lighting: Afternoon sunlight; fill flash
Film: Kodachrome 64
Exposure: 1/125 second at *f*-5.6

If I had metered exposure for the faces, I would not have needed fill flash. However, I wanted the foliage in the background to record fairly dark and did not want the rim light on the heads to "burn out" too severely. This meant underexposing the faces. To regain detail in the faces without brightening them too much, I had to use carefully controlled fill flash.

With the shutter at 1/125 second, a meter reading of the trees in the background indicated *f*-5.6. A spot reading of the faces indicated *f*-2.8 to *f*-4. I shot at 1/125 second at *f*-5.6.

Without flash, the faces would be underexposed by about 1-1/2 exposure steps. I decided to add about 1/4 the full flash exposure, to brighten the faces slightly. This is how I did it:

Dividing the flash guide number by *f*-5.6 gave a flash-to-subject distance about twice my actual camera-and-flash distance from the faces. Setting the flash to 1/4 power gave me "correct" exposure under normal flash conditions. Setting the flash to 1/8 power gave half the light output needed for full flash exposure.

Because I was working outdoors, with no reflective walls or ceilings nearby, the flash would not be as effective as in a typical indoor setting. This, I estimated, nearly halved the effect of the flash again, giving me the 1/4 full-flash exposure I needed. I exposed accordingly, and the image reproduced here is the result.

I asked the father to repeatedly raise the baby high in the air. After a couple of lifts, my subjects had the happy expressions I was looking for. It just remained for me to make an exposure each time baby reached the highest point of the swing. □

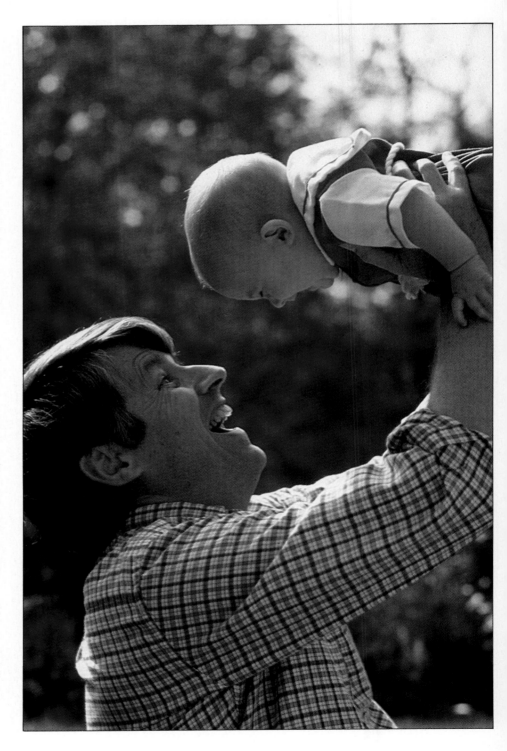

I thought that this photogenic family would make a good photograph for a magazine cover. I took the shot speculatively, having no specific magazine in mind. The photo would also be a useful addition to my general stock files.

I liked the feeling of protectiveness and pride shown by the parents and the obvious happiness of the baby and wanted to show these qualities in my photo. The most appropriate pose was for the parents to hold the baby between them.

The parents looked toward the camera over the back of the couch they were sitting on. The baby was placed on the back of the couch. This way, I was able to keep the three heads close together without having the parents tire by holing the baby up high for an extended period.

The main light was a frontal umbrella flash, just to the right of the camera position. A second flash was bounced from the ceiling.

In all portraiture, expression is of major importance. If the expression of a subject isn't right, no amount of good lighting and composition can save the image. In a family group, you have several expressions to watch out for.

In this photo, I recorded a happy family group at just the right moment. No matter how alert a photographer you are, only a proportion of your shots are going to satisfy you totally. In a situation like this, shoot plenty of film. Then make your selection at your leisure, when the slides come back from the processing lab.□

Purpose: Submission for a magazine cover
Location: My studio, New York City
Camera: Nikon FM
Lens: 50mm f-**1**.4 Auto-Nikkor
Lighting: Two 200-watt-second electronic flash units in umbrellas
Film: Kodachrome 64
Exposure: f-8 (shutter at 1/125 second)

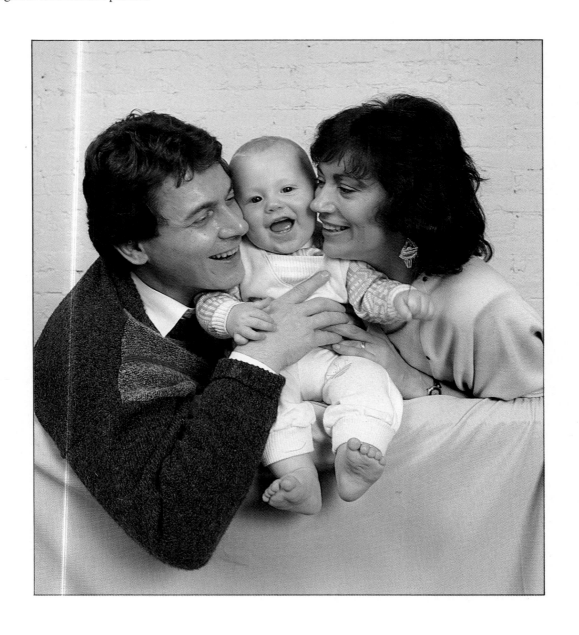

Purpose: Possible use on a
magazine cover
Location: Central Park, New York City
Camera: Nikon F
Lens: 35mm *f*-2 Auto-Nikkor
Lighting: Late-afternoon soon;
light overcast
Film: Kodachrome 64
Exposure: 1/125 second at *f*-5.6

Seeking a possible cover shot with an autumn theme, I took a family to New York's Central Park for a shooting session. At one point during the shooting, the two-year-old girl walked off through the leaves. It's not easy to *direct* a small child to walk away from you without getting a wary, self-conscious backward glance. So, to get this *natural-looking* shot, I had to work fast.

I happened to have the 35mm lens on my camera. It may not be the one I would have chosen for the shot, but I didn't have time to change lenses. I focused quickly on the walking child and made the exposure. The depth of field was adequate to give me an overall sharp image.

When you deliberately intend to take photos of this kind, you can use zone focusing. This means setting the distance scale and lens aperture in such a way that a specific distance zone is in sharp focus. Use the depth of field scale on the camera lens to achieve this.

You can also use zone focusing to deliberately get image parts *out of focus*. By using a longer lens and a wide-open lens aperture, I could have limited image sharpness to the child, with the leaves in front and behind out of focus. This method is useful when you want to avoid clutter. For example, it would have been useful if the leaves in the background had been full of litter.

If you sell your photographs, I advise you to shoot as many pictures of the different seasons as possible, whether you have a sure sale at the time or not. Buyers will want fall pictures in spring and winter pictures in summer, so keep plenty of images in your files.☐

When you take photos of this kind, use zone focusing.
This means setting the distance scale and lens aperture
in such a way that a specific distance zone is in sharp
focus.

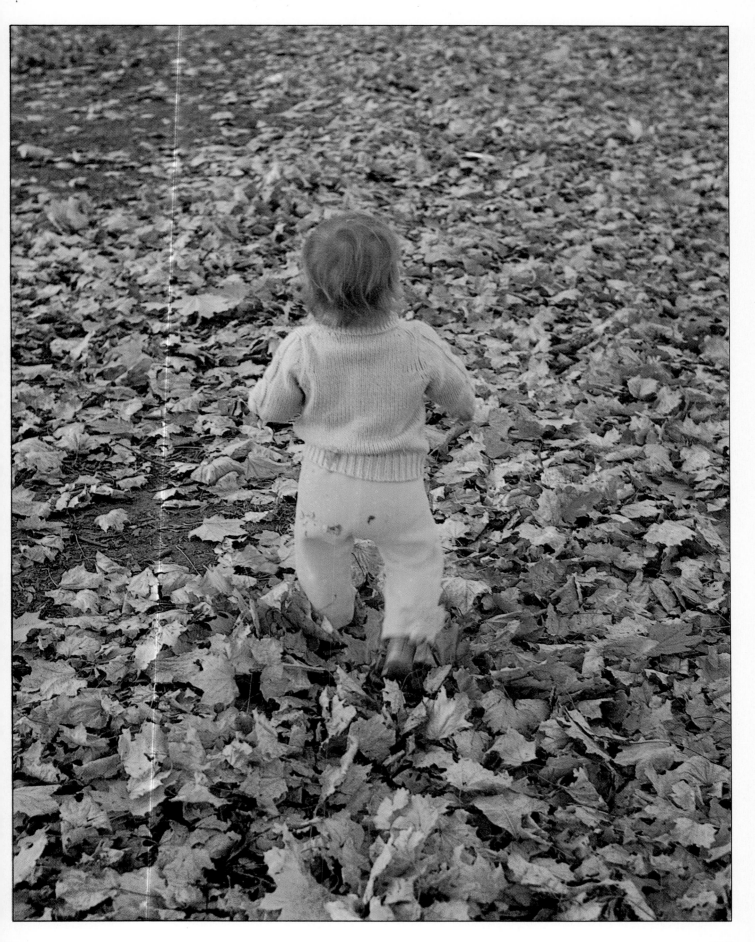

HP Photobooks—Take Your Best Shot

Pro Techniques

Pro Techniques of Beauty & Glamour Photography—Bernstein	$12.95
Pro Techniques of Photographing Children—Stone	9.95
Pro Techniques of Creative Photography—Bradshaw	14.95
Pro Techniques of Landscape Photography—Muench	14.95
Pro Techniques of People Photography—Bernstein	12.95

General Photo Guides

Cibachrome Printing—Krause & Shull	$14.95
Close-Up Photography	7.95
Electronic Flash—Bailey	11.95
Great Pictures with Your SLR—Jacobs	9.95
How to Buy & Use Home Video Equipment—Costello/Heiss	12.95
How to Photograph Flowers, Plants & Landscapes—Fell	7.95
How to Photograph Sports & Action—McQuilkin	11.95
How to Photograph Water Sports—Sammon	7.95
Improve Your Photography	14.95
Photographing People—Busselle	14.95
Photograph Landscapes & Scenic Views—Brooks	11.95
Photographic Lighting—Brooks	12.95
Nature & Wildlife Photos—Freeman	14.95
SLR Photographer's Handbook (Revised Edition)—Shipman	12.95
Understanding Photography—Shipman	9.95
Use & Display Pictures—Kirkman	9.95
Weddings, Groups & Ceremonies—Burk	9.95
Zone System for B&W Photography—Schaefer	14.95

Learn Photography Series

B&W Darkroom Techniques	$8.95
Color Darkroom Techniques	7.95
Creative Darkroom Techniques	7.95
How to Compose Better Photos	8.95
How to Photograph Pets & Animals	7.95
How to Photograph People	8.95
How to Photograph Women	8.95
How to Select & Use Your SLR System	7.95
Make Better Color Photos	7.95
SLR Tips & Techniques	8.95
Take Pictures Like A Pro	7.95
Use Light Creatively	7.95

SLR Camera Guides

Canon SLR Cameras*—Shipman	$12.95
Minolta SLR Cameras—incl. New Maxxum 8-pg Supplement*—Shipman	12.95
Nikon SLR Cameras*—Shipman	12.95
Olympus SLR Cameras*—Shipman	12.95
Pentax SLR Cameras*—Shipman	12.95

*SLR camera guides are updated regularly to include most up-to-date camera models.
All books are paperback.

HP photo books are available wherever fine photography books are sold, or order direct from the publisher. Send check or money order payable in U.S. funds to:

HPBooks, Inc., P.O. Box 5367, Dept. CPH-66, Tucson, AZ 85703

Include $1.95 postage and handling for first book; $1.00 for each additional book. Arizona residents add 7% sales tax. Please allow 4-6 weeks for delivery. Prices subject to change.